D1174599

COLORATURA

HIGH JEWELRY AND PRECIOUS OBJECTS BY CARTIER

FRANÇOIS CHAILLE

Flammarion

EXECUTIVE DIRECTOR
Suzanne Tise-Isoré
Style & Design Collection

EDITORIAL COORDINATION
Lara Lo Calzo

GRAPHIC DESIGN
Bernard Lagacé
Lysandre Le Cléac'h

TRANSLATED FROM THE FRENCH BY
Language Consulting Congressi, Milan

COPYEDITING AND PROOFREADING
Christine Schultz-Touge

PRODUCTION
Corinne Trovarelli

COLOR SEPARATION
Les Artisans du Regard, Paris

PRINTED BY
Musumeci, Italy

Simultaneously published in French
by Flammarion as *Coloratura, Haute joaillerie
et objets précieux par Cartier*.

© Flammarion, S.A., Paris, 2018
© Cartier, 2018

English-language edition
© Flammarion, S.A., Paris, 2018
© Cartier, 2018

All rights reserved. No part of this publication may
be reproduced in any form or by any means, electronic,
photocopy, information retrieval system or otherwise,
without written permission from Flammarion, S. A.
and Cartier International.

Flammarion, S.A.
87, quai Panhard et Levassor
75647 Paris Cedex 13
editions.flammarion.com
styleetdesign-flammarion.com

18 19 20
ISBN: 978-2-08-020385-4
Legal Deposit: September 2018

CONTENTS

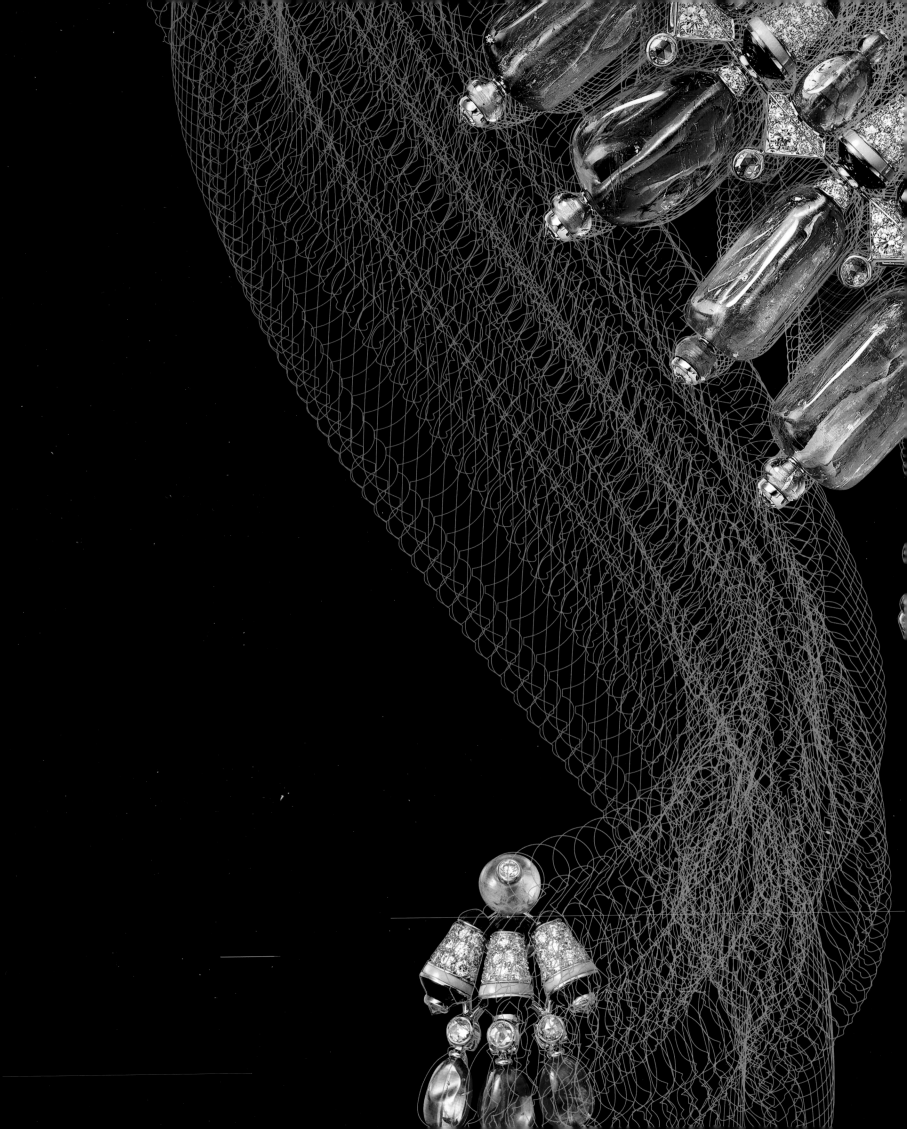

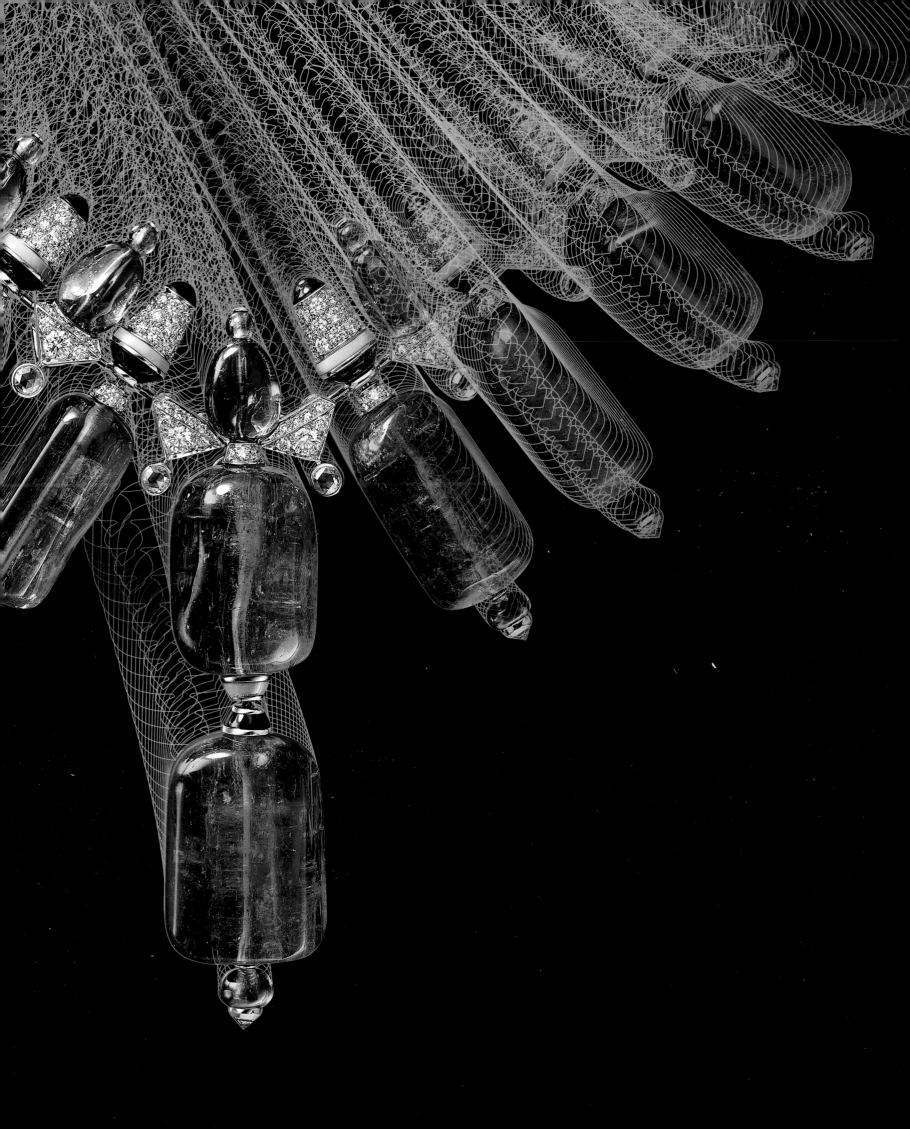

INTRODUCTION Anyone who has heard Maria Callas sing *Norma*, Cecilia Bartoli "Una voce poco fa" from *The Barber of Seville*, or Natalie Dessay "Der Hölle Rache" from *The Magic Flute* has experienced coloratura, an old sixteenth-century Italian word signifying chromatic ornamentation, deriving from the Latin verb *colorare* ("to color"). It is not a question of the timbre of the voice of a dramatic soprano like Callas, a mezzo-soprano *leggero* like Bartoli, or a soprano *leggero* like Dessay. Coloratura is the virtuoso expressivity of those voices, the elaborate melodies embellished with runs, trills, and leaps. It demands vocal agility and range, the ability to emphasize contrasts between notes up and down the scale, to instantly shift, without breaking harmony, from intense passion to delicate freshness. Coloratura is a matter of spirit.

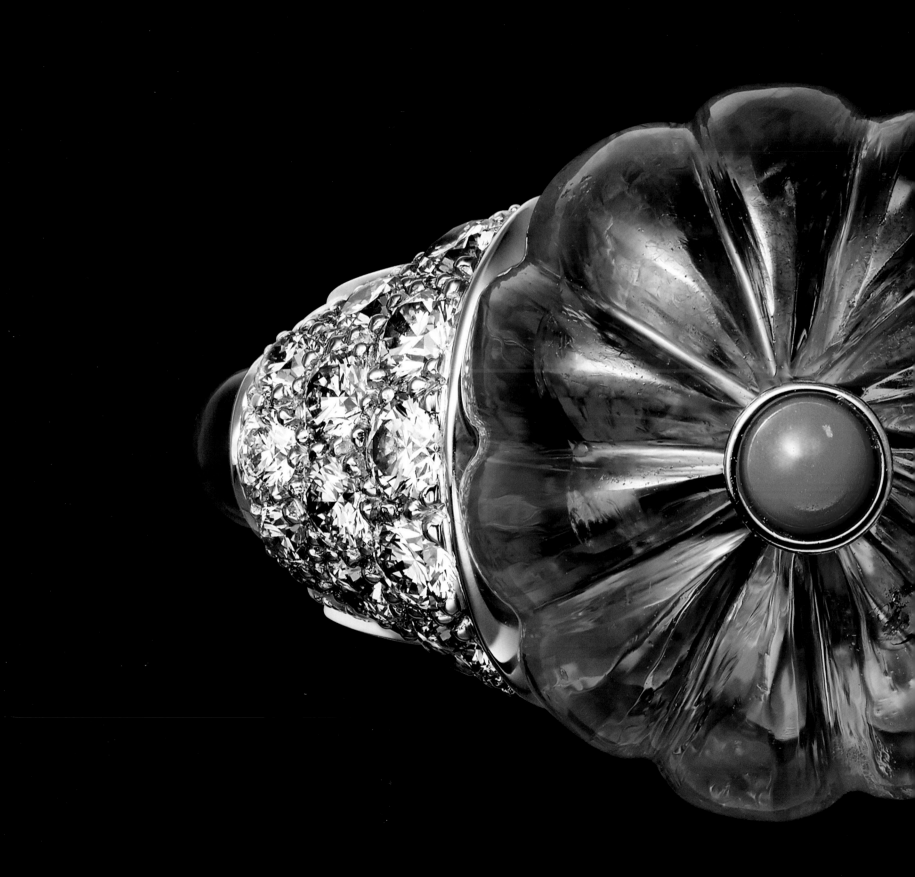

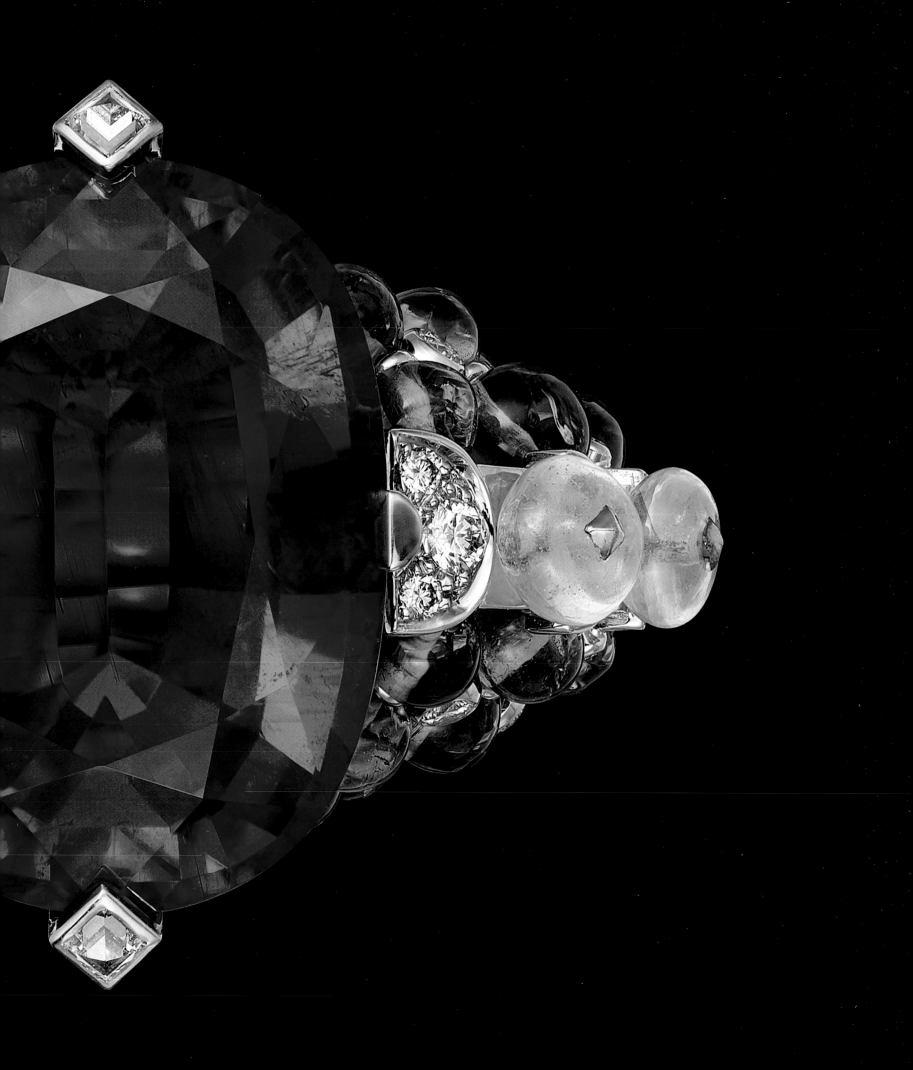

Doesn't this mastery, this beauty born of virtuosity, aptly describe the art of Cartier—and particularly the flourishes of its color palette? And this year, especially, for its Coloratura collection? Is not each and every one of its jewels a masterpiece of coloratura? Where the colors of two gems long thought antagonistic—green and black, blue and green—become a dazzling leap? Where a tone played out in subtle gradations or vibrant variations conjures the most extravagantly lovely magic? Where divergent geometries overlap to create an uncharted planet, a sensual and majestic utopia? Or where contrasting materials—glittering or polished crystal, translucent or opaque stones—are mutually seduced in amorous interplay? When these orchestrated gems light up in joyful, cadenced song, in the rhythm of a beating heart, bringing life to a designer's drawing?

Dzanga-Sangha
05:32/12:07

African Forest Elephant
Éléphant de forêt d'Afrique

Cartier, the voice of gemstones. As in opera, this jeweled coloratura is not simply a question of technical mastery, just as the thrill of Maria Callas's silky low notes and the range and brilliance of her high notes are not simply the culmination of years of work. Her vocal poetry dwells in character and inspiration. Likewise, Cartier's coloratura is not simply the fruit of ancestral know-how and thousands of hours of work in its *ateliers*. It comes from a deeply rooted identity, from intense and unflagging curiosity, leading to a passion for all the colors of the world, for the chromatic harmonies and styles of distant lands.

The three Cartier brothers inherited their curiosity for the cultures of other lands from their father and grandfather. They knew how to nourish it, deepen it, and infuse it into their creations. In the early years of the twentieth century, Louis was passionately interested in cultures that might offer him new inspirations, new patterns, new colors. He was strongly impressed by the *Exhibition of Islamic Art* organized by the Union centrale des Arts décoratifs in Paris in 1903. This was the first time that the public had a chance to view close to a thousand objects and fabrics from Arabia and Persia. It was probably at this time that he began collecting them, scouring antique shops, and also developed an interest in the arts of Japan, China, and ancient Egypt. In 1909 he was once again seized by wonder at the sight of the costumes and stage sets, the audacious contrasting colors, of Diaghilev's Ballets Russes. Wholly novel color combinations began to appear in his jewelry compositions: blue and green, blue and purple, green and orange, blue and green and red.

In the meantime, Louis's brothers, Pierre and Jacques, set out to conquer the world. After visiting Russia, Pierre attained near fetish status as jeweler for wealthy American families who had become rich during the Gilded Age. Jacques, now director of the London branch, traveled through the Persian Gulf and India, hobnobbed with maharajahs and, most importantly, brought back ideas for unusual ornaments and colors.

This audacious color palette, introduced at the beginning of the twentieth century and continuing to flourish ever since, is inseparable from the Cartier identity. It reached out to new horizons in its creations and collections to better seize the essence of an era that has transported us beyond space and time, adding the colors and rhythms of Latin America, Africa, Oceania . . .

"Color above all, and perhaps even more than drawing, is a means of liberation," wrote Henri Matisse in 1945 for an anthology of texts by different painters titled *Les Problèmes de la peinture*. And liberation is always, perforce, a pleasure. In this regard, the chromatic art of Cartier is not just a quest for harmony and beauty. Louis Cartier and his colleagues, most notably the creative director Jeanne Toussaint and the designer Charles Jacqueau, cultivated color as an expression of joy, the enchanted bliss of requited love. Cartier has always been part of the tradition of radiant color worn on the body. One that would bring out an inner delight and make it dazzle the eyes of the world. Because since time immemorial, in every land, one rejoices in colors. Those of all the carnivals of the world, those that render homage to springtime, those of the gladdest events.

The Coloratura collection is a celebration. A joyful, precious, and virtuoso spirit giving voice to all the universal happiness of life.

PAGES 10–11
Bernie Krause, UVA, view of the exhibition *The Great Animal Orchestra*, 2016. Fondation Cartier pour l'art contemporain. Paris.

FACING PAGE
Willem de Kooning, *Merritt Parkway*, 1959. Detroit Institute of Arts, Detroit, MI.

PAGES 14–15
Frank Stella, *Mitered Squares*, 1968. Private collection.

PAGE 16
William Eggleston, *Untitled*, *Paris* series, 2006–2008. Collection Fondation Cartier pour l'art contemporain, Paris.

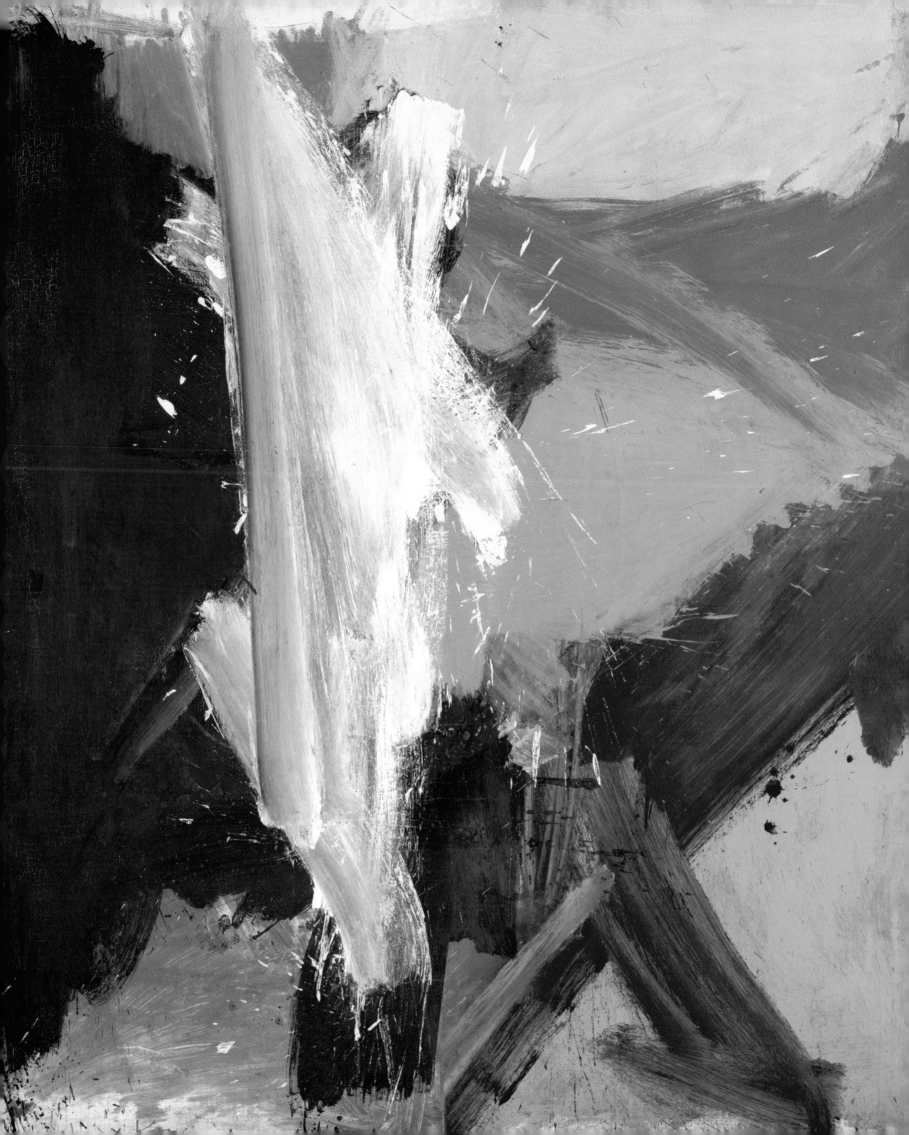

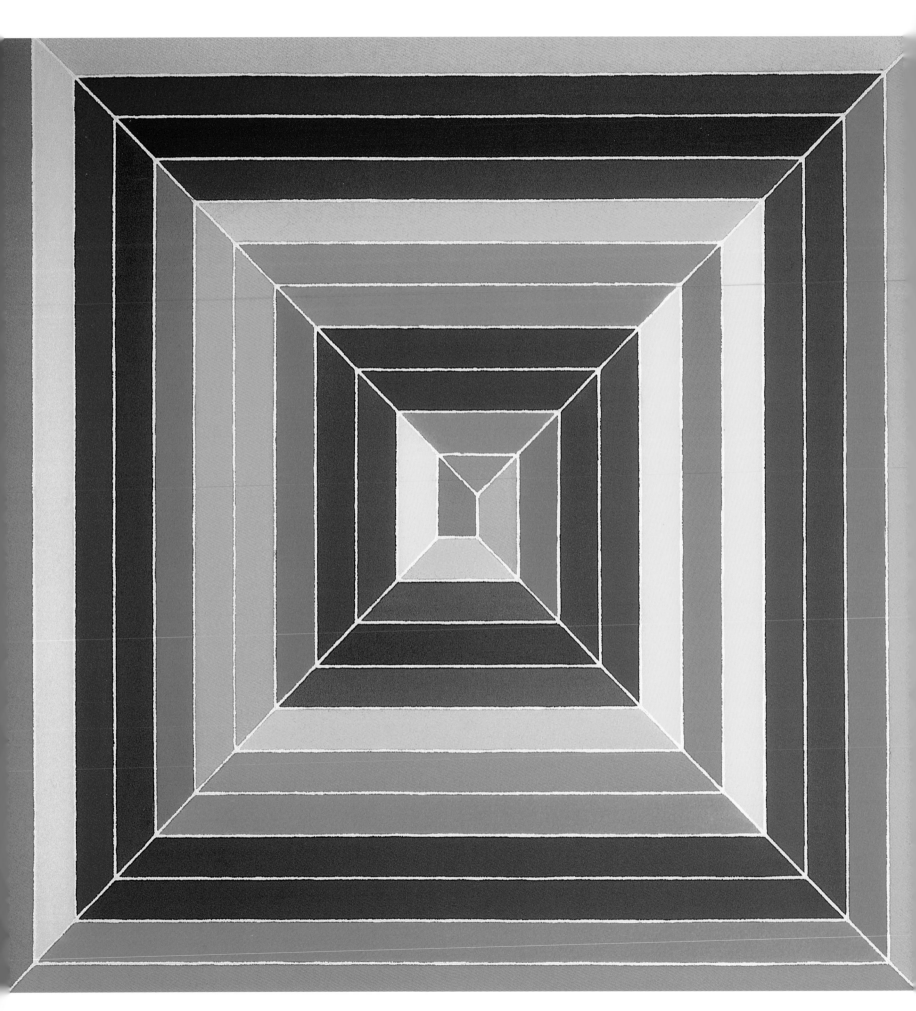

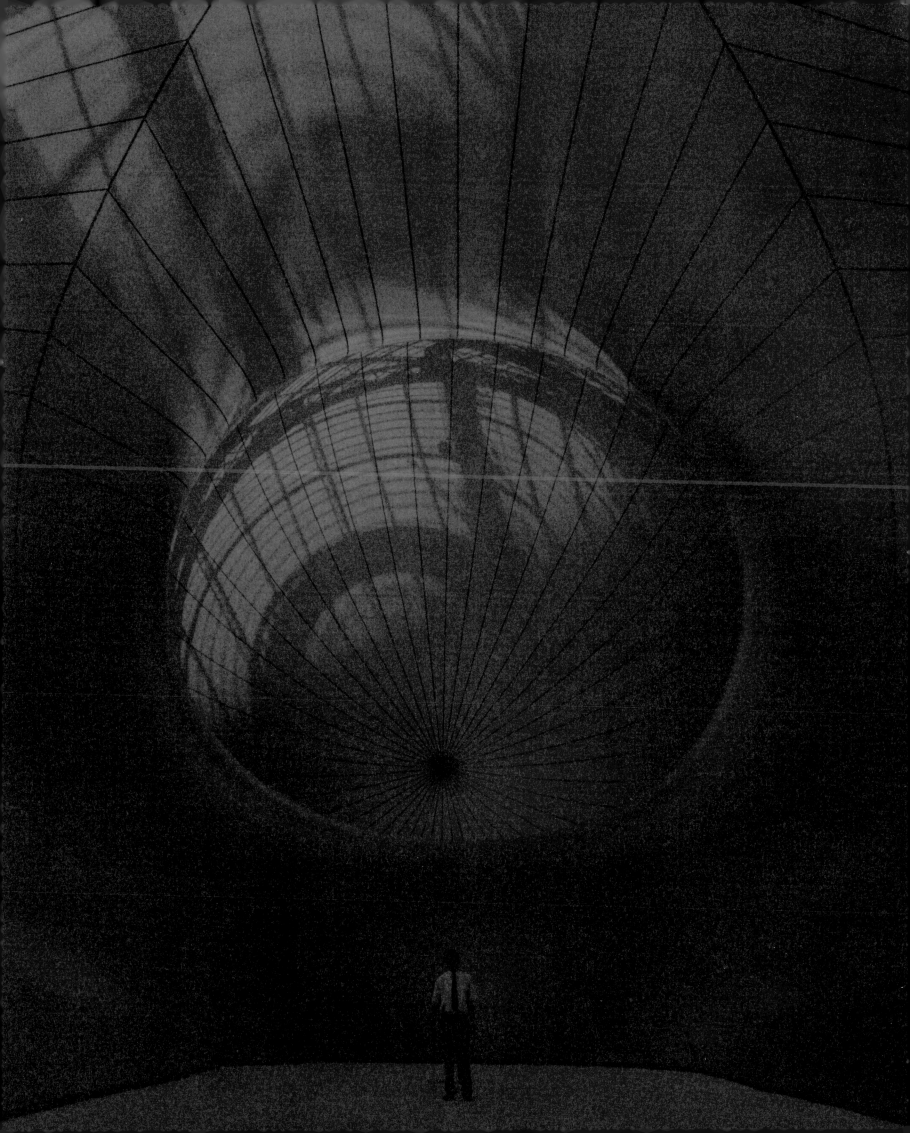

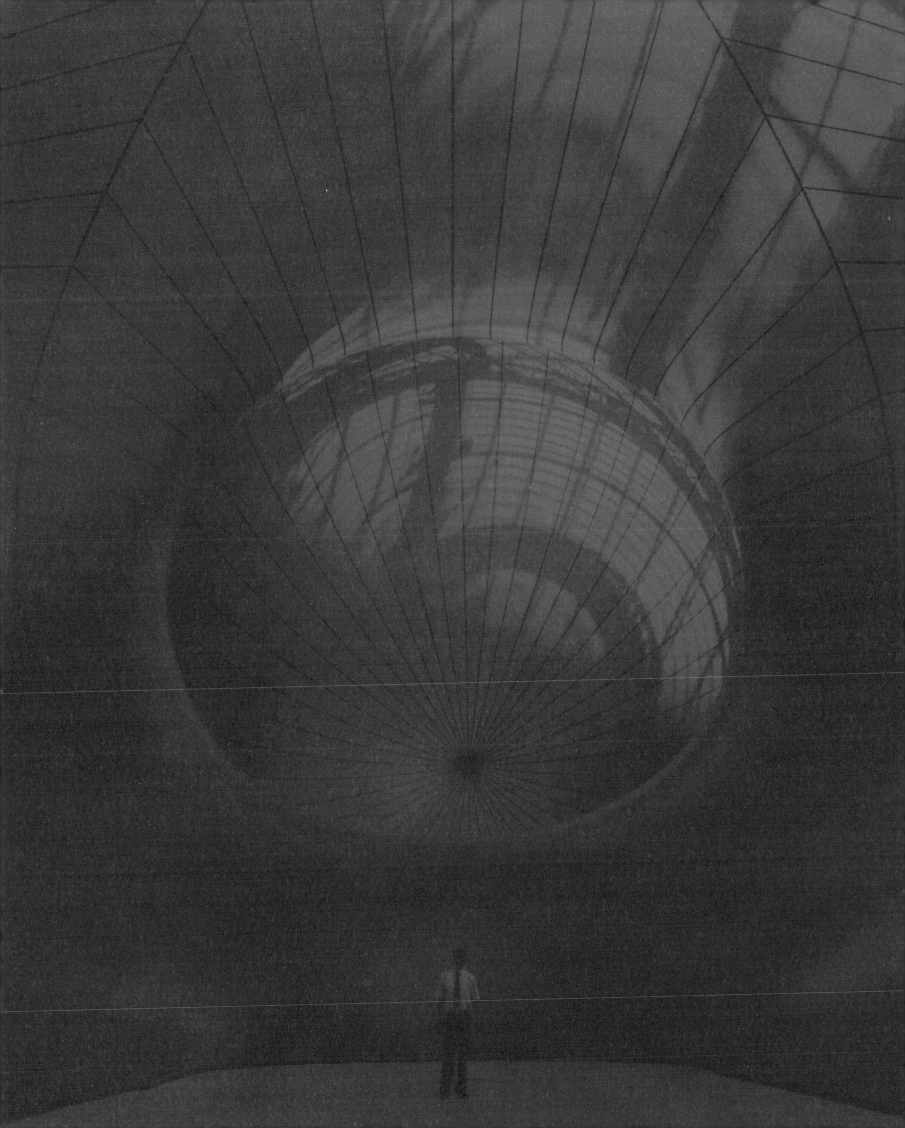

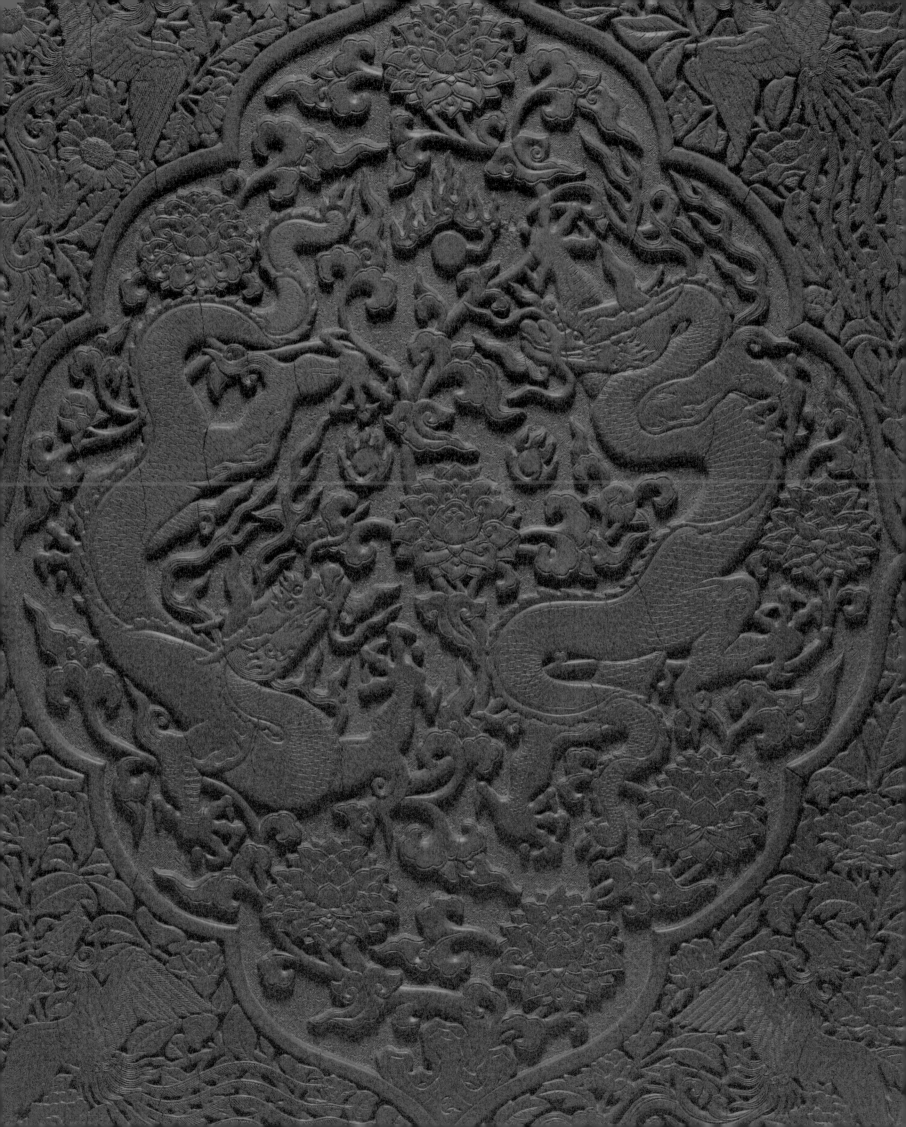

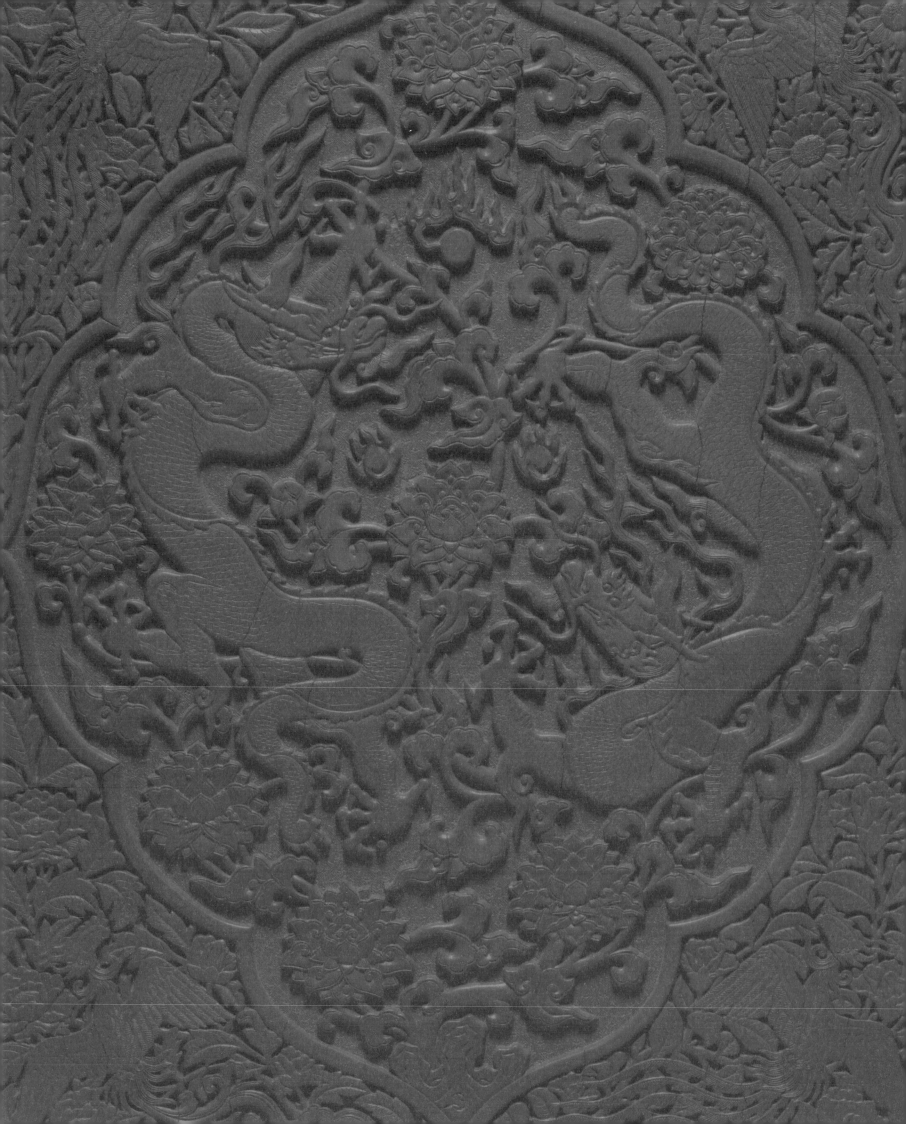

Anish Kapoor, *Leviathan*, presented during the exhibition *Monumenta* at the Grand Palais in Paris in 2011.

Decorative panel with two dragons, Ming dynasty, circa 1426–1435. British Museum, London.

Red is humanity's first color. It dominated the Paleolithic cave paintings and the many colored objects created by the Magdalenian culture. The people of Lascaux knew how to extract hematite—the principal ore of iron—from the soil and transform it in crucibles, adding various oily substances, into something that would adhere to the walls of the caves. We do not know why they seemed to favor red, but we may imagine a relationship with two fundamental elements that must have been highly symbolic early on: blood and fire.

Over the millennia, red has reigned both aesthetically and symbolically. In at least two languages, Latin and Spanish, the same word—*coloratus* and *colorado*, respectively—means both "colored" and "red." In Russian, the words "red" (*krasnyy*) and "beautiful" (*krasivy*) share the same root. Red is recognized and named in thousands of shades, and in most languages it commands a lexicon unequalled by any other color.

Its wealth is again manifested on the symbolic level: no other color encompasses such a breadth of metaphorical meaning. The color of blood and fire, elements that can be both positive and negative, it symbolizes four things in Christian culture: a sanctifying vital force, the blood of Christ, but also the impurity of violence and sin; fire that gives light, heats, and encourages, like the Holy Spirit, but also the flames of hell, the diabolical power of Satan that burns and destroys. Red is the color of love, passion, desire, and seduction but equally—as clearly represented by the lanterns and decorations of brothels and the red-light district of Amsterdam—that of debauchery. It is as much the color of prohibition and danger as it is that of spectacles and festivities such as Christmas, the color of the carpet at the Cannes Film Festival, theater curtains and seats, and, in Paris, that famous windmill, the Moulin Rouge.

This powerful, dominant color has also long been one of the principal emblems of power. Throughout the ancient Mediterranean, the rare fabrics dyed purple—using a violet-red dye obtained at great expense from the glands of a certain sea snail—were reserved for royalty, the priesthood, and statues of the gods. In Rome, while purple fabrics might be worn by officials or high magistrates, appearing fully garbed in this variety of red was the exclusive privilege of the emperor. Violators could be punished by death. Later, in the Middle Ages,

red characterized the attire of the emperor, the doges, and the Pope, while aristocrats in seventeenth-century France were recognized by their red heels. The color of the elite and prestige, in many countries it still characterizes the portfolios of ministers, the highest medals of honor, and the long carpet unrolled before visiting heads of state.

Its radiance often dominates in paintings to the point where a single dab of red becomes the salient feature of the work. Is not the eye immediately drawn to the red foulard in Cézanne's *Man in a Blue Smock*? Many painters were its impassioned devotees, holding it to be the queen of colors, imposing its majesty in compositions structured to best exalt it. Among the many, we may name Uccello, Rubens, Titian, La Tour, Delacroix and also Renoir, Matisse, Gauguin, and Rothko. Later, fashion designers and plastic artists used it to convey the most intense emotions. In 2011, Anish Kapoor envisioned a majestic inflatable sculpture, *Leviathan*, exhibited at the Grand Palais in Paris. Visitors entering the structure found themselves enveloped in the overwhelming red of an immense maternal womb.

In its tradition of jewelry cases and boxes and its long engagement with rubies and coral, Cartier embraces red as its emblematic color. Thanks to Jacques's close relationships with Indian princes, in the 1910s he began conceiving extraordinary ruby parures. On the subcontinent, precious gems symbolize the power of the gods, bringing strength and protection to the maharajahs who wore them. Sovereign among them are rubies: their name in Sanskrit is *ratnaraj*, "king of precious stones." Indeed, two of the most exceptional jewelry masterpieces ever made are the parure composed by Cartier in 1931 for the Maharani of Patiala—comprising a choker of cabochon-cut rubies, natural pearls, and diamonds, a central necklace, and a plastron necklace alternating rubies and natural pearls—and another created for the Maharajah of Nawanagar in 1937 with 119 rubies from Burma.

The Amadis necklace is a chorus of three voices, three close timbres modulating different bass tones, uniting intertwining phrases into a single song. The three harmonious timbres crystalize in three deeply limpid rubies from Mozambique. Placed at three different levels of the melodic line, they sing to each other in an intense, cheerful red against a slightly bluish background or in reddish-orange flames. Each of them holds the accent in a sparkling measure of diamonds and is ready to perform as a soloist or in a duet depending on the occasion or wearer's mood.

For those familiar with the history of Maison Cartier, this piece naturally evokes the neo-Marie-Antoinette style of necklaces, inspired by the laces of a corset, which was in vogue during the Belle Époque. But here we have a contemporary interpretation: sensual knotted pendants disappearing around the neck, the caressing suppleness of the platinum setting, fluid interlacing, tension generated by the trapezoid geometry of the diamonds.

AMADIS NECKLACE
Platinum, three cushion-shaped rubies from Mozambique totaling 20.84 carats, five cut-cornered trapezoid step-cut diamonds totaling 3.51 carats, one 0.57-carat modified shield-shaped step-cut diamond, brilliant-cut diamonds. The piece can be worn in three different ways.

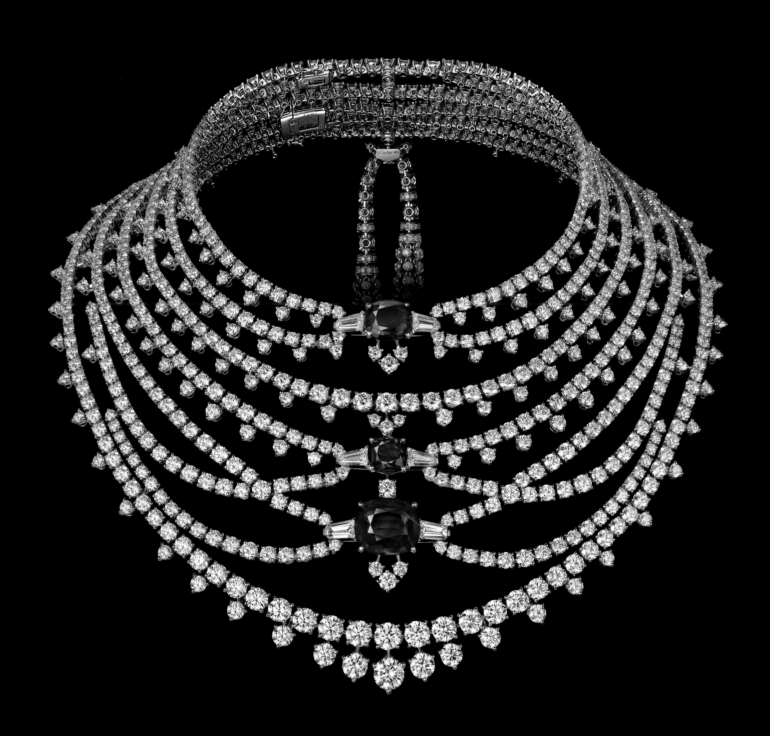

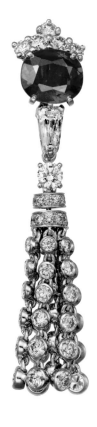
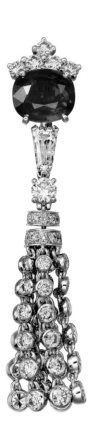

AMADIS EARRINGS
Platinum, two oval-shaped rubies from Mozambique
totaling 8.14 carats, two modified shield-shaped step-cut
diamonds totaling 1.05 carats, brilliant-cut diamonds.
The earrings can be worn in two different ways.

AMADIS RING
Platinum, one 7.03-carat oval-shaped ruby from
Mozambique, two cut-cornered trapezoid step-cut
diamonds totaling 1.46 carats, brilliant-cut diamonds.

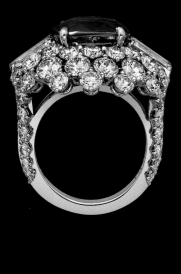
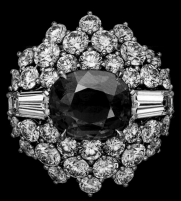
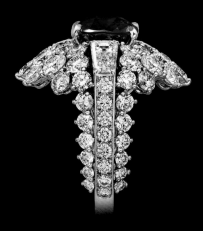

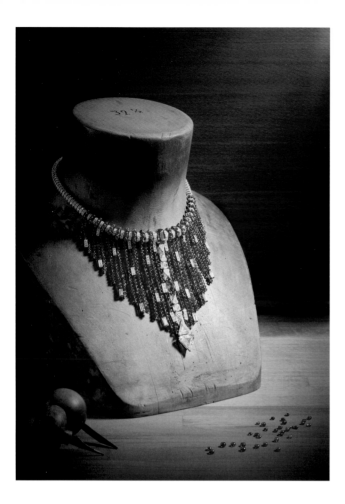

A torrential cascade, warm colors, quicksilver rhythm . . . the distant echoes of Africa.

The cascade of spinel droplets evokes the ornaments of traditional ceremonies, rich in color, while the central element, abstract and geometrical—composed of two glittering spinels with pinkish-orange highlights, along with triangular-shaped, as well as brilliant- and baguette-cut diamonds—is inspired by spectacular tribal masks, the type that may reach several meters in height. The two most remarkable triangular-shaped diamonds are step-cut to represent sparkling pyramids. This central motif imbues the necklace with the power of a monolith connecting heaven to earth. The torrent of spinels flanking it is animated by the intermittent flash of diamonds.

This powerful evocation of cosmic energy has been generated, and tamed, by its extreme refinement of execution: fluid, vibrant, the cascade drapes over the neckline with great elegance, evoking a liquid murmur.

KANAGA NECKLACE
White gold, two orangey pink spinels
totaling 7.58 carats, two triangular-shaped
step-cut diamonds totaling 8.39 carats, spinel
beads, modified shield-shaped, kite-shaped,
baguette-cut, and brilliant-cut diamonds.

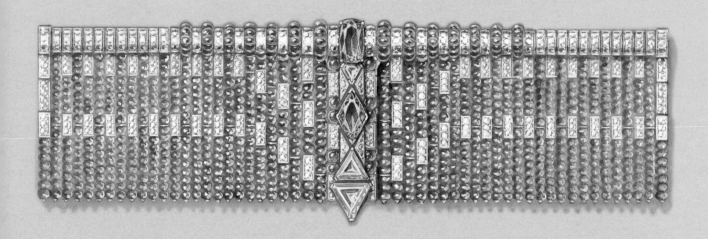

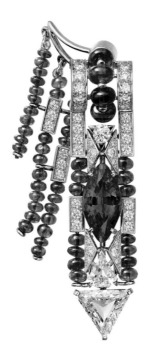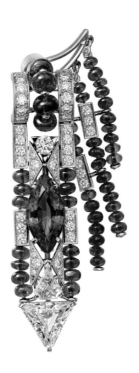

KANAGA BRACELET
White gold, two orangey pink spinels totaling 5.92 carats,
two triangular-shaped step-cut diamonds totaling
4.79 carats, one 0.55-carat modified shield-shaped
step-cut diamond, spinel beads, brilliant-cut diamonds.

KANAGA EARRINGS
White gold, two orangey pink spinels totaling 5.49 carats,
two triangular-shaped step-cut diamonds totaling
3.15 carats, spinel beads, kite-shaped diamonds,
brilliant-cut diamonds.

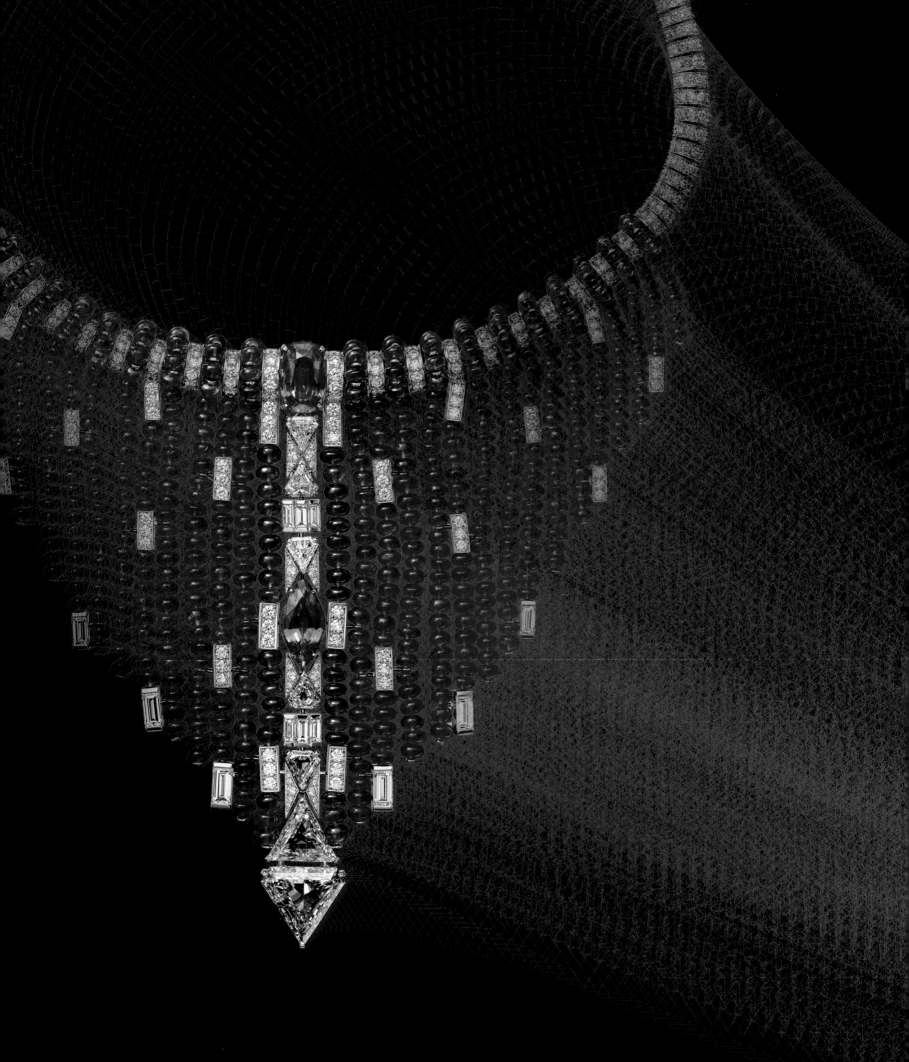

SÉRAPHINE NECKLACE
White gold, one 5.70-carat cushion-shaped ruby
from Mozambique, baguette-cut diamonds, square-
shaped diamonds, brilliant-cut diamonds.

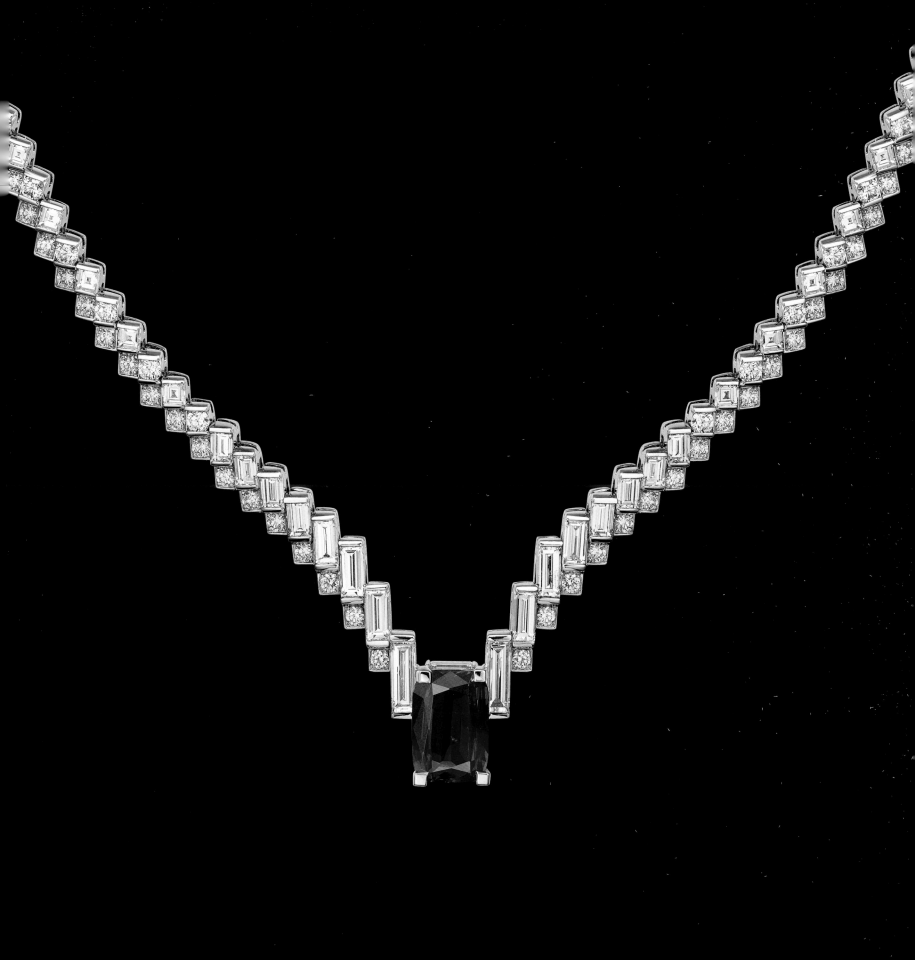

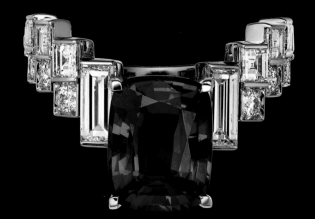

SÉRAPHINE RING
White gold, one 4.17-carat cushion-shaped ruby
from Mozambique, baguette-cut diamonds,
square-shaped diamonds, tapered diamonds,
brilliant-cut diamonds.

ARROW WRISTWATCH
White gold, one 15.90-carat rectangular-shaped
rubellite, black lacquer, fancy-cut diamonds, brilliant-cut
diamonds, quartz movement.

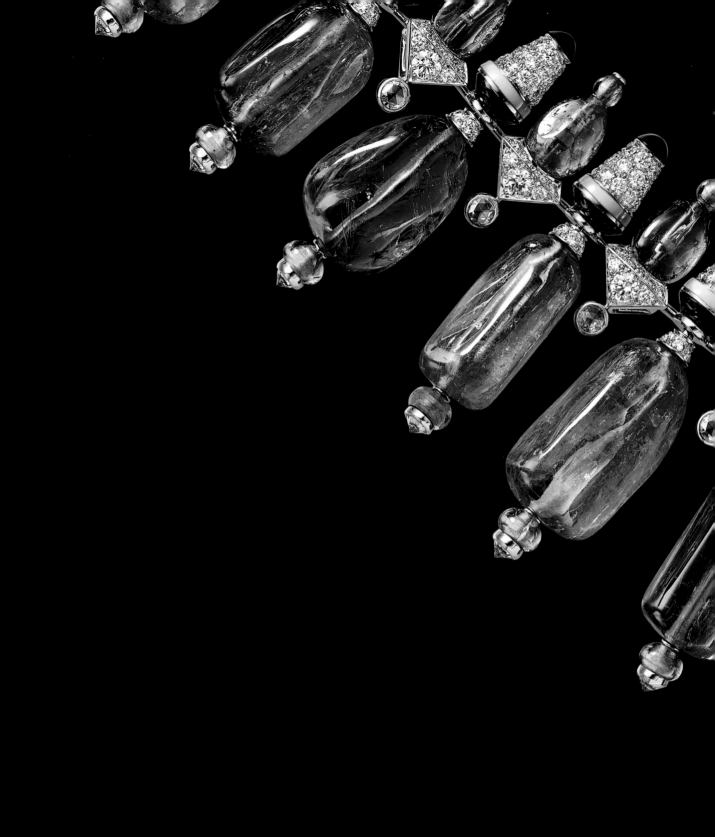

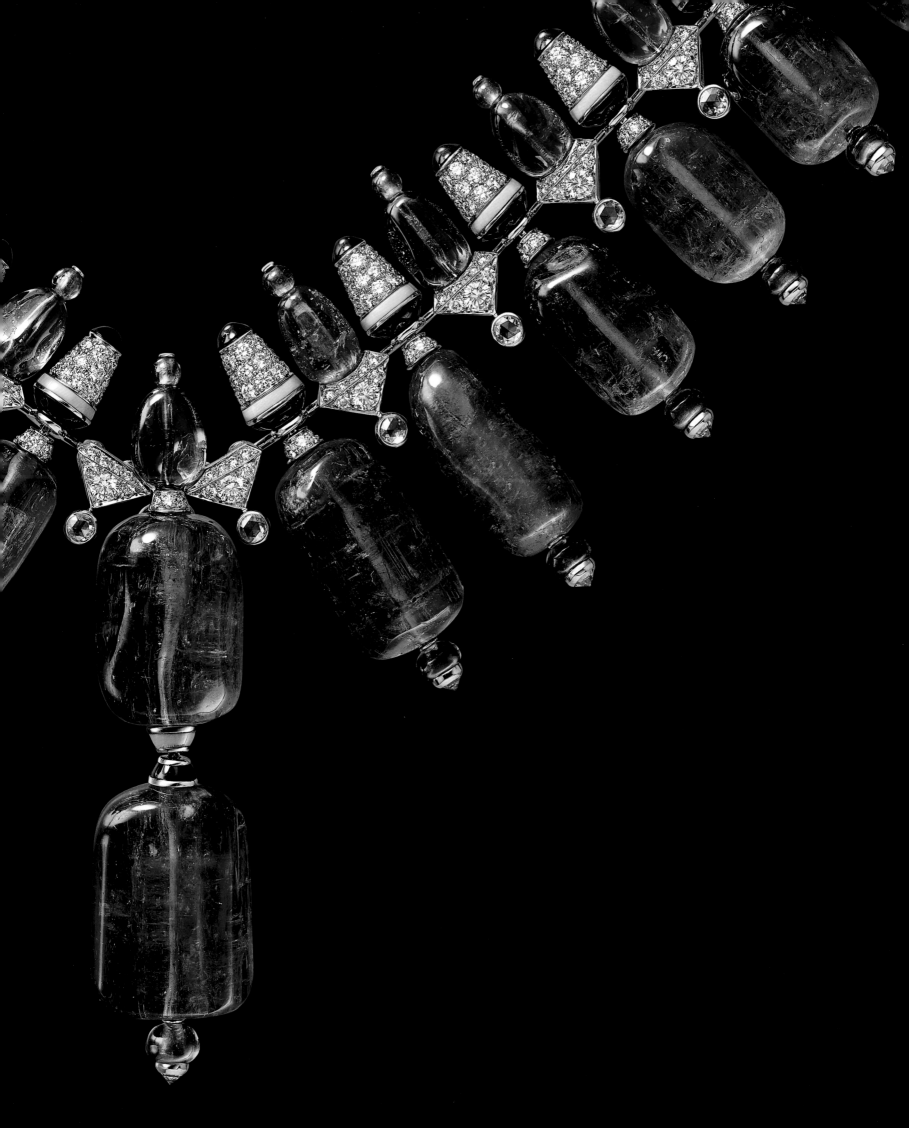

In the Orient, there are songs whose beauty is cadenced by a compelling rhythm. They may take the form of prayers or music for religious dances. Profound and regular as a heartbeat, their effect is a deep enchantment. But their echo would not have such power if each measure were always the same: their soul is expressed in tiny variations.

The twenty-two magnificent emeralds from Afghanistan—totaling close to 200 carats—in the Chromaphonia necklace visually intone a powerfully rhythmic melody. The color of a very intense water, they enchant for the natural grace of their baroque cut. Each one of them is a unique note on a stave that they transform, almost imperceptibly, by subtle variations of form and a sparkling dance of light.

The designers have amplified this subtle resonance in a complementary chromatic punctuation to the green of the emeralds: spinels alternate in sequence with garnets, modulating the rhythm with notes of onyx, turquoise, and diamonds.

CHROMAPHONIA NECKLACE
White gold, twenty-two baroque emerald beads from Afghanistan totaling 199.02 carats, spinel beads, mandarin garnet beads, turquoises, onyx, rose-cut diamonds, brilliant-cut diamonds.

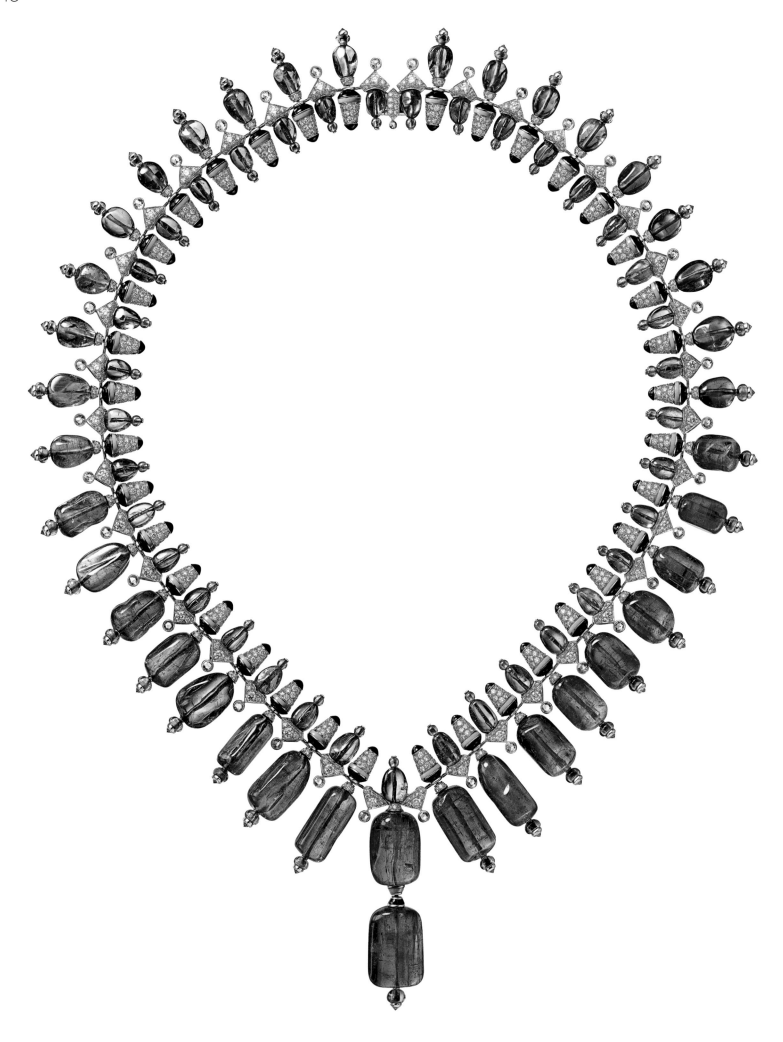

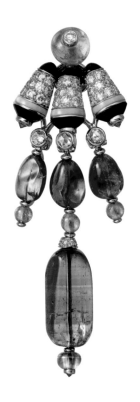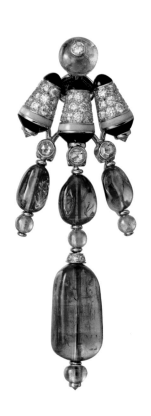

CHROMAPHONIA EARRINGS
White gold, two fancy-shaped emeralds from
Afghanistan totaling 10.87 carats, spinel beads, mandarin
garnet beads, turquoises, onyx, rose-cut diamonds,
brilliant-cut diamonds.

CHROMAPHONIA RING
White gold, one 15.53-carat button-shaped emerald
from Zambia, cabochon-cut spinels, cabochon-cut fire
opals, onyx, turquoises, brilliant-cut diamonds.

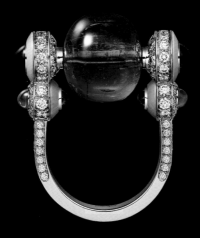

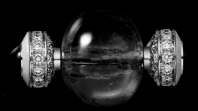

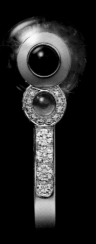

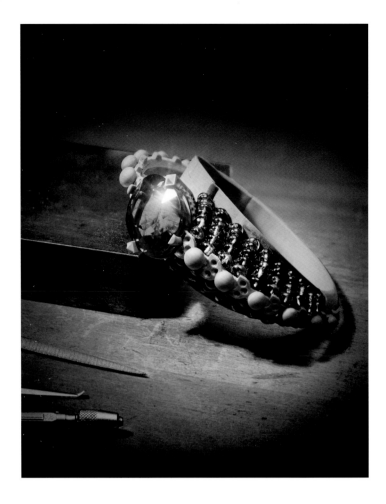

Red, green, and blue compose one of the chromatic chords most frequently played by Cartier over the past century. In the 1990s, the jewelry house further embellished this harmony with pastel-hued and also more piercingly intense stones. The designers of this ring found their inspiration in the Indian festival of colors, Holi. The colors and symbols of this ancient Hindu celebration—red for love and happiness, green for harmony, blue for vitality—join with joyous clouds of powdered pigment thrown by the fistful into the air. This spirit is expressed in the fresh sparkling of a multitude of chrysoberyl beads, grouped like *pizzicato* notes rising to a crescendo of tourmalines played *legato*. And then suddenly, like the crash of cymbals, a red star, ardent as love, settles into this spring-colored cloud: a cushion-shaped rubellite. The ensemble of colors in this musical architecture engenders deep feelings of jubilation.

HOLIKA EARRINGS
White gold, blue tourmaline beads, cabochon-cut pink tourmalines, chrysoberyl beads, brilliant-cut diamonds.

HOLIKA BRACELET
White gold, one 65.78-carat cushion-shaped rubellite, chrysoberyl beads, blue tourmaline beads, square-shaped blue tourmalines, cabochon-cut pink tourmalines, brilliant-cut diamonds.

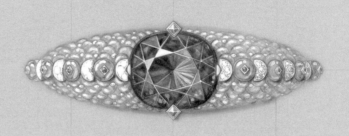

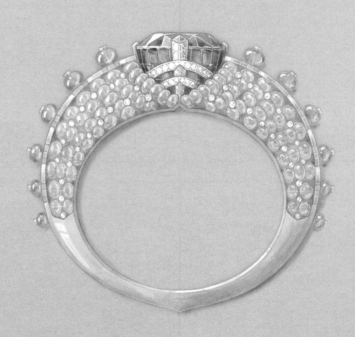

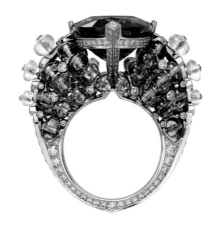

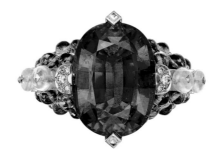

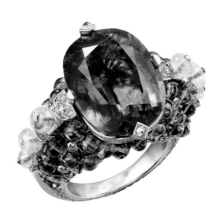

HOLIKA RING
White gold, one 15.05-carat cushion-shaped
rubellite, blue tourmaline beads, chrysoberyl beads,
square-shaped diamonds, brilliant-cut diamonds.

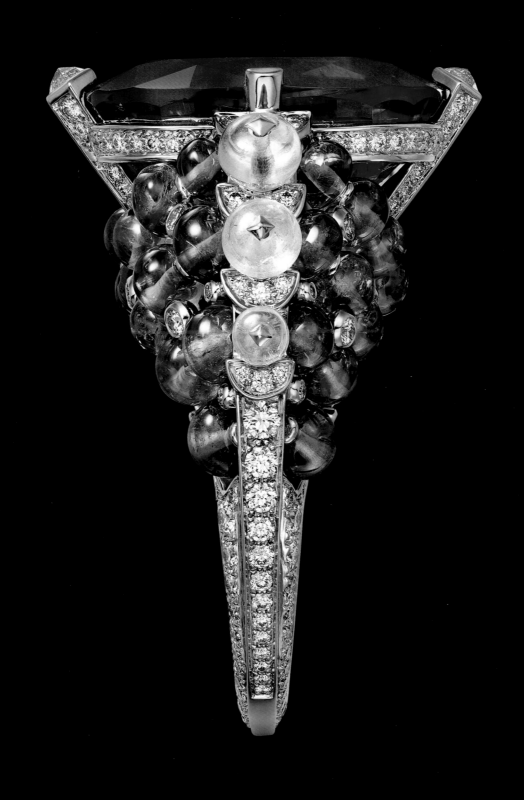

TANGANYIKA EARRINGS
Platinum, cushion-shaped peridots,
two half moon-shaped diamonds totaling
1.00 carat, triangular-shaped diamonds.

TANGANYIKA BRACELET
Platinum, cushion-shaped peridots,
two pentagonal-shaped step-cut diamonds
totaling 1.63 carats, triangular-shaped
diamonds, rock crystal.

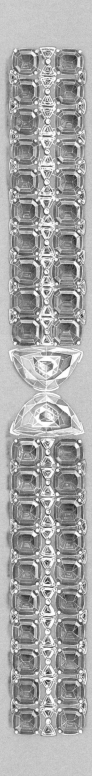

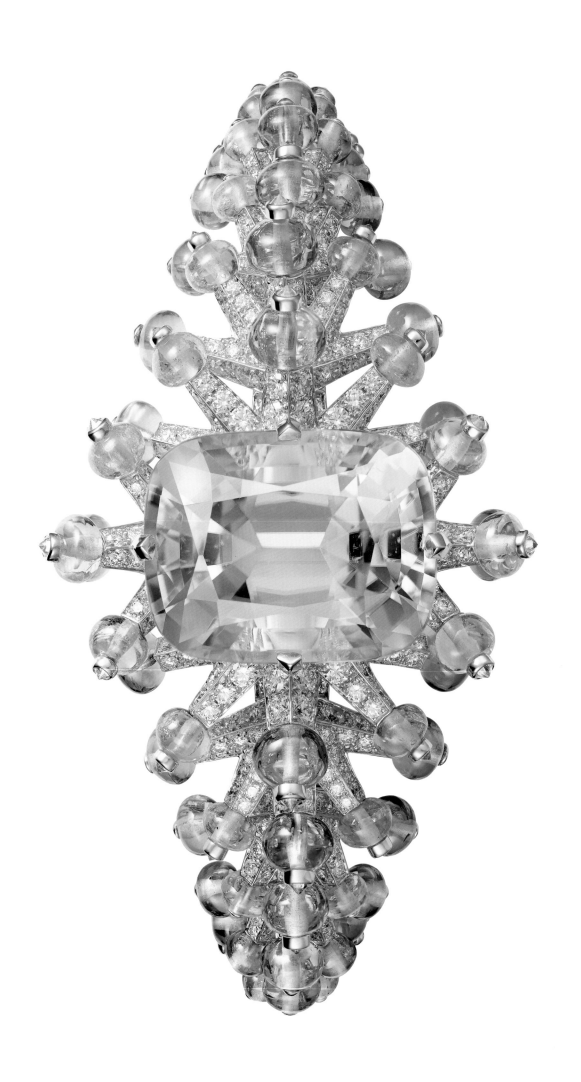

BLUE
AND GREEN

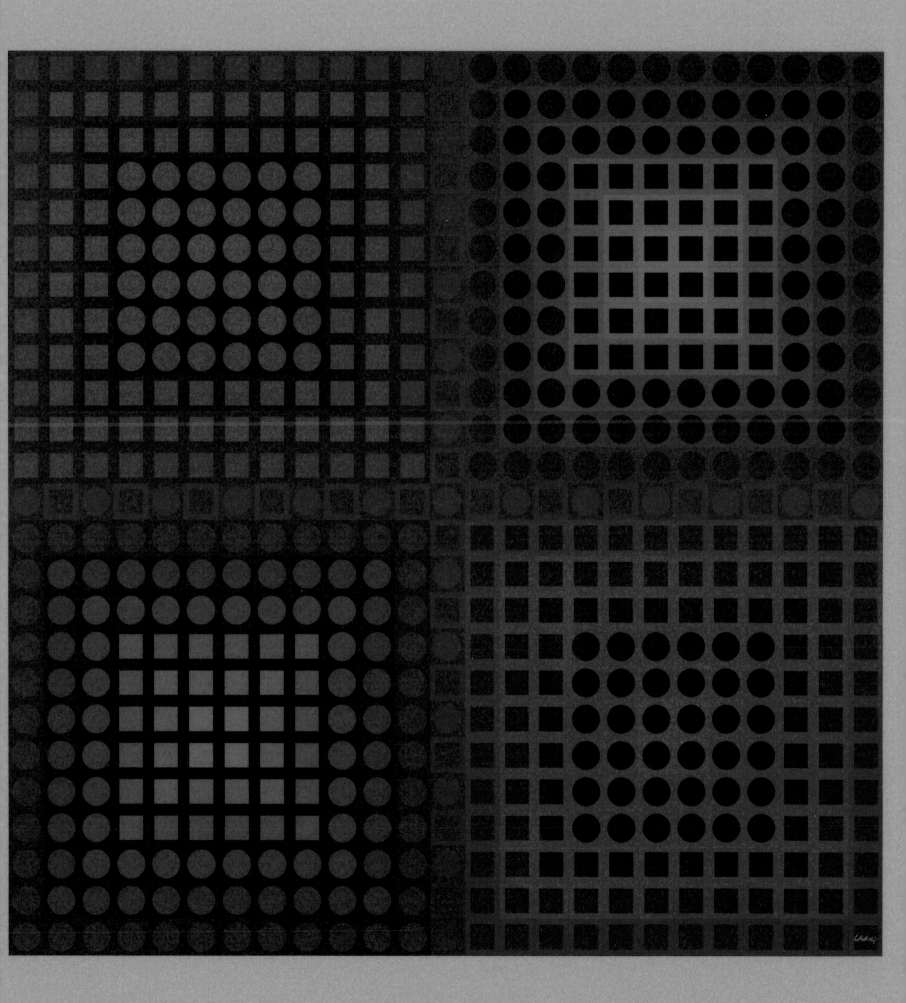

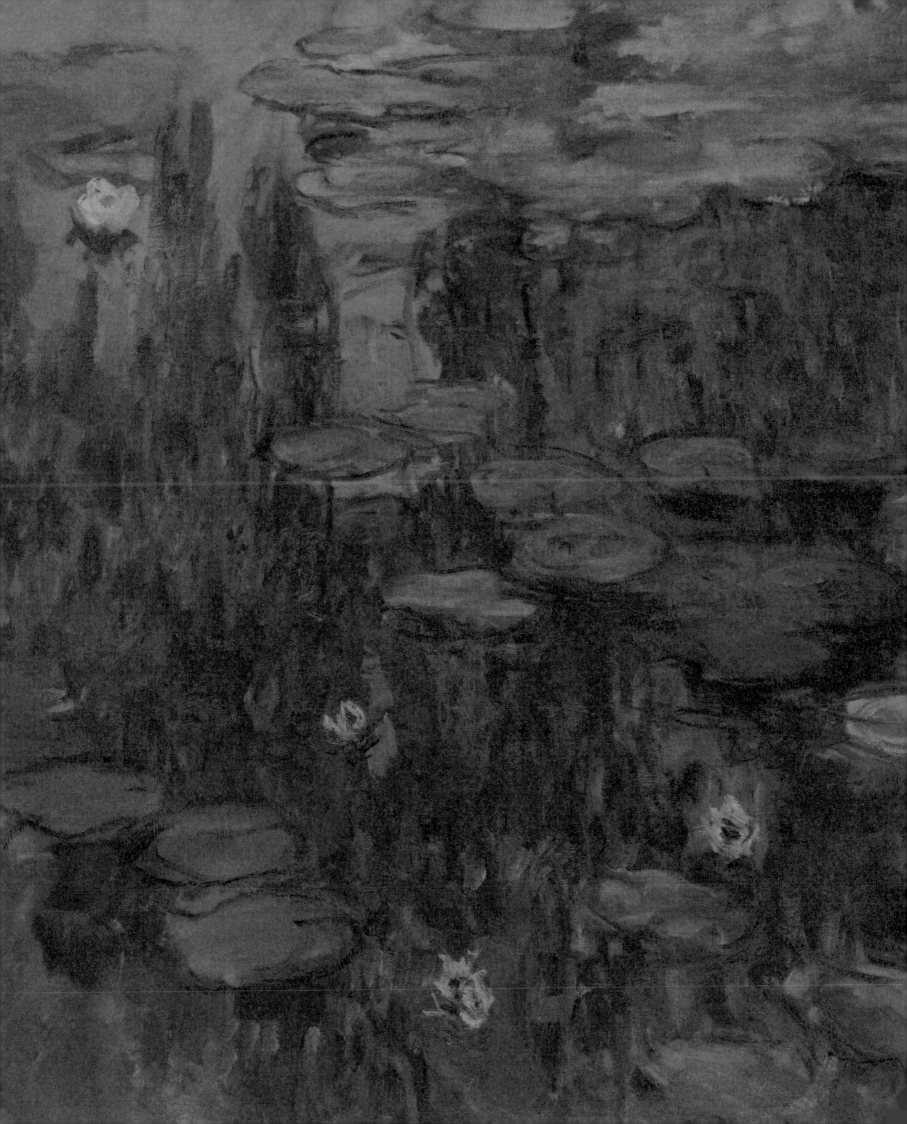

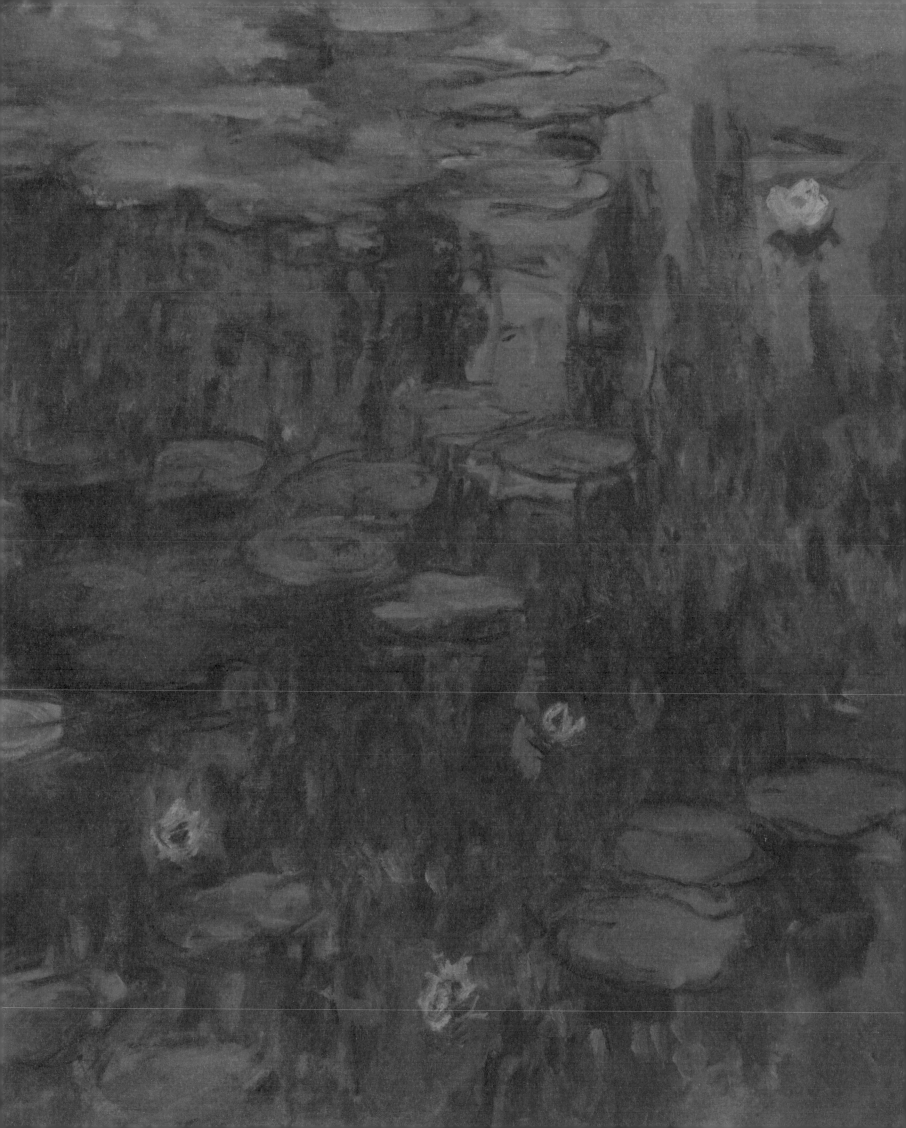

Victor Vasarely, *EG-1-2*, from the series *Kanta*, 1973.
Szépművészeti Múzeum, Budapest.

Claude Monet, *Water Lilies* (detail),
circa 1915. Bayerische Staatsgemäldesammlungen,
Neue Pinakothek, Munich.

With its midnight blue body shimmering in metallic blues and greens and the stunning corona of its blue-eyed golden-green tail fan, the blue peacock has to be one of the world's most beautiful birds. Yet the combination of these two colors is often disparaged, spurned as lacking in harmony and taste. Indeed, a widespread pseudo-scientific theory has it that the combination of these colors, neither similar nor complementary, actually irritates the eye. Our perception of colors being largely dictated by social codes that are frequently based on the theories of learned scholars, it was long accepted that green and blue simply do not go together.

Oddly, these two colors do not appear in the vocabulary of the ancient Greeks, which only clearly distinguishes white, black, and red. Among poets such as Homer, the word *glaukos* might refer to green, gray, blue, yellow, or brown. Actually, it was long believed, as Nietzsche writes in *Daybreak*, "How different nature must have appeared to the Greeks if, as we have to admit, their eyes were blind to blue and green, and instead of the former saw deep brown, instead of the latter yellow." But they must have been seen, it was just a question of "seeing" versus "naming." The ancient Egyptians, like the Mesopotamians, saw them, named them, and readily combined them, considering them to be beneficial, tutelary colors. Later, in the Islamic world, the combination of these two colors was not infrequently seen in Persian decorative motifs and Iznik pottery.

The first explicit condemnation of green and blue occurred in Imperial Rome, when they appeared in paintings and decorative arts. Artists versed in the "good form" of their day sneered at them, holding that only "sensible" colors like white, black, and red were acceptable. Thus, in an epigram about daily life in ancient Rome, the poet Martial made fun of the *lecti pavonini* (peacock beds) where the bedsteads were made of tinted cedar or lemon wood imitating peacock plumage.

Although these two colors were sometimes found together in the works of Mannerist painters such as Pontormo or his pupil Bronzino, Western opinion still held that these two colors could not be used together, as encoded in early-eighteenth-century German and English proverbs: *"Blau oder Grün muss man wählen"* (blue or green, you have to choose) and *"Blue with green should never be seen"*.

And yet we have the intense or soft green of vegetation, of new grass and springtime foliage, the green of chlorophyll. And it goes so well with the blue of

a clear sky or the limpid water of a pristine lagoon, the blue of peace. Why can't we bring these colors together in harmony as they are in nature at its most serene?

Little by little, starting in the mid-nineteenth century, the perception of this combination began to change. Rimbaud—probably one of the most color-sighted poets of all time—extols the "green azures" of the sea in his poem *The Drunken Boat*, conveying the dominant color harmonies of the seascape, a sight that never fails to enthrall. At the turn of the century, the Romantic painter Caspar David Friedrich used blue and green in some of his turbulent landscapes. But we would have to wait for the painters to take their easel outdoors, into the gardens or to the seaside, particularly van Gogh and the Impressionists, to see what has since seemed to be the most natural of color combinations in paintings. Green and blue became an obsession for van Gogh, dominating his *Irises*, sharing the canvas in *Wheatfield under Thunderclouds*, and swirling in the background of one of his many self-portraits. Greens and blues populate Sisley's *Lane of Poplars at Moret*, and confer full harmony to Berthe Morisot's *Bois de Boulogne* and all their liquid magic to Monet's *Water Lilies*. Much later, in one of his *Optical Compositions*, Victor Vasarely, pioneer of Op Art, brought these essential colors of nature into shimmering unity in our blue (and green) planet.

While established in painting, the combination of blue and green had yet to be accepted in the decorative arts at the turn of the twentieth century. Louis Cartier was thus quite audacious when he began presenting his so-called "peacock pattern" in the early years of the century. Perhaps he had admired van Gogh's paintings at the Bernheim-Jeune gallery in Paris in 1901, or was dazzled by the chromatic freedom of the costumes in Diaghilev's Ballets Russes, particularly those in *Sheherazade*. A great deal of Cartier designs and jewelry still testify to what he affirmed as one of his favorite color combinations. Since then it has never ceased to be featured in the Maison's stylistic vocabulary, as we see once again in certain pieces in the Coloratura collection.

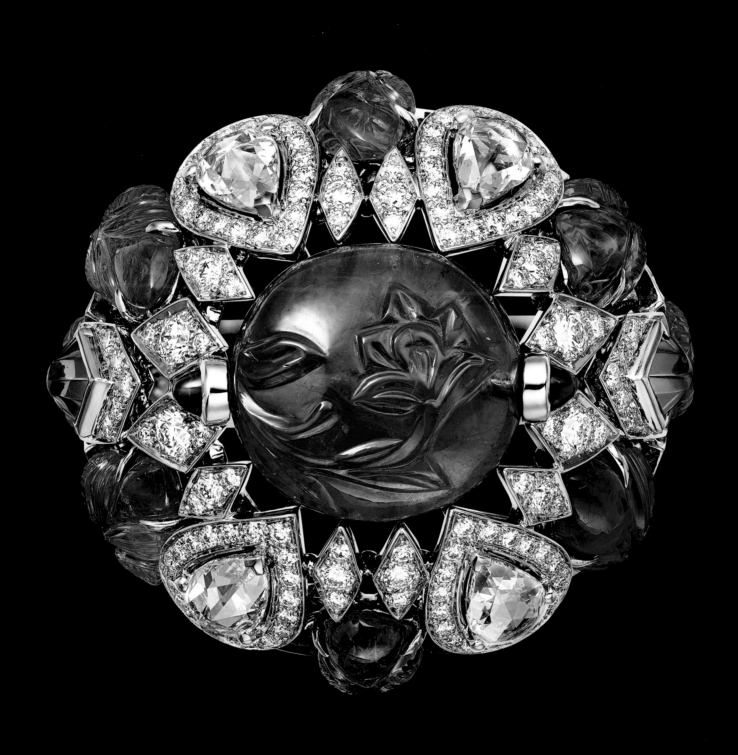

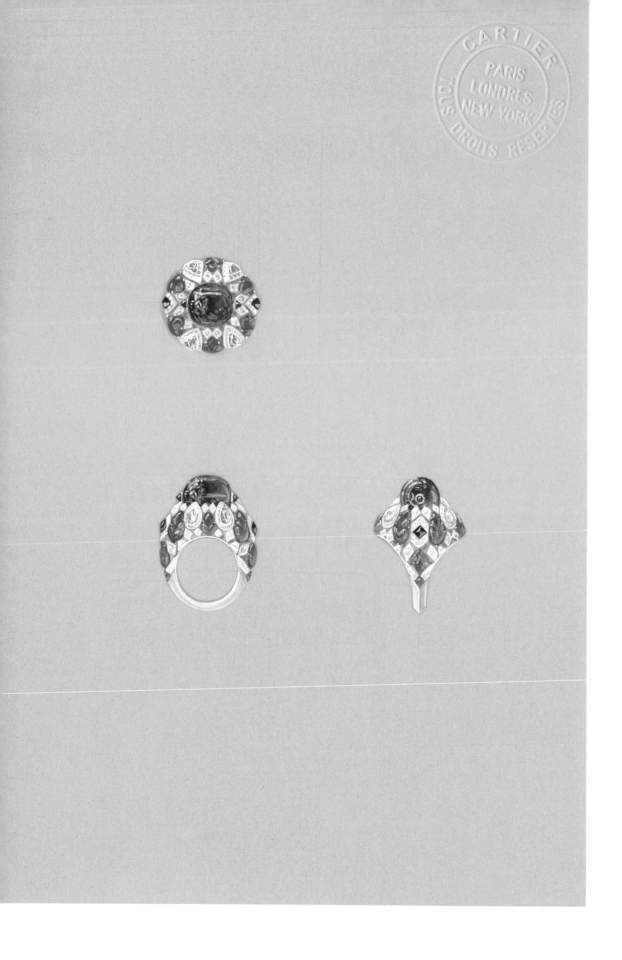

LOKA RING
Platinum, one 13.83-carat carved sapphire
from Burma, carved emeralds, cabochon-cut
sapphires and emeralds, pear-shaped
diamonds, brilliant-cut diamonds.

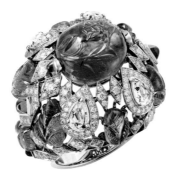

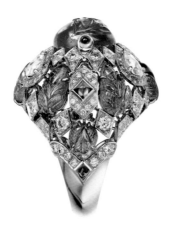

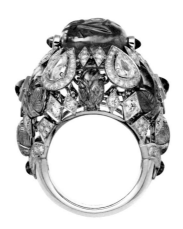

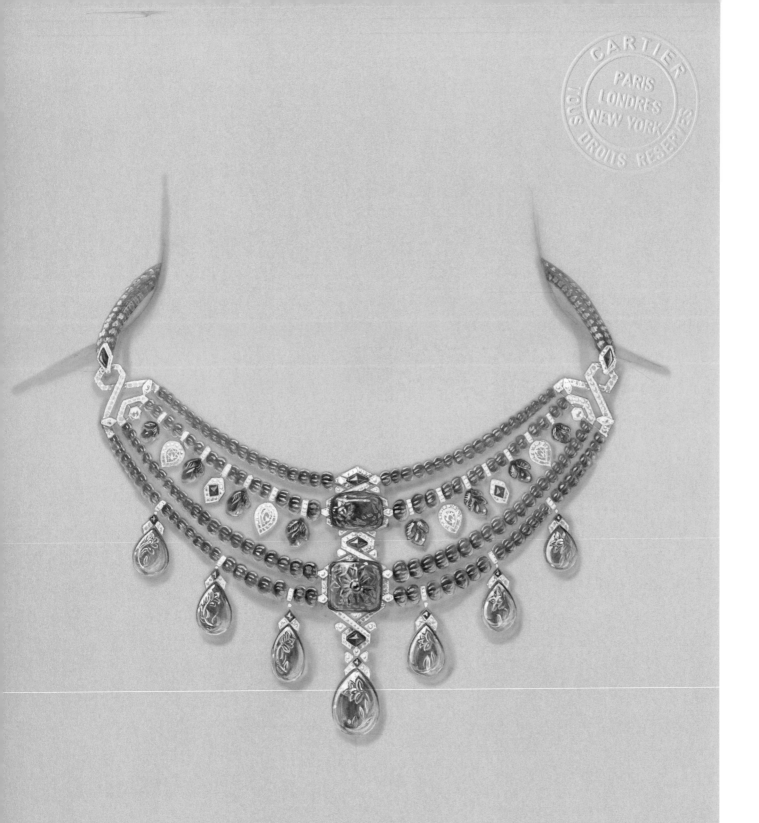

LOKA NECKLACE
Platinum, seven carved sapphire drops from Burma
totaling 62.29 carats, one 18.37-carat carved emerald
from Afghanistan, one 12.76-carat carved sapphire from
Burma, melon-cut emerald beads, carved sapphires,
cabochon-cut sapphires and emeralds, rose-cut
diamonds, brilliant-cut diamonds.

LOKA EARRINGS
Platinum, two carved sapphire drops from Burma
totaling 19.06 carats, carved sapphires and emeralds,
cabochon-cut sapphires and emeralds, pear-shaped
rose-cut diamonds, brilliant-cut diamonds.

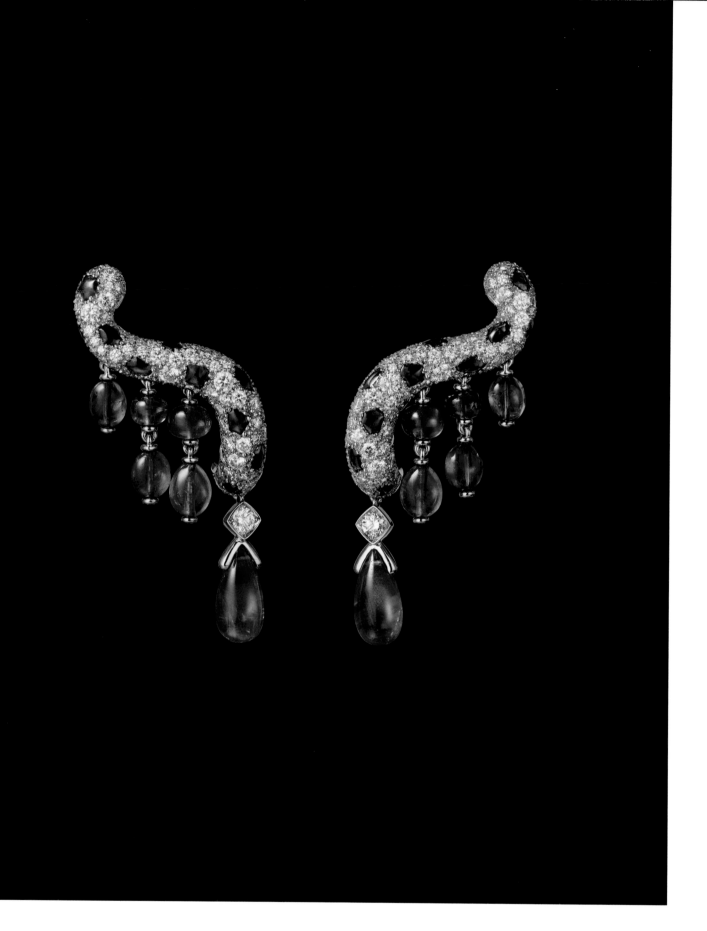

PANTHÈRE IMPÉRIEUSE EARRINGS
Platinum, two sapphire drops from Burma totaling 4.70 carats,
emerald and sapphire beads, sapphires, brilliant-cut diamonds.

PANTHÈRE IMPÉRIEUSE NECKLACE
Platinum, one 41.06-carat cabochon-cut sapphire from Ceylon, one
5.14-carat emerald drop from Zambia, one 0.92-carat modified
shield-shaped step-cut diamond, emerald drops, sapphire beads,
sapphires, emerald eyes, onyx, brilliant-cut diamonds.

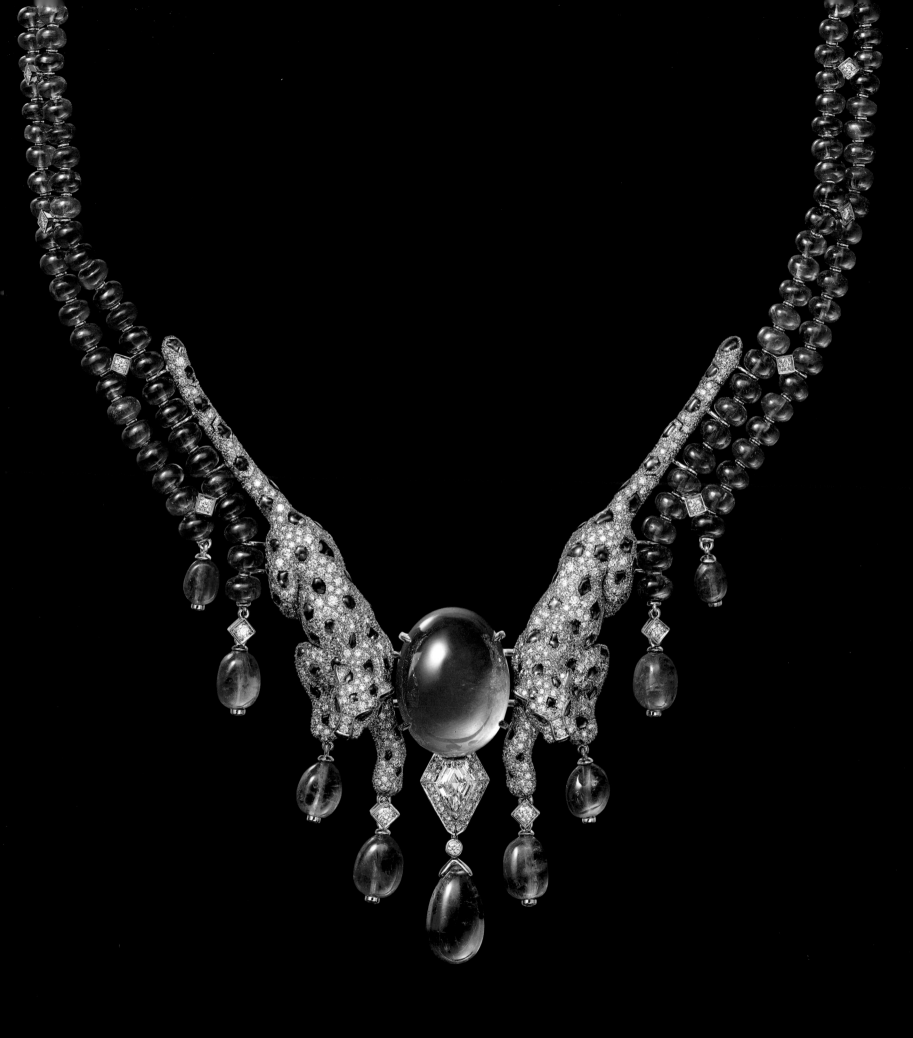

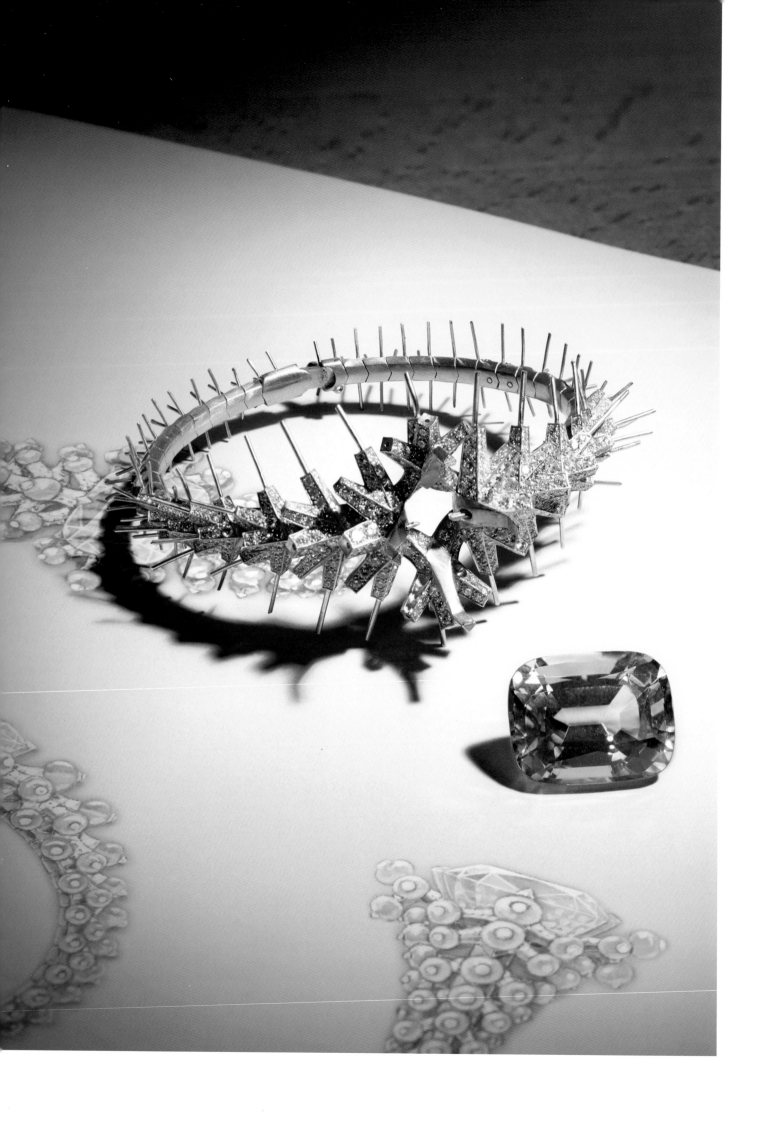

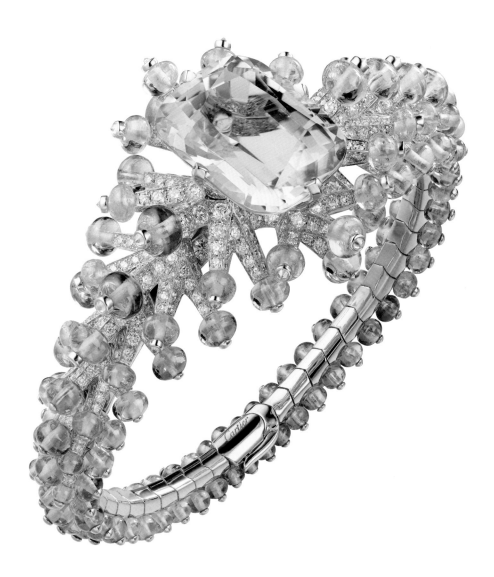

SYNESTIA BRACELET
Yellow gold, one 29.42-carat cushion-shaped
green tourmaline, garnet and mandarin garnet
beads, brilliant-cut diamonds.

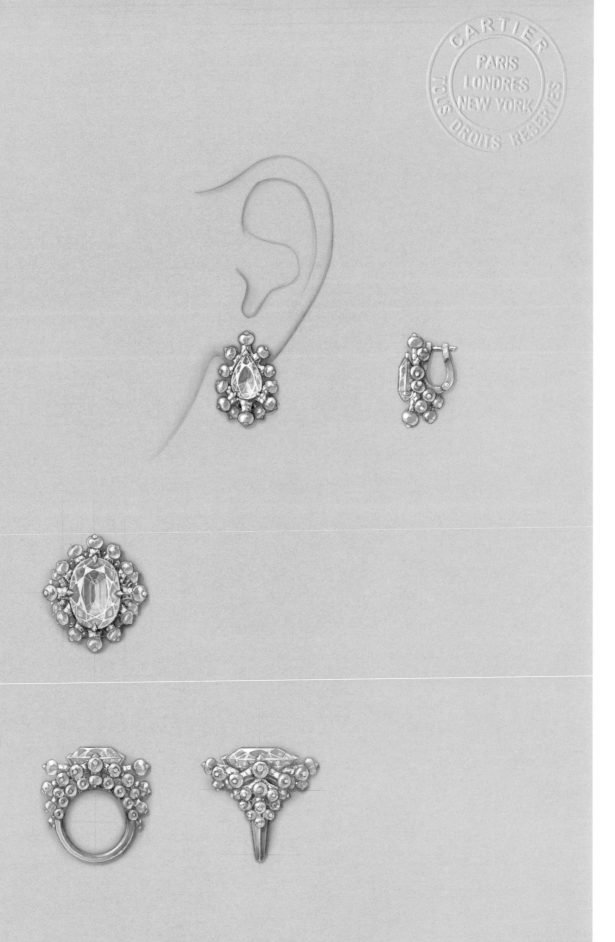

SYNESTIA EARRINGS
Yellow gold, two pear-shaped tourmalines
totaling 5.61 carats, garnet and mandarin garnet
beads, brilliant-cut diamonds.

SYNESTIA RING
Yellow gold, one 17.16-carat cushion-shaped
tourmaline, garnet and mandarin garnet beads,
brilliant-cut diamonds.

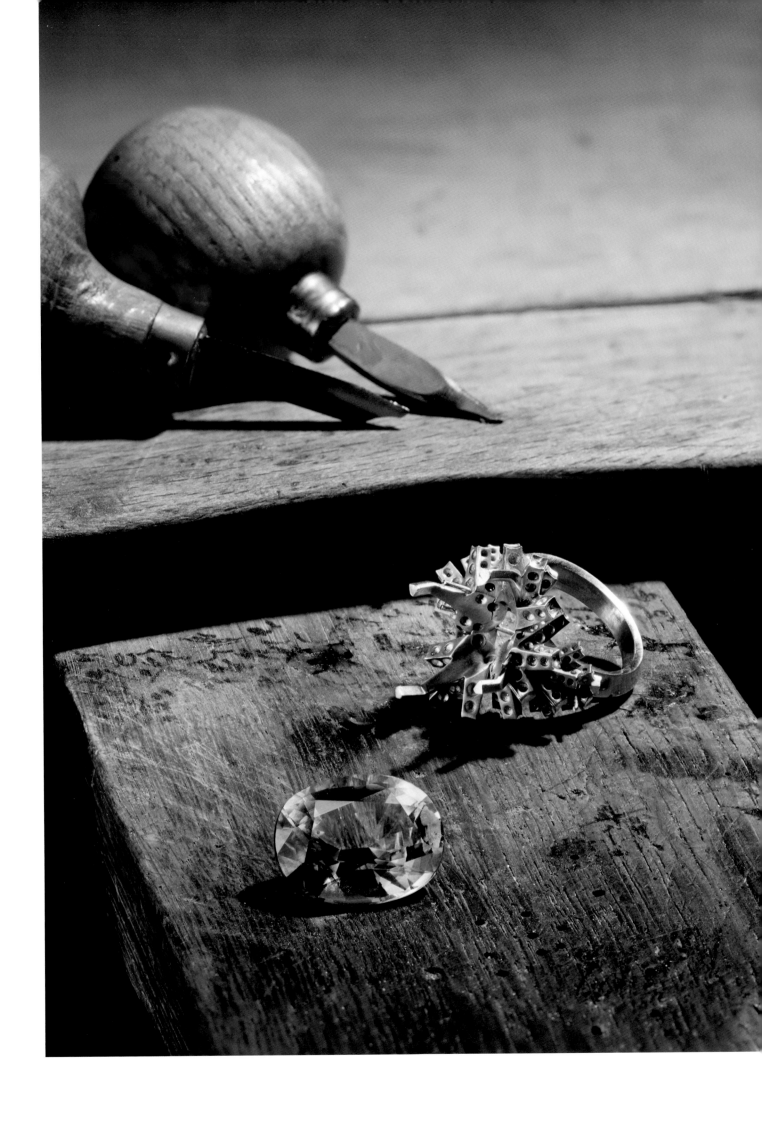

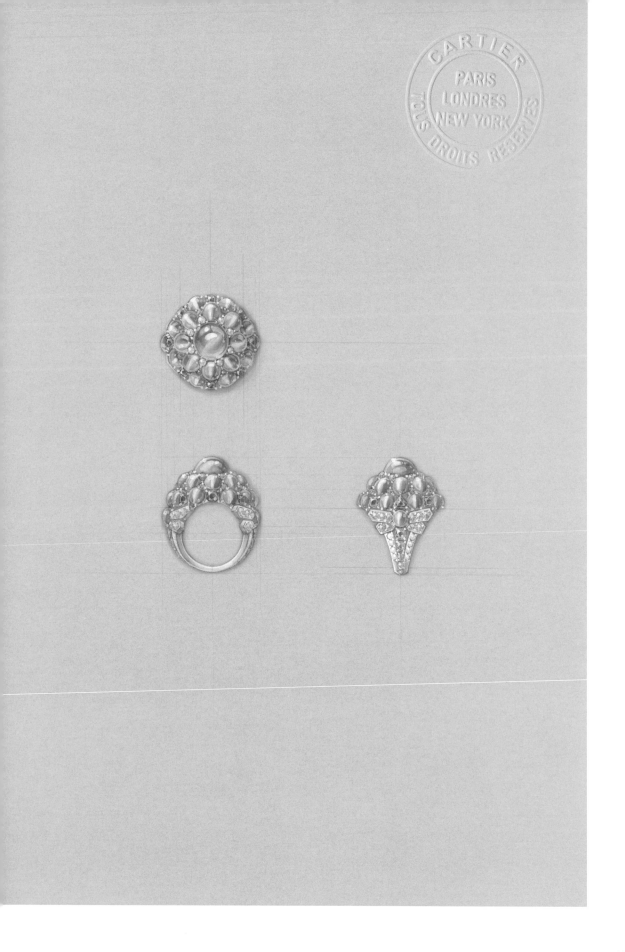

ODONATA RING

Yellow gold, cabochon-cut chrysoberyls, pear-shaped,
cushion-shaped, and brilliant-cut yellow diamonds,
brilliant-cut orange diamonds, brilliant-cut diamonds.

ODONATA BRACELET

Yellow gold, cabochon-cut chrysoberyls, pear-shaped,
cushion-shaped, and brilliant-cut yellow diamonds,
brilliant-cut diamonds.

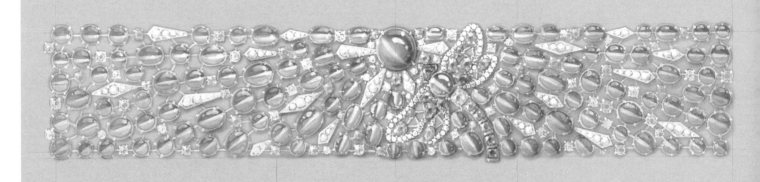

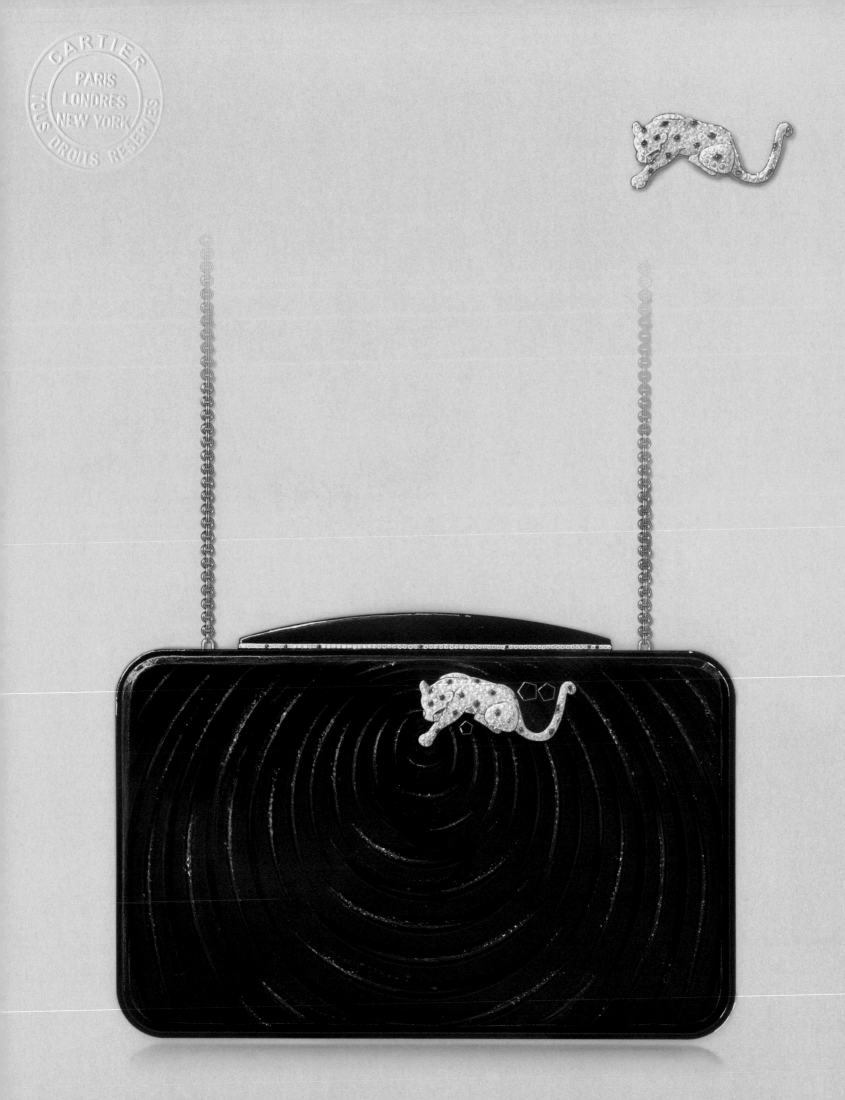
CARTIER
PARIS
LONDRES
NEW YORK
TOUS DROITS RÉSERVÉS

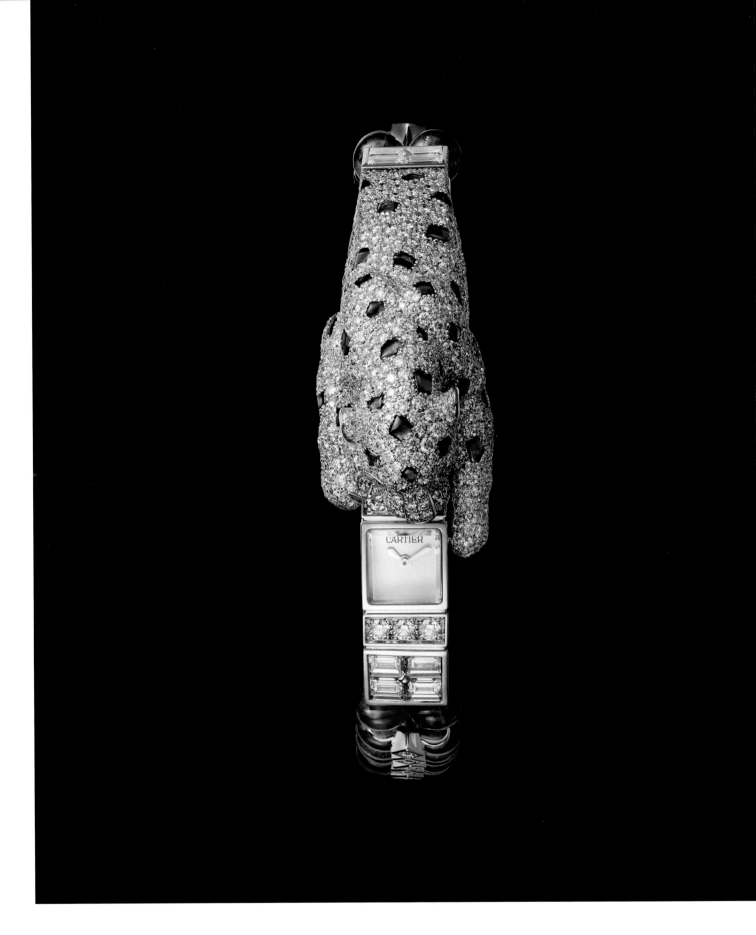

REFLET DE PANTHÈRE EVENING BAG
White gold, brilliant-cut diamonds, sapphires, emerald eyes, onyx.
Midnight blue satin silk with handmade embroidered décor,
interior in lambskin. The panther jewel can be worn as a brooch.

PANTHÈRE BONDISSANTE SAPPHIRE WRISTWATCH
White gold, sapphire beads, sapphires, emerald eyes, onyx,
baguette-cut diamonds, brilliant-cut diamonds, mechanical
movement with manual winding, caliber 101.

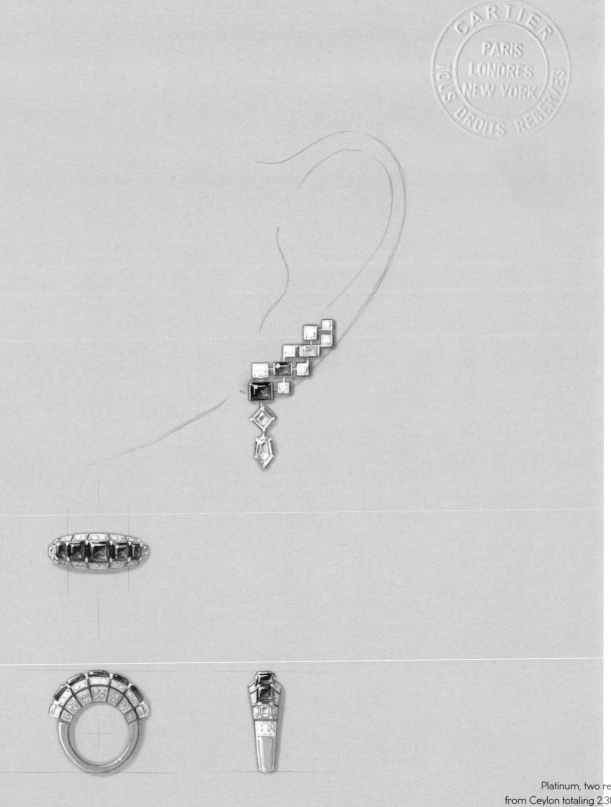

CARTIER
PARIS
LONDRES
NEW YORK
TOUS DROITS RESERVES

NAÏA EARRINGS
Platinum, two rectangular-shaped sapphires from Ceylon totaling 2.30 carats, rectangular-shaped sapphires, kite-shaped, and square-shaped diamonds, baguette-cut, and brilliant-cut diamonds.

NAÏA RING
Platinum, five rectangular-shaped sapphires from Ceylon totaling 5.84 carats, square-shaped diamonds, brilliant-cut diamonds.

NAÏA NECKLACE/BRACELET
Platinum, one 16.11-carat square-shaped sapphire from Ceylon, fifteen square-shaped sapphires from Ceylon totaling 18.38 carats, three modified kite-shaped diamonds totaling 1.57 carats, square-shaped diamonds, baguette-cut, and brilliant-cut diamonds. The necklace can be worn either long or short with a bracelet.

OCÉANIDE EARRINGS
Platinum, two cushion-shaped sapphires from
Madagascar totaling 19.43 carats, trapezoid
step-cut diamonds, baguette-cut diamonds, tapered
diamonds, brilliant-cut diamonds.

OCÉANIDE RING
Platinum, one 7.72-carat cushion-shaped sapphire from
Ceylon, tapered diamonds, brilliant-cut diamonds.

OCÉANIDE NECKLACE
Platinum, one 17.58-carat cushion-shaped
sapphire from Ceylon, eight rectangular-shaped
diamonds totaling 4.91 carats, trapezoid
step-cut diamonds, baguette-cut diamonds,
brilliant-cut diamonds.

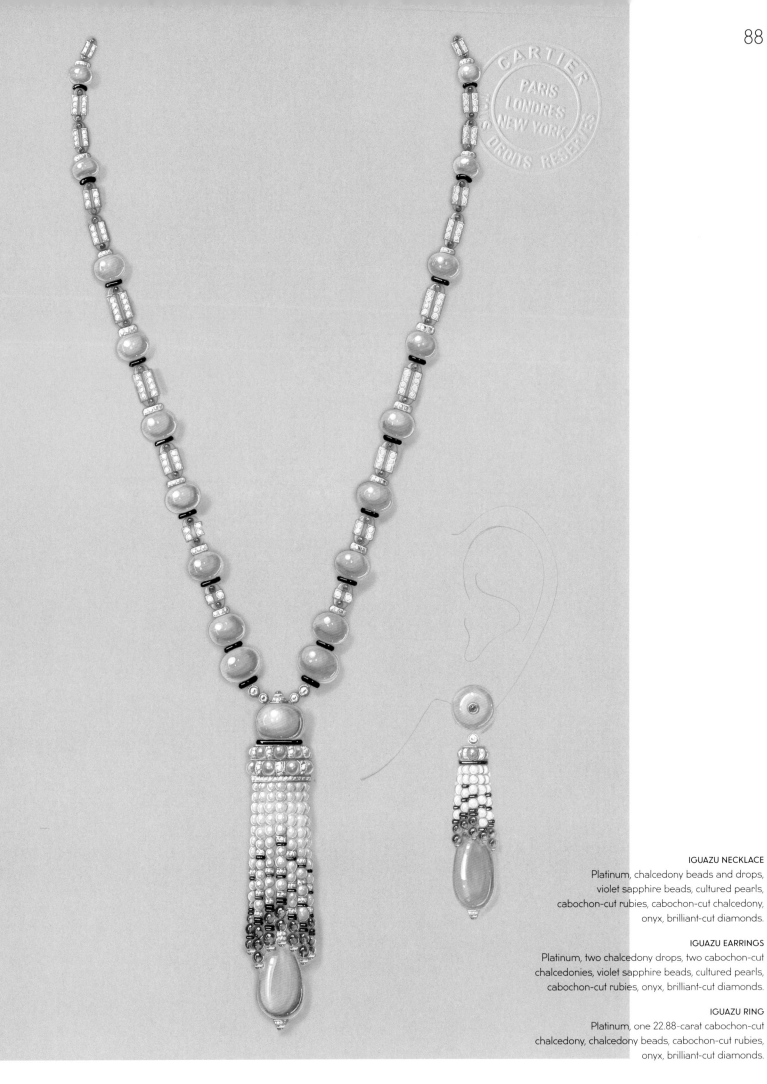

IGUAZU NECKLACE
Platinum, chalcedony beads and drops,
violet sapphire beads, cultured pearls,
cabochon-cut rubies, cabochon-cut chalcedony,
onyx, brilliant-cut diamonds.

IGUAZU EARRINGS
Platinum, two chalcedony drops, two cabochon-cut
chalcedonies, violet sapphire beads, cultured pearls,
cabochon-cut rubies, onyx, brilliant-cut diamonds.

IGUAZU RING
Platinum, one 22.88-carat cabochon-cut
chalcedony, chalcedony beads, cabochon-cut rubies,
onyx, brilliant-cut diamonds.

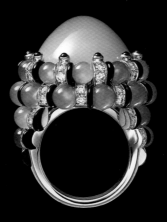

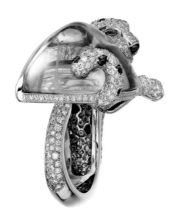

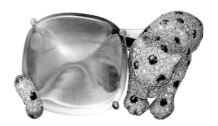

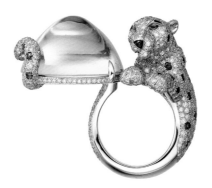

PANTHÈRE AQUA RING
White gold, one 40.84-carat sugarloaf aquamarine,
sapphires, emerald eyes, onyx, brilliant-cut diamonds.

PANTHÈRE AQUA BRACELET
White gold, one 97.23-carat sugarloaf aquamarine,
sapphires, emerald eyes, onyx, brilliant-cut diamonds.

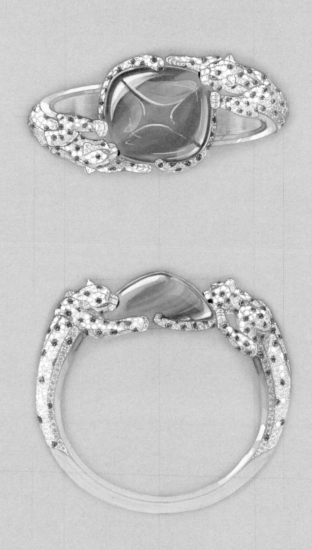

ARIETTA RING
Platinum, one chalcedony bead, cabochon-cut
sapphires, brilliant-cut diamonds.

ARIETTA NECKLACE
Platinum, chalcedony beads, two modified
triangular-shaped diamonds
totaling 4.94 carats, cabochon-cut sapphires,
onyx, brilliant-cut diamonds.

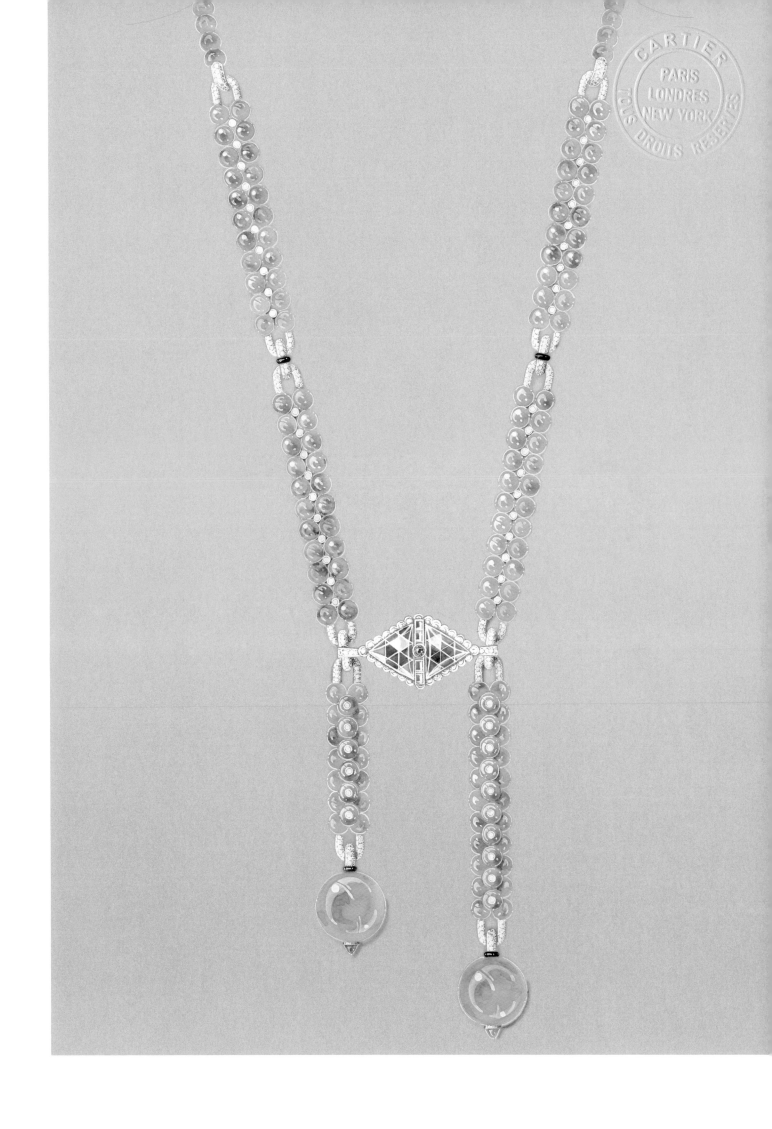

CARTIER
PARIS
LONDRES
NEW YORK
TOUS DROITS RÉSERVÉS

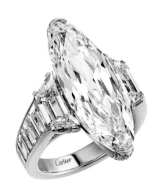

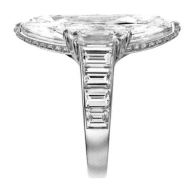

SÉLÉNÉ RING
Platinum, one 12.17-carat F VVS1 marquise-shaped
diamond, two trapezoid diamonds totaling 3.08 carats,
tapered diamonds, brilliant-cut diamonds.

SÉRÉNITÉ PENDANT AND BRACELET WATCH
White gold, one 10.36-carat F VVS2 pear-shaped
brilliant-cut diamond, one 3.52-carat cushion-shaped
modified brilliant-cut diamond, one 1.29-carat kite-
shaped diamond, sixty oval-shaped diamonds
totaling 43.78 carats, baguette-cut and brilliant-cut
diamonds, quartz movement. The piece
can be worn in different ways.

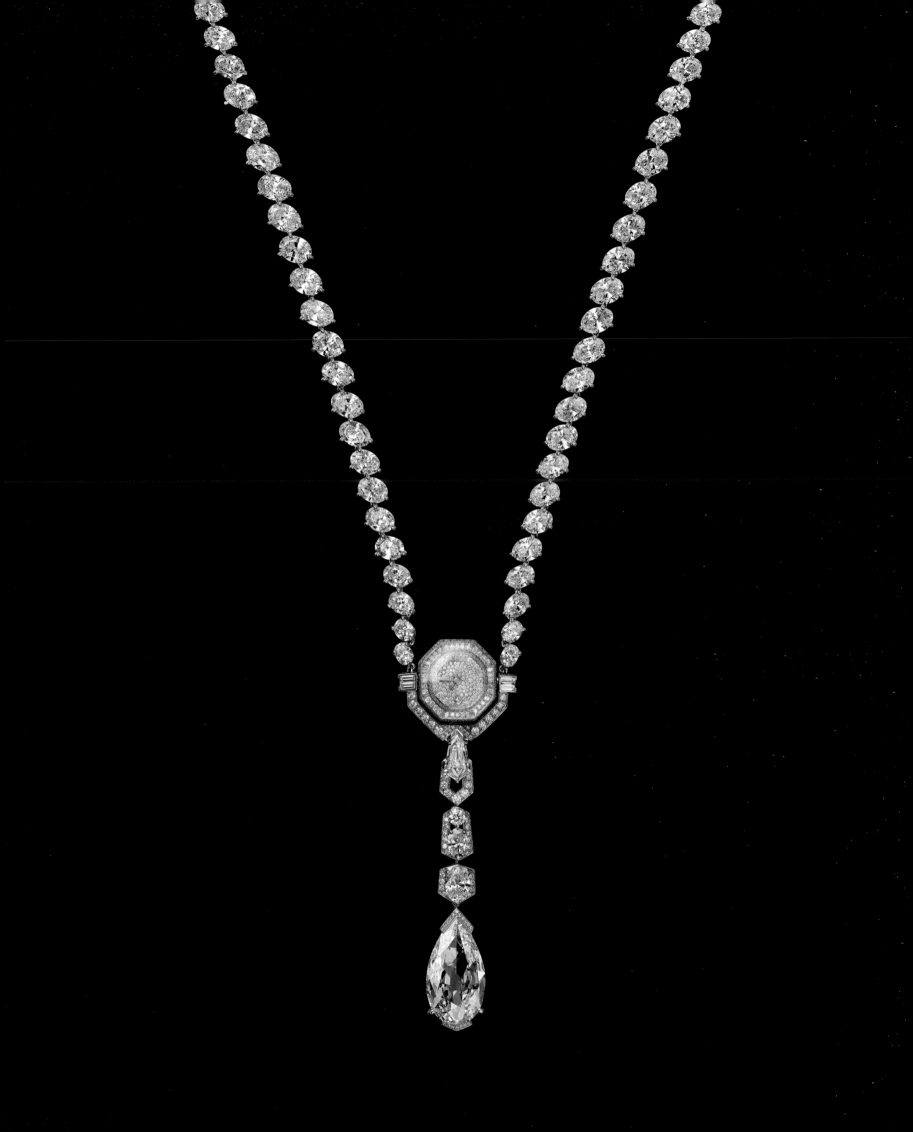

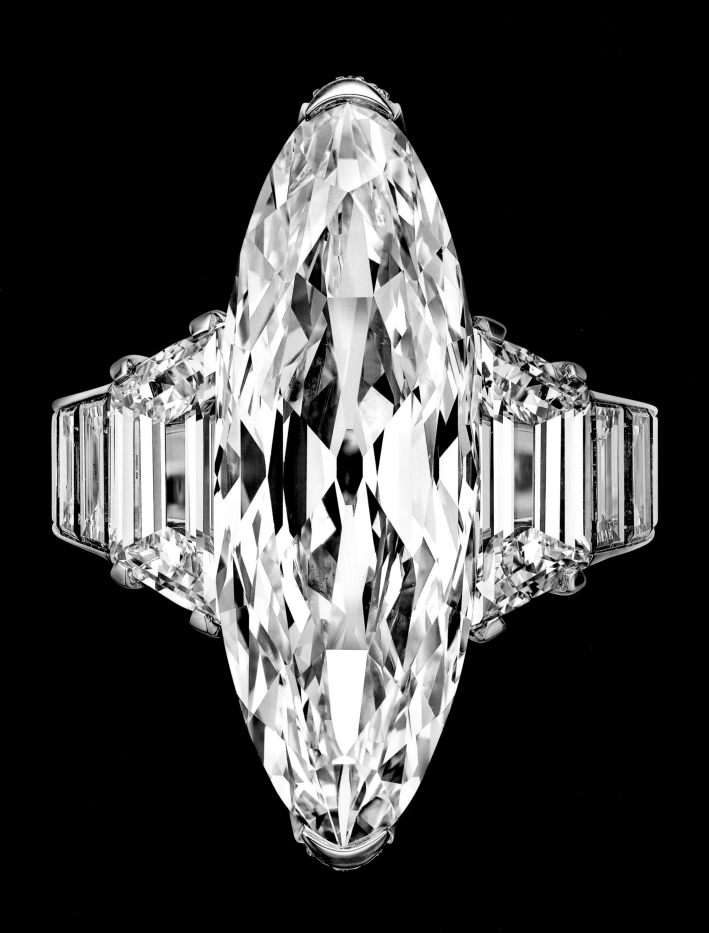

IS WHITE
A COLOR?

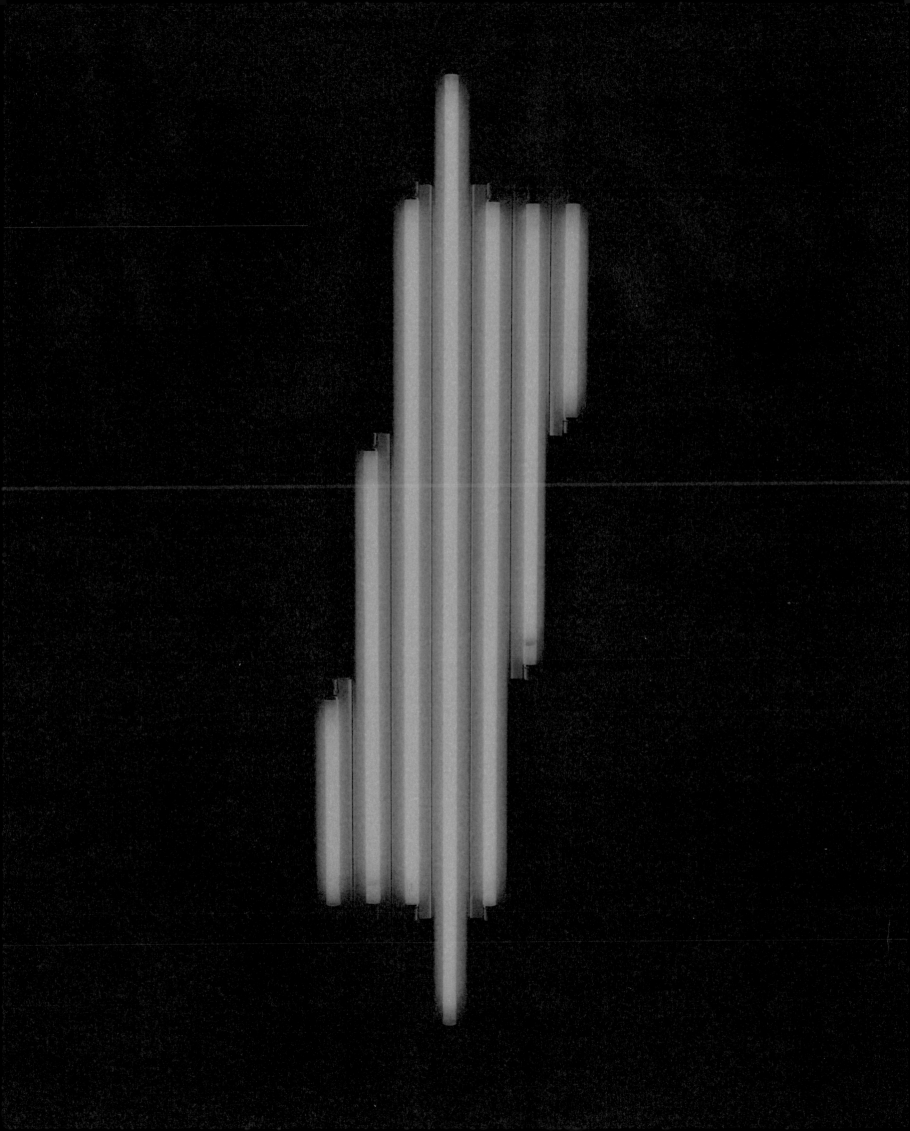

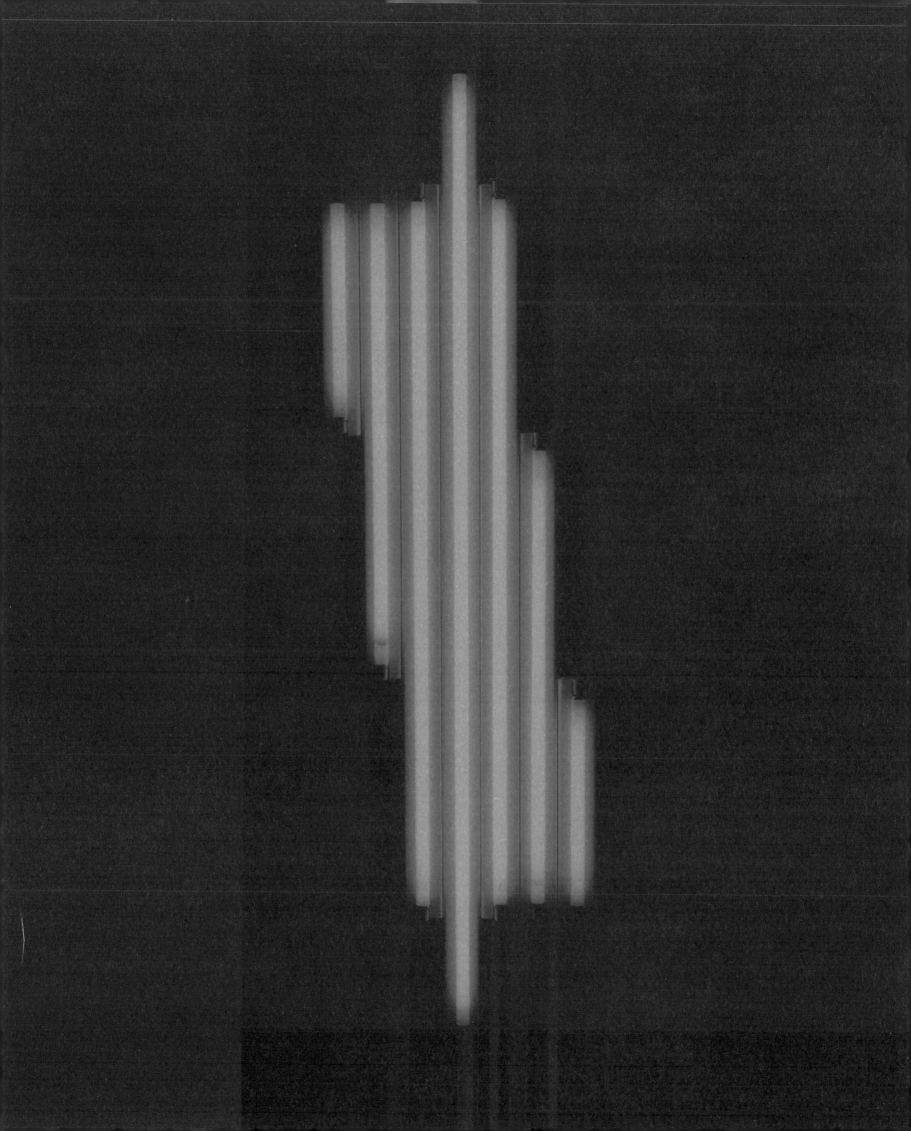

Sol LeWitt, *Incomplete Open Cube 8/8*, 1974.
Private collection.

Dan Flavin, *"Monument" for V. Tatlin*, 1967.
Private collection.

It happened in the early Renaissance, in the mid-fifteenth century, just after the invention of the printing press: white ceased to be a color. After being the color of drawings for tens of thousands of years, with its qualities and nuances distinguished and named in ancient Rome and in the Middle Ages—for example flat or glossy—white was unceremoniously evicted from the community of colors. The reason is as simple as it is absurd: the surfaces to which pigments were applied had always been considered colorless. Hence stone had no color, nor did parchment or raw fabric. And now, we had words printed on white paper. A few centuries later, Newton's work on light and the spectrum added another nail to this coffin. The white light of the sun was nothing more than the sum total of different types of colored light, seven to be exact: violet, indigo, blue, green, yellow, orange, red. This spectrum—Newton himself realized later that it was artificial—excluded white (and black), which was again denied the status of color.

Today, sociologists, neuroscientists, and physicists agree that white should be reinstated to the rank of color, as should black.

The symbolism of white in many civilizations did little to establish white as a color on a par with the others: almost everywhere, since time immemorial, it has symbolized purity. In other words, that which is untainted, and thus innocence, virginity, and cleanliness. It doubtlessly owes this role to its strong luminosity. It is also not impossible that, in certain regions, millennia ago, this feeling of purity was inspired by the sight of the only element in nature with an invariably pure and immaculate color: snow.

The spiritual connotation of white, deriving from the purity it evokes, is shared by many religions. The invariably white alb—from the Latin *alba*, "white"—worn by Christian priests in Western churches has a counterpart in the East: the white *jōe*, meaning "pure cloth," worn by priests and laymen alike during certain Shinto rites. In Africa and many Asian lands, including China, white is associated with death, which is considered to be a journey to the spirit world, and is often the color of mourning.

The purity that white evokes does not imply that it is always as luminous and immaculate as snow. The best proof that white is a color is that it exists in multiple nuances. At the Charvet shop on Place Vendôme in Paris, the customer requesting a white shirt will be taken to the "wall of whites": no fewer than five hundred

nuances of white are proposed, some with subtle pink, blue, or lilac highlights. In Japan, where the favorite color is white—unlike Western countries, where blue has dominated for three centuries—it has as many names as it does nuances, from the most opaque to the most brilliant.

The same goes for the white of painters. If we except Mondrian, master of pure colors, the "painters of white" did not make it look like snow. Jesus's shining white tunic in Giovanni Bellini's *Transfiguration of Christ* has brown shadows, the whites of Zurbarán only appear pure and luminous against a dark background, as in his *Still Life with Pottery Jars*. Kazimir Malevich's famous *White On White* (1918), the first monochrome in contemporary painting, is composed of a blue-nuanced white square against a background with beige or ivory overtones.

Lastly—and this is true since time immemorial if we think of the Paleolithic "hand negatives"—white is not so much a color as a graphic void: the design of the empty space delimited by another color. The drawings of the artist M. C. Escher, where the space between elements forms different or similar patterns, take this to the highest expression. A similar approach is also seen, often with abstract motifs, in the Japanese *notan* technique.

This technique of negative space has been a feature of the art of Cartier since the beginning of the twentieth century. Splendid pieces of jewelry have been designed where the space between the gems creates a particular motif. But at the Maison, the art of white is expressed above all in the sculptures of light, when all the colors of the spectrum are gathered into the glitter of diamonds, or into the glinting counterpoint of a subtle concerto of rock crystal and diamonds. In this vein, we mention a treasure in the Cartier Collection created in 1934: a carved and sculpted crystal bracelet adorned with a spiral of diamonds in the center, which can be removed and worn as a brooch. Eighty-two years later we have the Illumination bracelet (2016), where a series of rock crystal laminae reflect and amplify the sparkle of a 31.16-carat emerald-cut diamond.

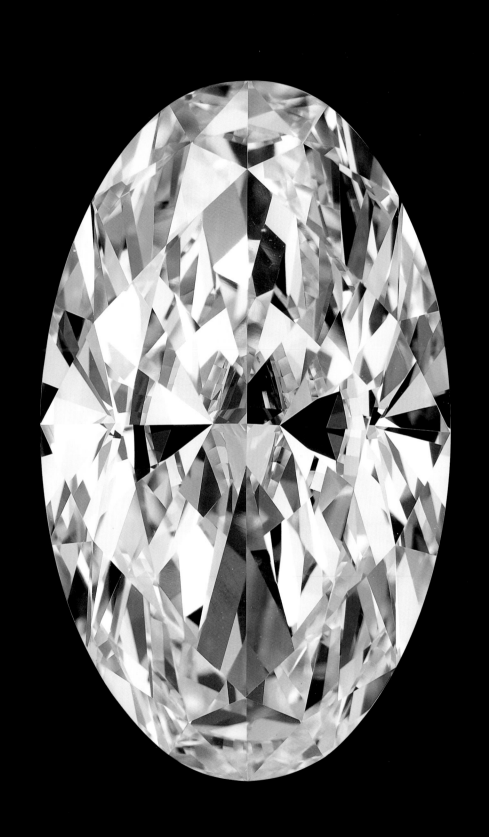

The Tanabata necklace offers a splendid stellar composition: the brilliant and extraordinary 37.27-carat diamond evoked visions of a comet and its scintillating halo in the minds of the designers. The diamond itself called for great virtuosity of design. A unique stone combining perfect harmony of form with exceptional purity and brilliance, it demanded an ensemble worthy of its qualities. The diamonds in the tail of the comet were cut and placed to evoke all the dynamism and apparent speed of the celestial object. They are followed by marquise-cut and narrower pear-shaped gems. The halo at the nape is a fluid myriad of diamonds whose intensity is enhanced by combined rose and brilliant cuts.

After more than a century, Cartier knows that the dazzle of pure light in jewelry is not just a question of gems, however precious and perfectly cut and set. Here, the jeweler has deployed all his know-how to create a platinum mount and a setting of supreme lightness, made almost invisible by meticulous polishing: nothing must prevent the gems from expressing the full splendor of their radiance. The Tanabata necklace thus continues its race through the infinite starry reaches, like an arrow of light shot toward an eternally beating heart.

In keeping with another Cartier tradition, the head of the comet is removable and can be worn as a ring.

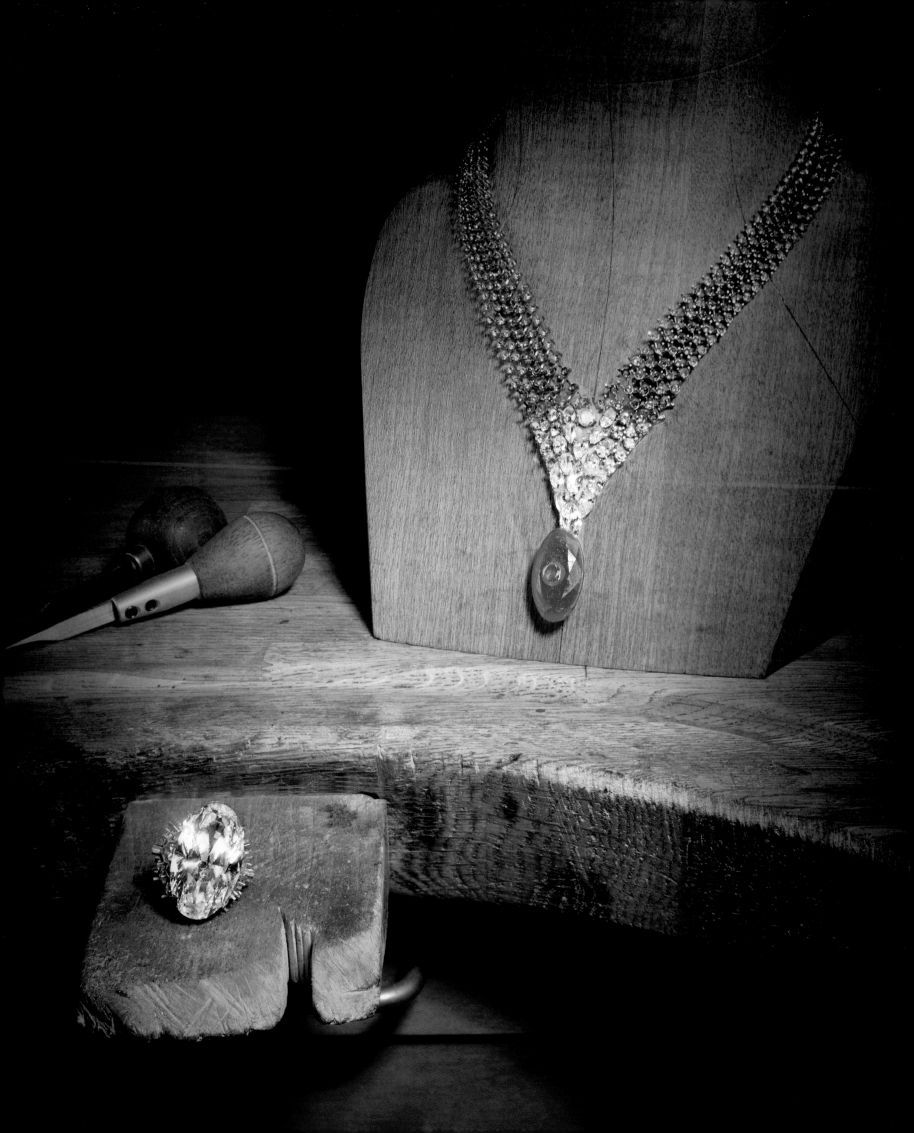

TANABATA EARRINGS
White gold, two D IF oval-shaped diamonds
totaling 6.10 carats, two D IF marquise-shaped
diamonds totaling 2.19 carats, marquise-shaped
diamonds, pear-shaped diamonds, rose-cut
diamonds, brilliant-cut diamonds.

TANABATA NECKLACE
White gold, one 37.27-carat D IF oval-shaped
diamond, two D FL/IF marquise-shaped
diamonds totaling 3.43 carats, six D IF oval-shaped
diamonds totaling 3.48 carats, eight D IF
pear-shaped diamonds totaling 5.12 carats, one
0.63-carat modified brilliant-cut diamond,
rose-cut diamonds, brilliant-cut diamonds.
The center stone can be worn either on
the necklace or on the ring.

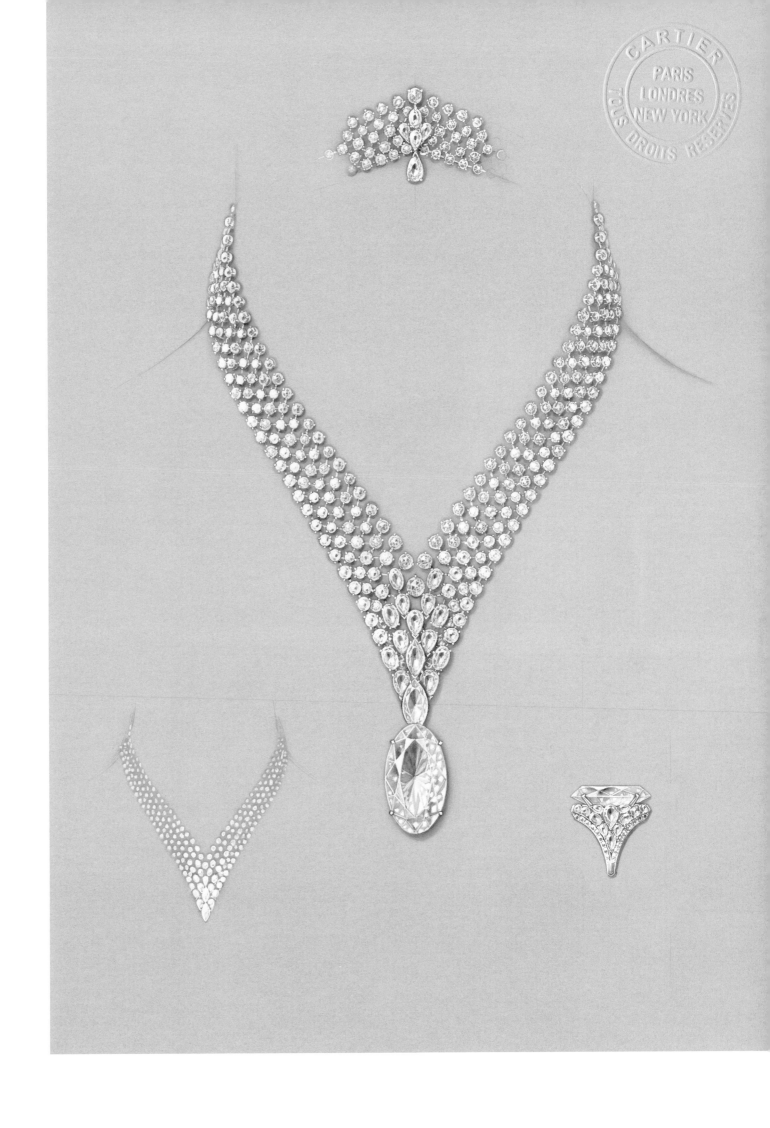

LIESSE EARRINGS
White gold, six emerald-cut diamonds totaling
5.33 carats, square-shaped diamonds, emerald-cut
diamonds, brilliant-cut diamonds.

LIESSE NECKLACE
White gold, one 3.02-carat emerald-cut diamond,
one 0.61-carat square-shaped diamond,
twenty-eight emerald-cut diamonds totaling
27.82 carats, emerald-cut diamonds, square-shaped
diamonds, brilliant-cut diamonds.

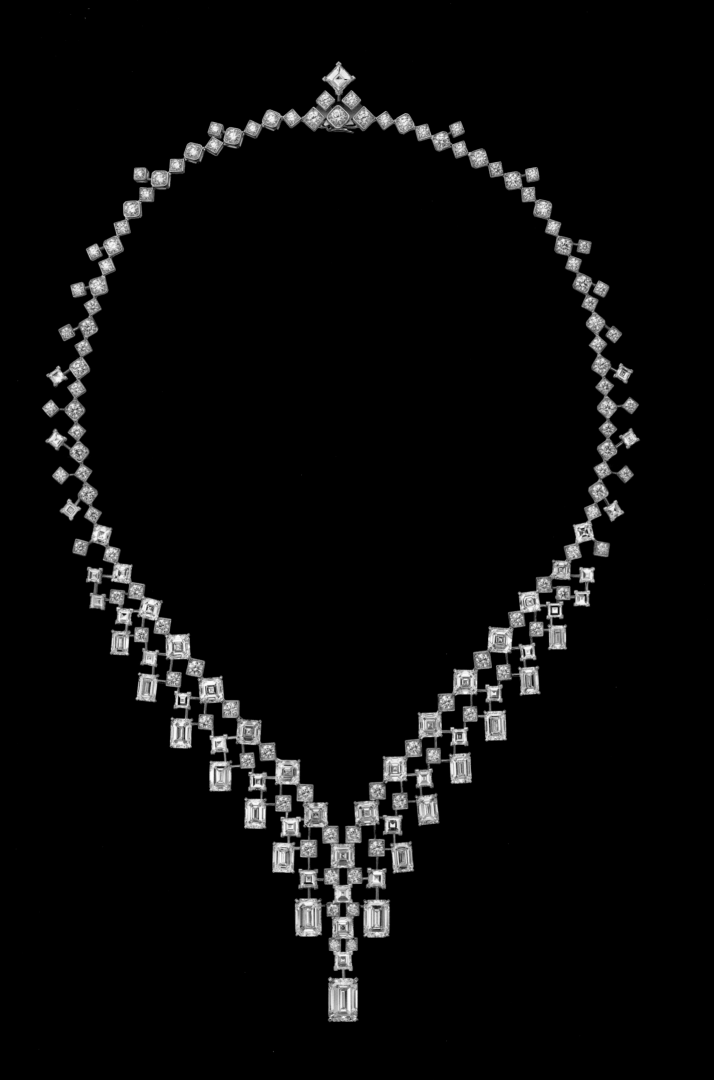

LUCINE NECKLACE

Platinum, one 8.01-carat D IF Type IIa pear-shaped diamond, one 1.11-carat Fancy Vivid Green-Blue VS1 modified cushion-shaped diamond, one 0.42-carat Fancy Vivid Green SI1 rectangular-shaped cut-cornered diamond, one triangular-shaped diamond, baguette-cut diamonds, brilliant-cut diamonds.

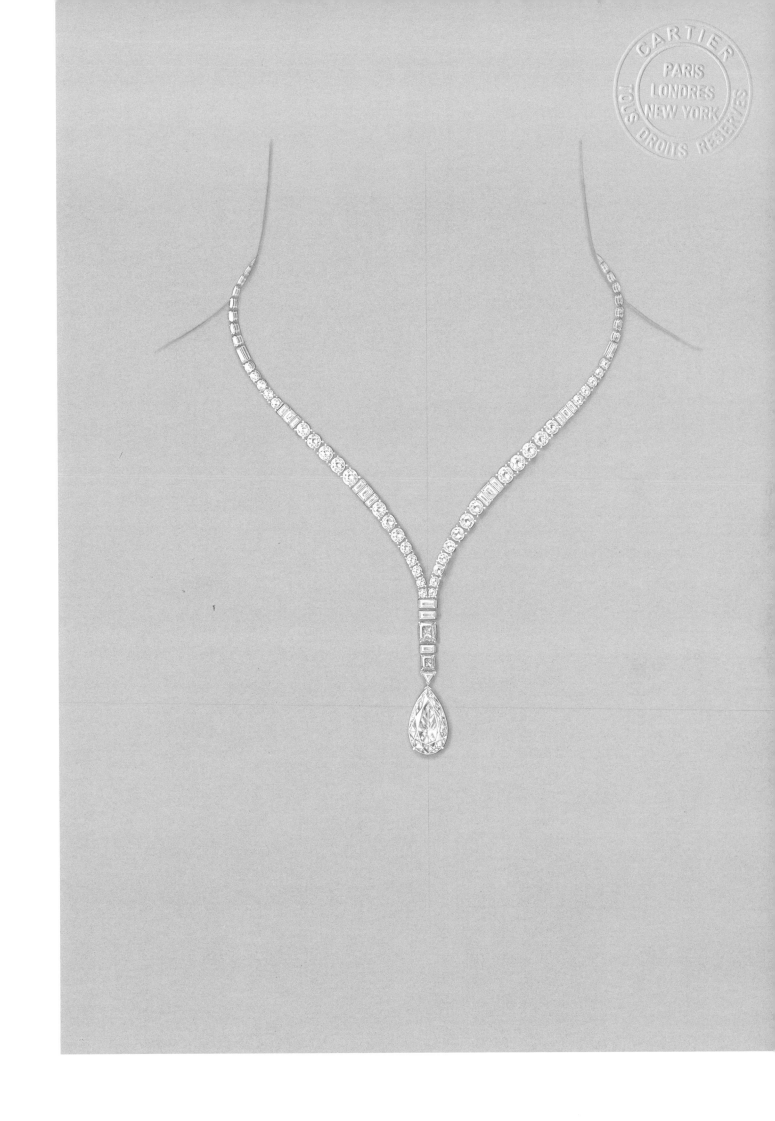

LUCINE EARRINGS
Platinum, two D IF pear-shaped diamonds totaling
6.02 carats, one 0.44-carat Fancy Vivid Green-Blue SI2
pear-shaped diamond, one 0.28-carat Fancy
Vivid Green VS2 pear-shaped diamond,
two triangular-shaped diamonds, baguette-cut
diamonds, brilliant-cut diamonds.

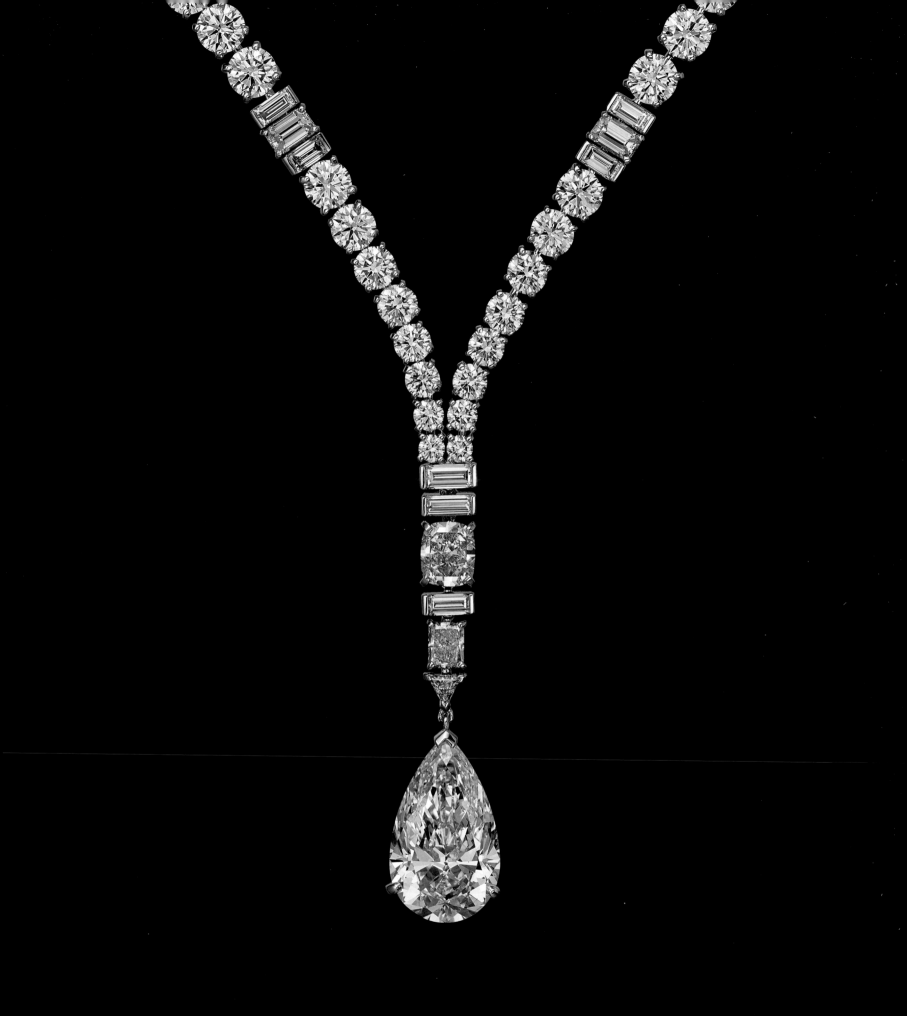

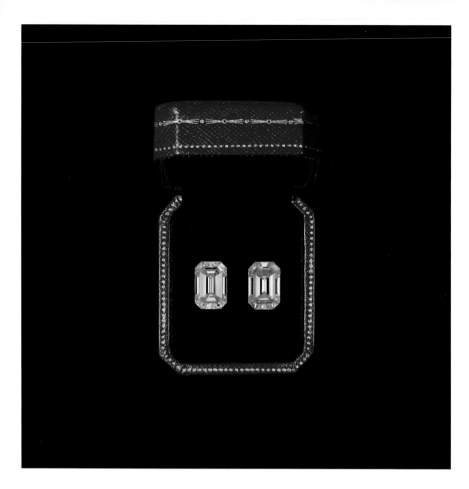

The symbol of infinity, the eternal re-beginning, characterizing the Canéphore bracelet, embraces two sublime emerald-cut yellow diamonds weighing 6.04 and 5.93 carats. Hued diamonds are very rare and particularly precious. These stones are of exceptional quality for the intensity and uniformity of their solar yellow. The designers have coupled them in a horizontal figure eight, evoking not only the infinite but also a fascinating Möbius strip or the lemniscate of Bernoulli. In China, where the word for the number 8 sounds like that of the word for luck, this motif is also a symbol of prosperity and happiness. It is a design that has been in the vocabulary of the Maison at least since the 1920s, recently witnessing a revival.

The motif is repeated here in an unending rhythm of emerald-cut and half moon-shaped diamonds along the entire length of the bracelet. Absorbed in the immanent purity of its continuity, the band defers to the cadenced light shining forth from the suns, a pulse measuring out the eternity of time, with an onyx corona accentuating their sparkle. Like a very precious good luck charm, a bit of the mystery of the universe wrapped around your wrist.

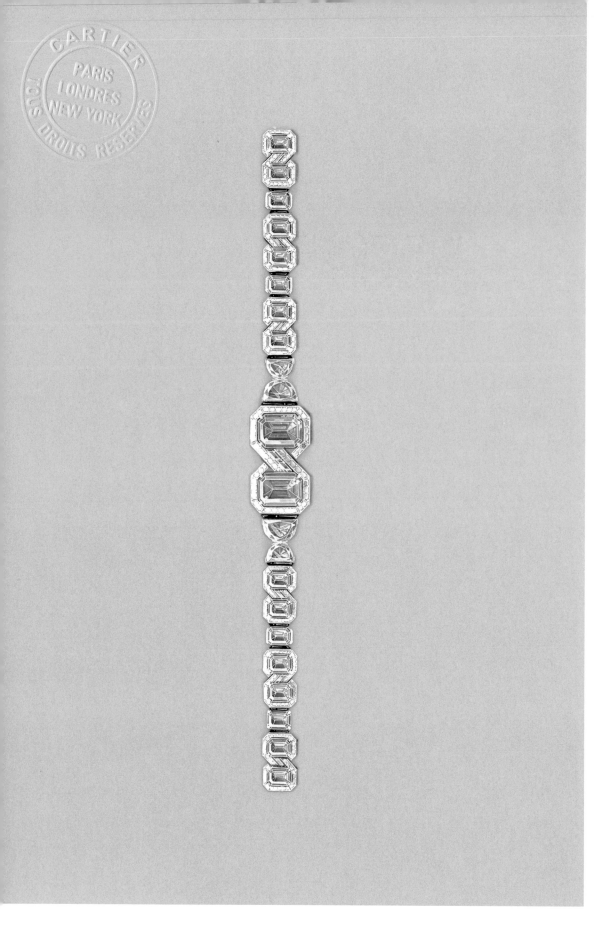

CARTIER
PARIS
LONDRES
NEW YORK
TOUS DROITS RÉSERVÉS

CANÉPHORE BRACELET
White gold, two Fancy Vivid Yellow
emerald-cut diamonds totaling 11.97 carats,
four half moon-shaped diamonds totaling
4.68 carats, sixteen emerald-cut diamonds totaling
12.89 carats, onyx, brilliant-cut diamonds.

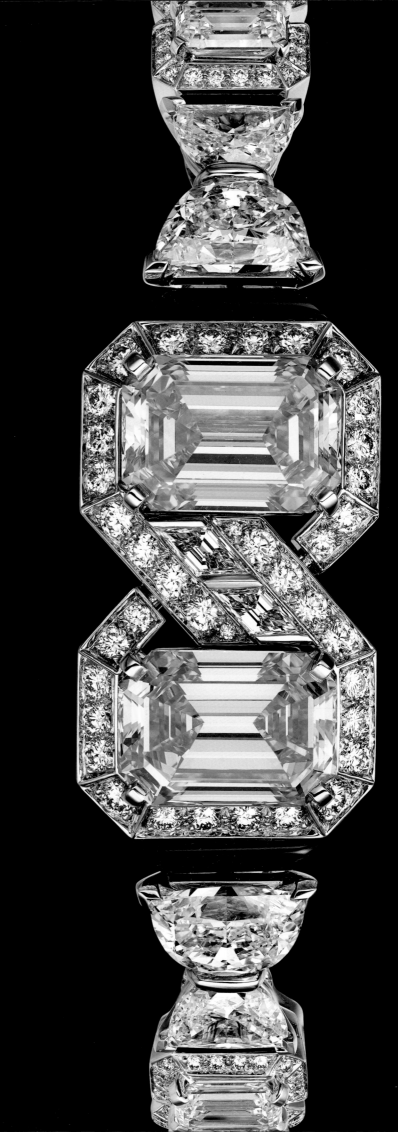

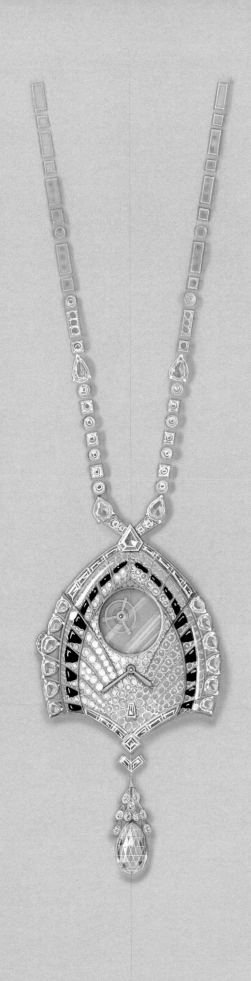

SIRIUS DE CARTIER PENDANT WATCH
Yellow gold, one 5.96-carat briolette-cut diamond,
four Fancy Light and Fancy Yellow modified pear-shaped
brilliant-cut diamonds totaling 2.73 carats,
one 0.84-carat modified shield-shaped step-cut
diamond, black lacquer, brilliant-cut yellow diamonds,
baguette-cut, rose-cut, tapered, and brilliant-cut
diamonds, mechanical movement with manual winding,
caliber 9463 MC, mysterious double tourbillon.

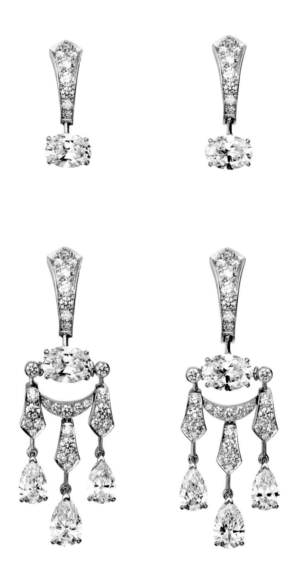

ALYSSE EARRINGS
Platinum, two oval-shaped diamonds totaling
2.02 carats, six pear-shaped diamonds
totaling 3.43 carats, brilliant-cut diamonds. The earrings
can be worn in two different ways.

ALYSSE NECKLACE
Platinum, six oval-shaped diamonds totaling
6.37 carats, thirteen pear-shaped diamonds totaling
9.87 carats, brilliant-cut diamonds.

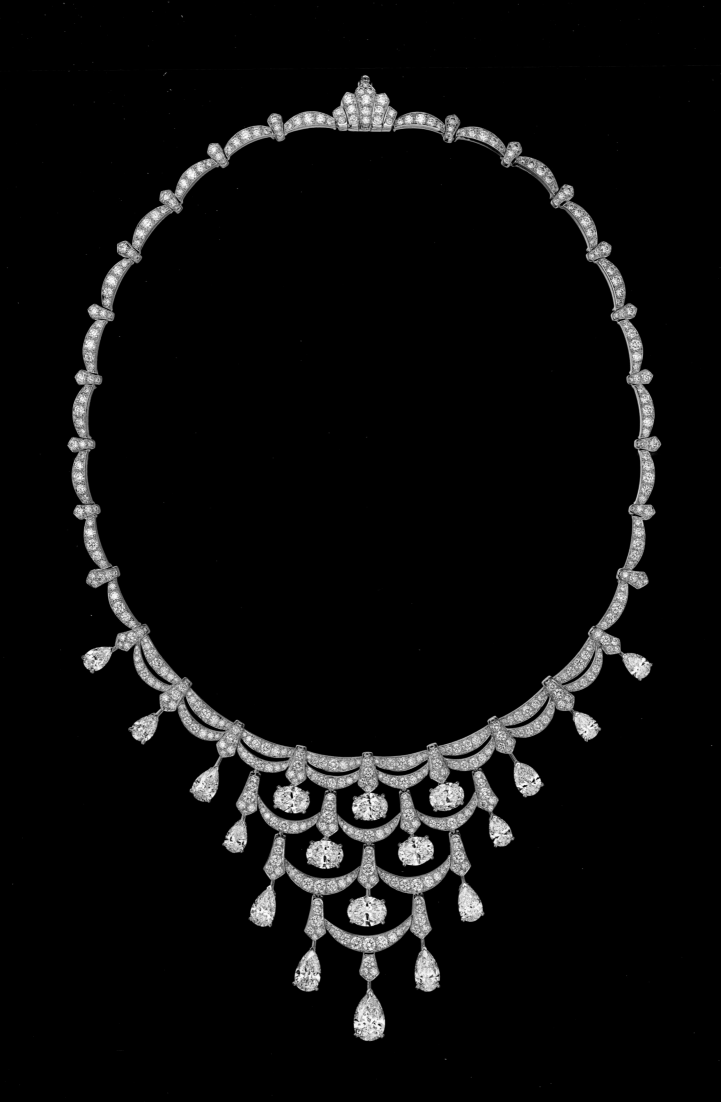

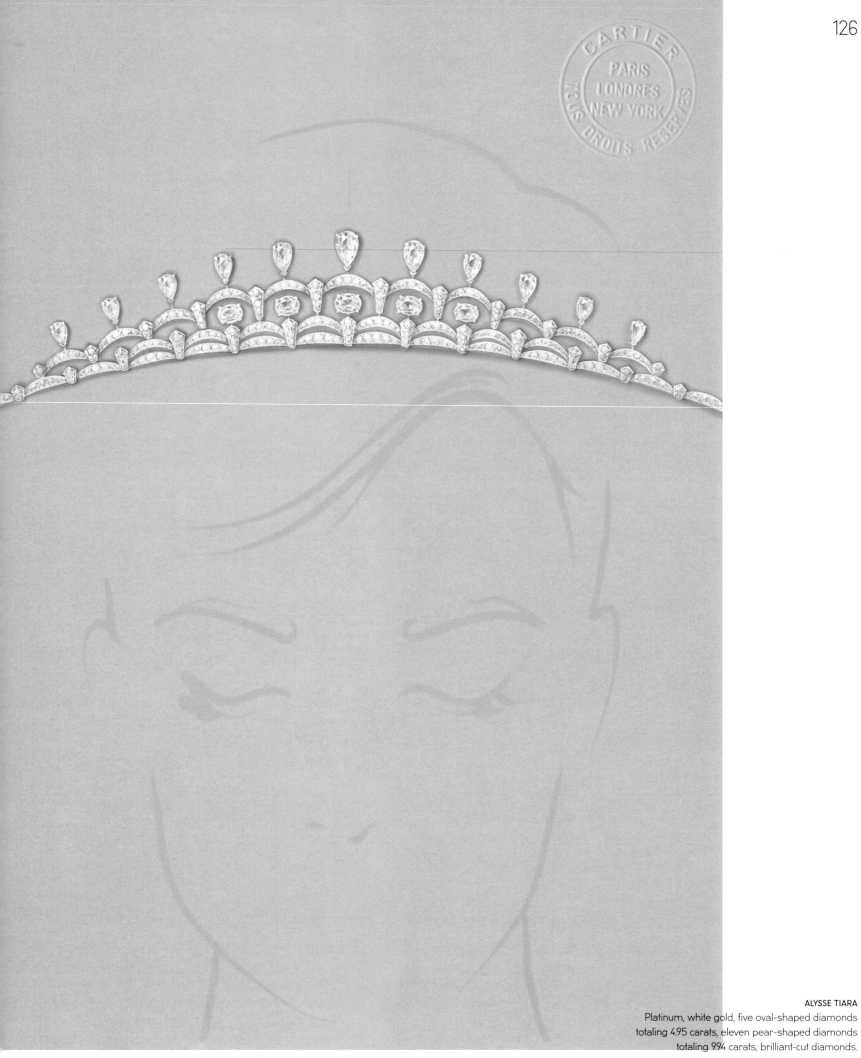

CARTIER
PARIS
LONDRES
NEW YORK
TOUS DROITS RÉSERVÉS

ALYSSE TIARA
Platinum, white gold, five oval-shaped diamonds
totaling 4.95 carats, eleven pear-shaped diamonds
totaling 9.94 carats, brilliant-cut diamonds.

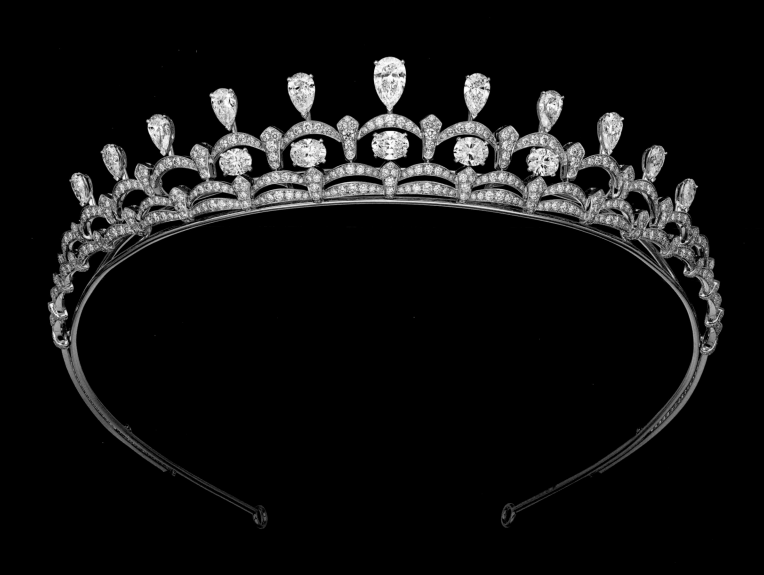

CARTIER
PARIS
LONDRES
NEW YORK
TOUS DROITS RESERVES

GOUTTES D'EAU & ÉMERAUDES WRISTWATCH
White gold, cabochon-cut emeralds, rose-cut diamonds,
brilliant-cut diamonds, quartz movement.

ONDOYANTE WRISTWATCH
White gold, one 6.22-carat sugarloaf emerald from
Zambia, half moon-shaped diamonds, emerald beads,
brilliant-cut diamonds, quartz movement.

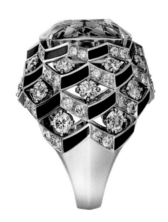

MATSURI RING
Platinum, one 26.20-carat cushion-shaped tourmaline,
onyx, brilliant-cut diamonds.

MATSURI BRACELET
Platinum, one 33.34-carat round-shaped tourmaline,
two cabochon-cut opals totaling 12.17 carats, tourmalines,
onyx, brilliant-cut diamonds.

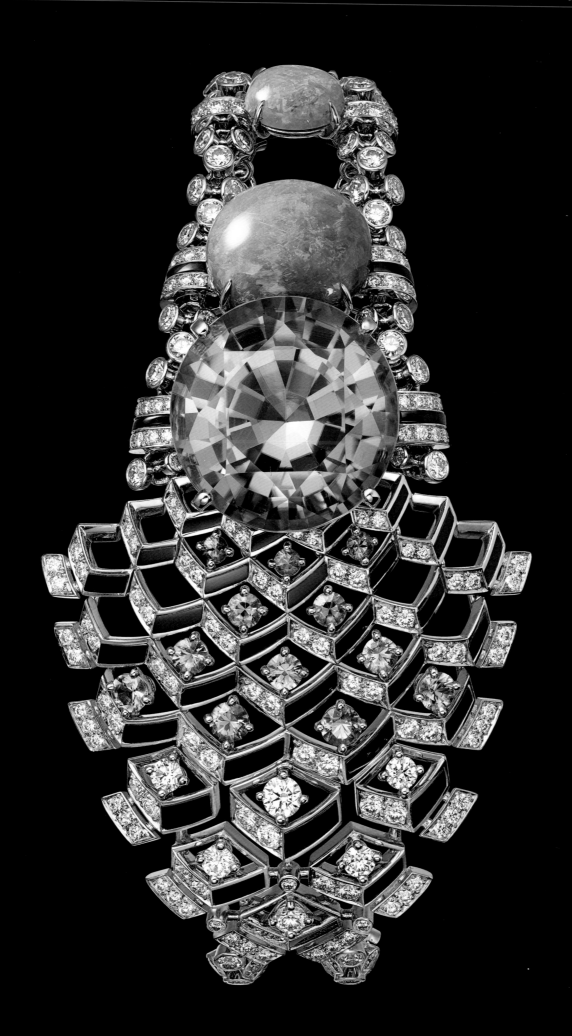

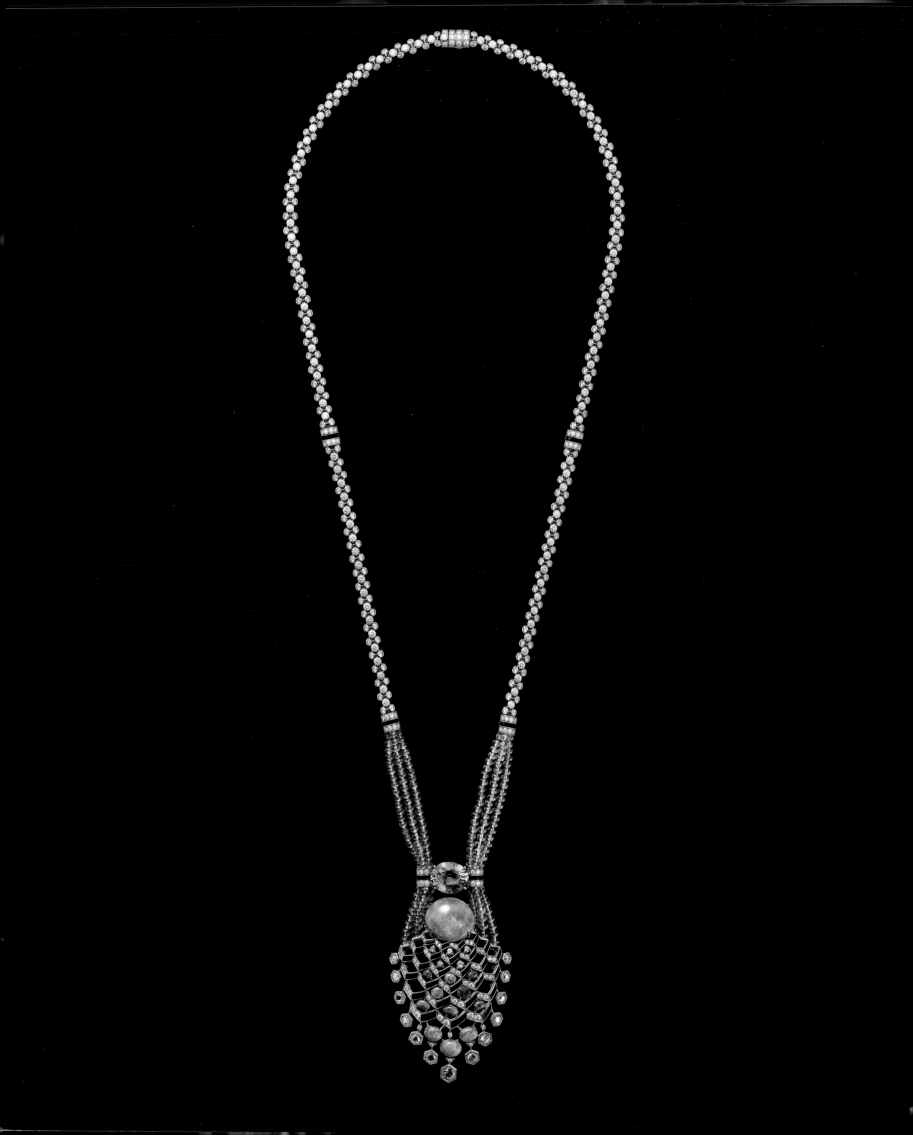

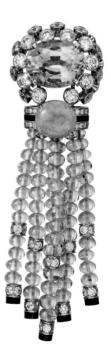

MATSURI NECKLACE
Platinum, one 14.82-carat cabochon-cut opal,
one 7.25-carat oval-shaped tourmaline, tourmaline
beads, tourmalines, opals, onyx, rose-cut
diamonds, brilliant-cut diamonds.

MATSURI EARRINGS
Platinum, two oval-shaped tourmalines totaling
8.32 carats, two cabochon-cut opals totaling 2.17 carats,
tourmaline beads, onyx, brilliant-cut diamonds.

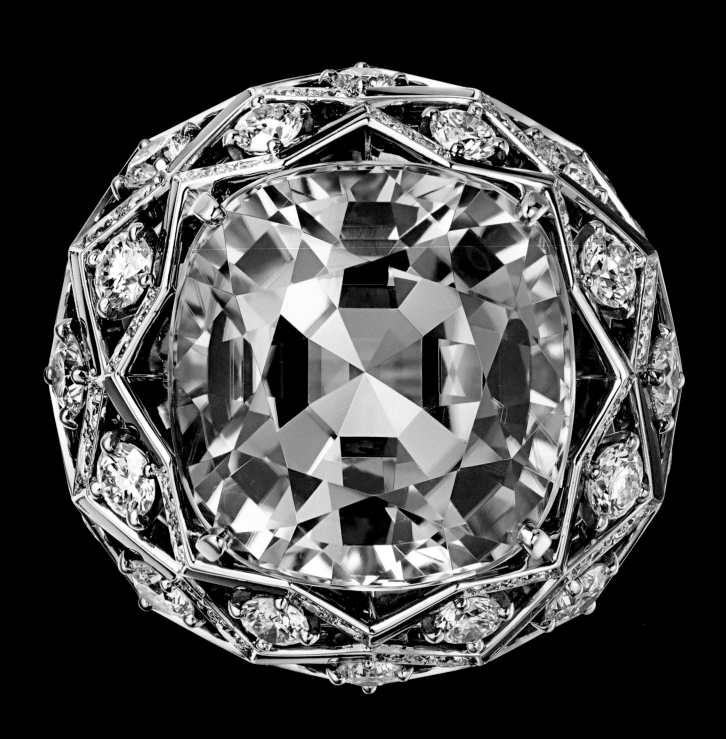

GREEN
AND BLACK

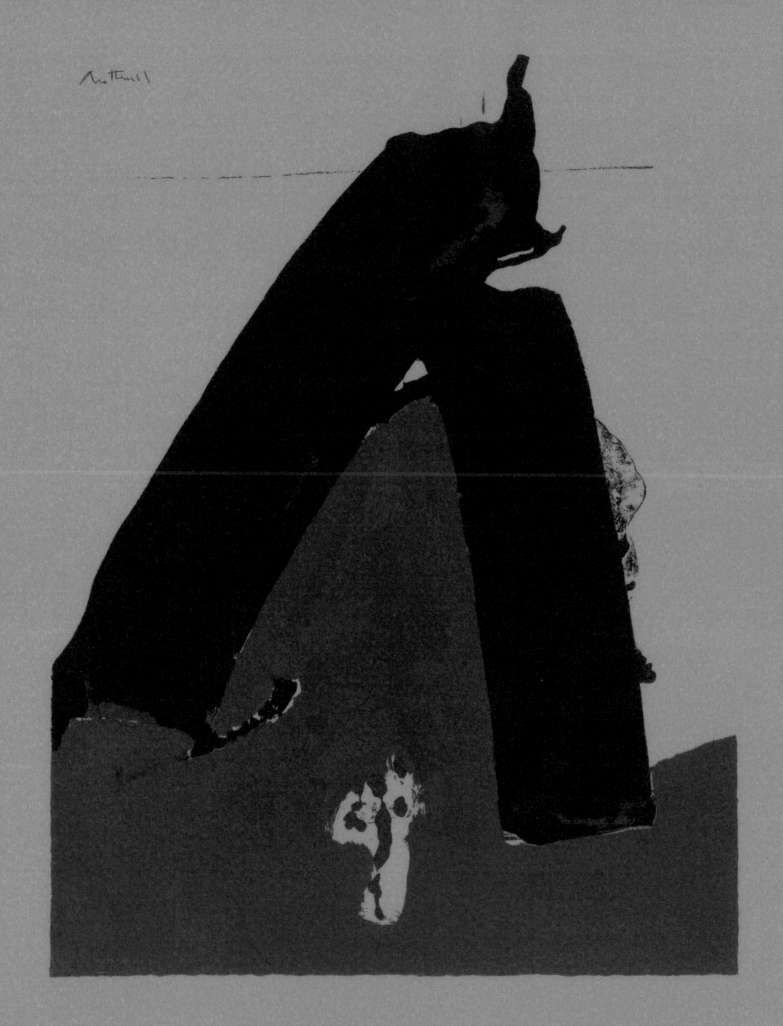

M

ixing green and black—at least at the end of the Middle Ages in the West—was something to be avoided. It was not because they clashed as colors, rather they were seen as being emotionally incompatible: vibrant, gay green, evoking springtime foliage, youth, and love, could not logically rub shoulders with the dark sorrow of black. In fifteenth-century France, the poet Jean Robertet, a resident of the court of Louis XI, expressed this in his *Exposition des couleurs* (*Exhibition of Colors*), a poem giving voice to eleven colors in eleven quatrains:

> *Green*
> *Like the emerald, you are precious,*
> *In perfect verdure a delight;*
> *Uneasy with the black of night,*
> *Only belonging to the joyous*

In the Renaissance, painters began to develop a completely different view of black. For a century it became the color of princely raiment, the favorite color of Charles V and his son, Philip II of Spain. Since black absorbs light, painters saw it as the best background for the colors that reflected light, and that, of course, included green. A great many portraits of historical notables bear testimony to this. One example is Hans Holbein the Younger and his *Charles de Solier, Sieur de Morette*, the *Portrait of the Merchant Georg Giese*, and his famous *Ambassadors*. One century later we have Rubens and his portrait of Bishop Michel Ophovius, or the sublime ode to green and black in the portrait of Apostle St. James the Greater by El Greco.

Painters from all cultures have continued to experiment with this combination, whose unquestionable beauty—or at least evident refinement—derives from a relatively discerning and sober contrast, not quite so discordant as, say, red and black, or red and green. In the twentieth century, certain great painters, unrivaled masters of color, frequently used it. We might mention Nicolas de Staël in his *Composition* of 1951, or in one of his *La Route d'Uzès* of 1954, or David Hockney with his *Place Furstenberg* of 1985 or *The Tall Tree* of 1986.

More generally speaking, black has long served to separate colors and describe forms in art. This is certainly true in Japanese prints, where every form,

every color, every volume is outlined in a fine black line drawn beforehand in India ink in a detailed preparatory drawing known as a *shita–e*. In the West we began with the art of stained glass. Much later, drawing inspiration from this vitreous art and also from Japanese prints, we had the Cloisonnism movement. It triumphed with the Pont-Aven School and its most illustrious representative, Paul Gauguin. Colors are separated by dark lines, often black—eschewing realism but revealing "where the truth lies." We find one of the most beautiful examples in Gauguin's self-portrait dedicated to van Gogh, *Les Misérables, à l'ami Vincent*, dating to 1888, where dark—sometimes black, sometimes red—lines delimit fields of green. Henri Matisse also applied this technique in many of his works, including one of his most famous, the three versions of *La Danse*, or in his *Still Life with Magnolia*, both works exploiting a combination of green and black.

One of the best known contemporary artists taking inspiration from the black lines of Japanese prints and from the more recent universe of manga is the Japanese painter Takashi Murakami. In both his Superflat works—*faux-naïf* art where two-dimensional drawings, multiplied ad infinitum in an explosion of color, conjure manga, op art, and pop art—and more recently in his extravagant interpretations, at once pop and Buddhist, of Japanese prints, Murakami deploys an eye-catching modern re-invention of Cloisonnism.

As for the unquestionable modernity of Louis Cartier, manifested since the first decade of the past century, precursor to what would later be labeled Art Deco, it too exploits the black line. Here it simulates a shadow, emphasizing the volumes of a motif by running a line of black enamel or onyx along one side. Two brooches, one dating to 1922, the other to 1927, are among the most emblematic pieces of this pictorial approach, and now part of the Cartier Collection. With diamonds and emeralds set off by black onyx or enamel, they again illustrate the combination of green and black that has been so dear to the Maison since the turn of the twentieth century.

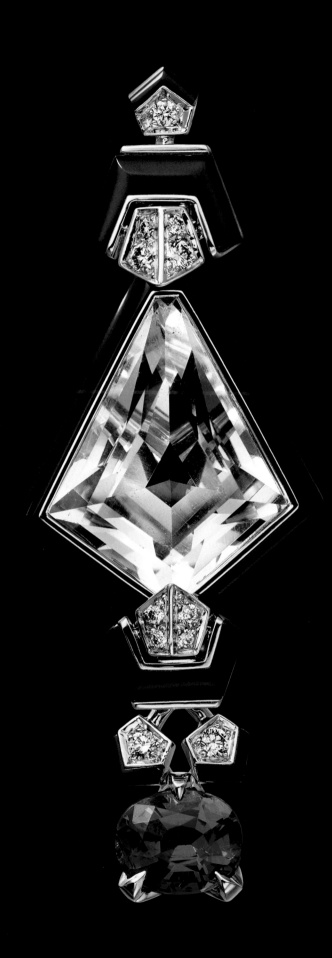

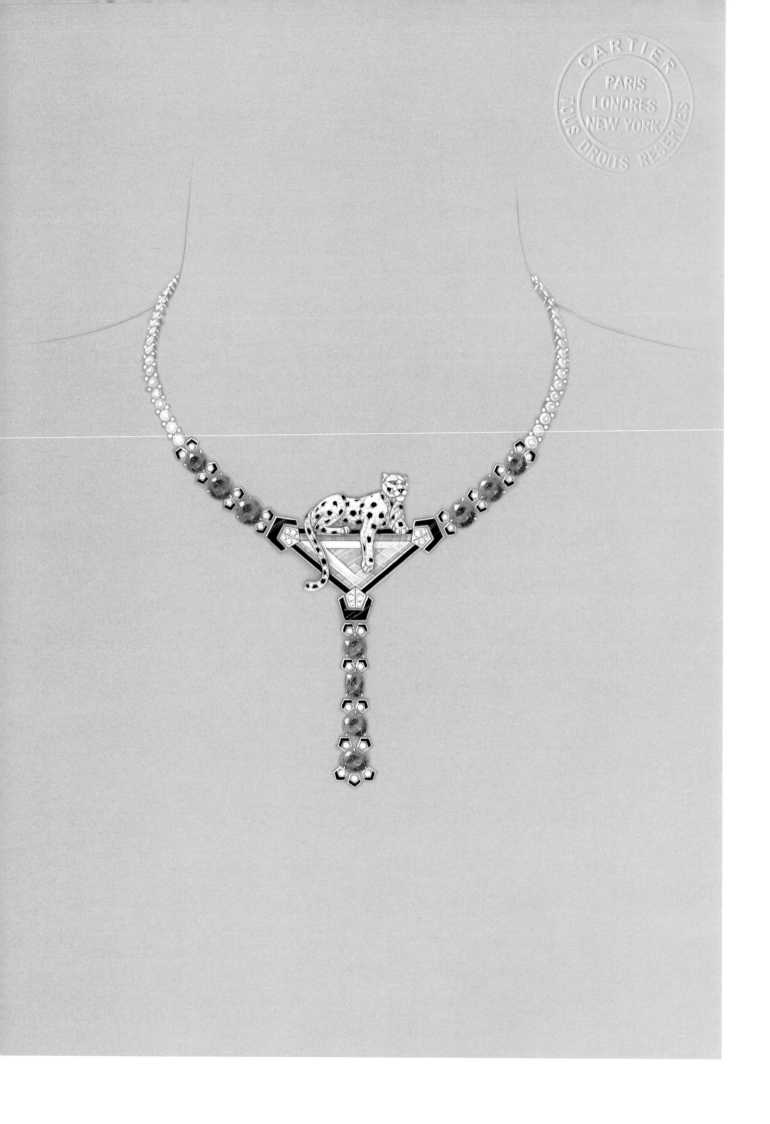

CARTIER
PARIS
LONDRES
NEW YORK
TOUS DROITS RÉSERVÉS

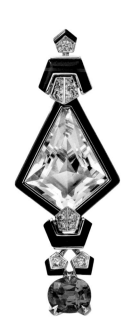

PANTHÈRE PÉTULANTE NECKLACE/BROOCH
Platinum, two oval-shaped and eight round-shaped
emeralds from Afghanistan totaling 11.07 carats,
carved rock crystal, onyx, emerald eyes, brilliant-cut
diamonds. The panther and rock crystal
can be removed and worn as a brooch. The necklace
can be worn alone with a second rock crystal.

PANTHÈRE PÉTULANTE EARRINGS
Platinum, two oval-shaped emeralds from
Afghanistan totaling 1.59 carats, carved rock crystal,
onyx, brilliant-cut diamonds.

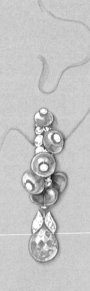

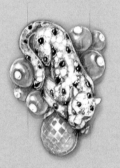

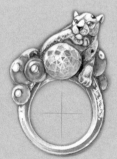

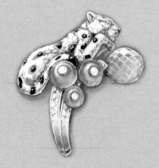

PANTHÈRE JAVA EARRINGS
Platinum, two briolette-cut emerald drops
from Colombia totaling 7.83 carats, emerald beads,
brilliant-cut diamonds.

PANTHÈRE JAVA RING
Platinum, one 11.00-carat briolette-cut emerald
drop from Colombia, emerald beads, emerald eyes,
onyx, brilliant-cut diamonds.

PANTHÈRE JAVA NECKLACE
Platinum, four briolette-cut emerald drops
from Colombia totaling 45.69 carats, briolette-cut
emerald drops, emerald beads, emerald eyes,
onyx, brilliant-cut diamonds.

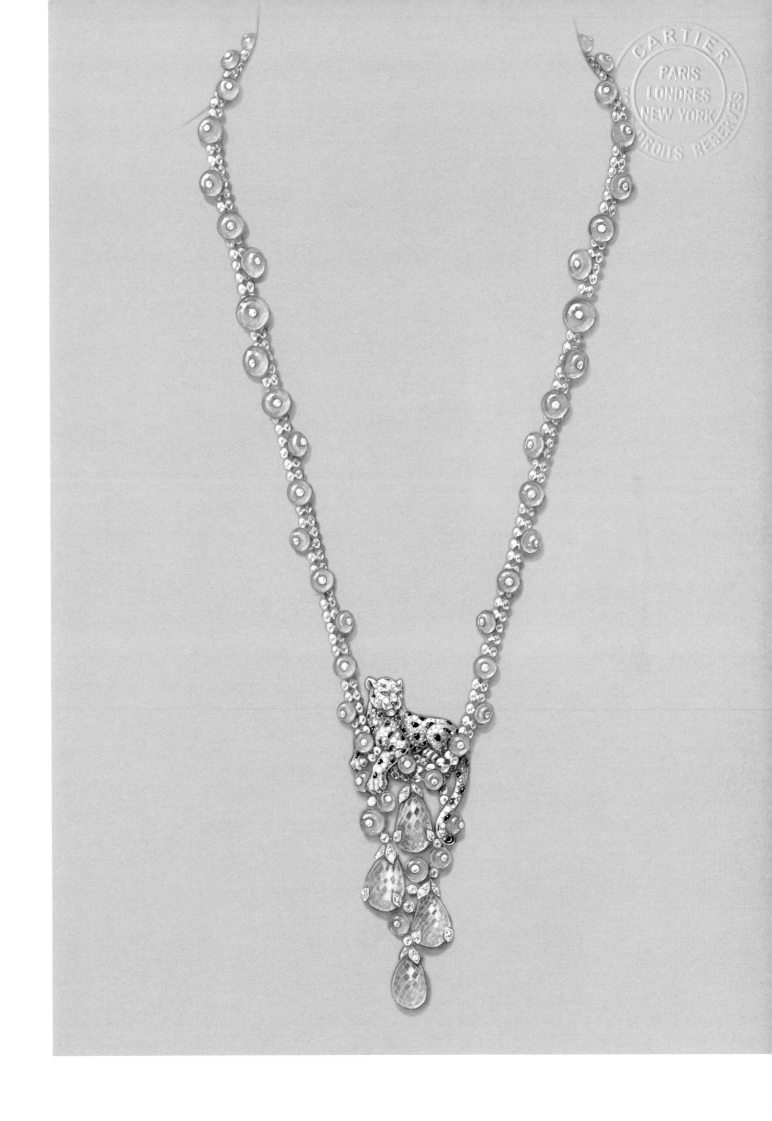

CARTIER
PARIS
LONDRES
NEW YORK
DROITS RESERVES

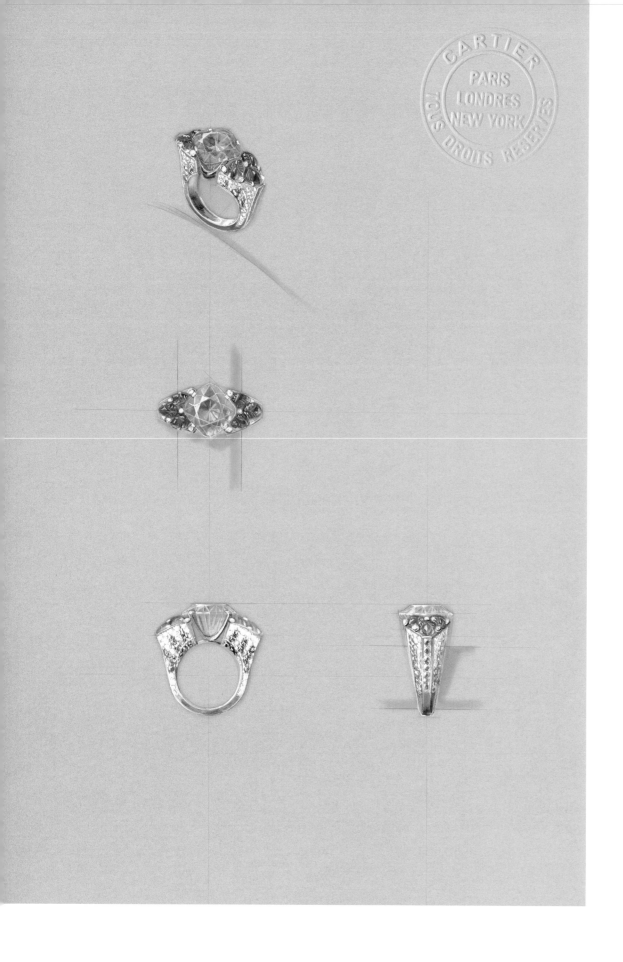

BROOKESIA RING
White gold, one 9.04-carat cushion-shaped green tourmaline, carved emeralds, brown and white brilliant-cut diamonds.

BROOKESIA NECKLACE/BROOCH
White gold, one 34.60-carat cabochon-cut opal, one 9.02-carat cushion-shaped green tourmaline, carved emeralds, melon-cut emerald beads, onyx, rose-cut diamonds, brown and white brilliant-cut diamonds. The chameleon motif can be detached and worn as a brooch.

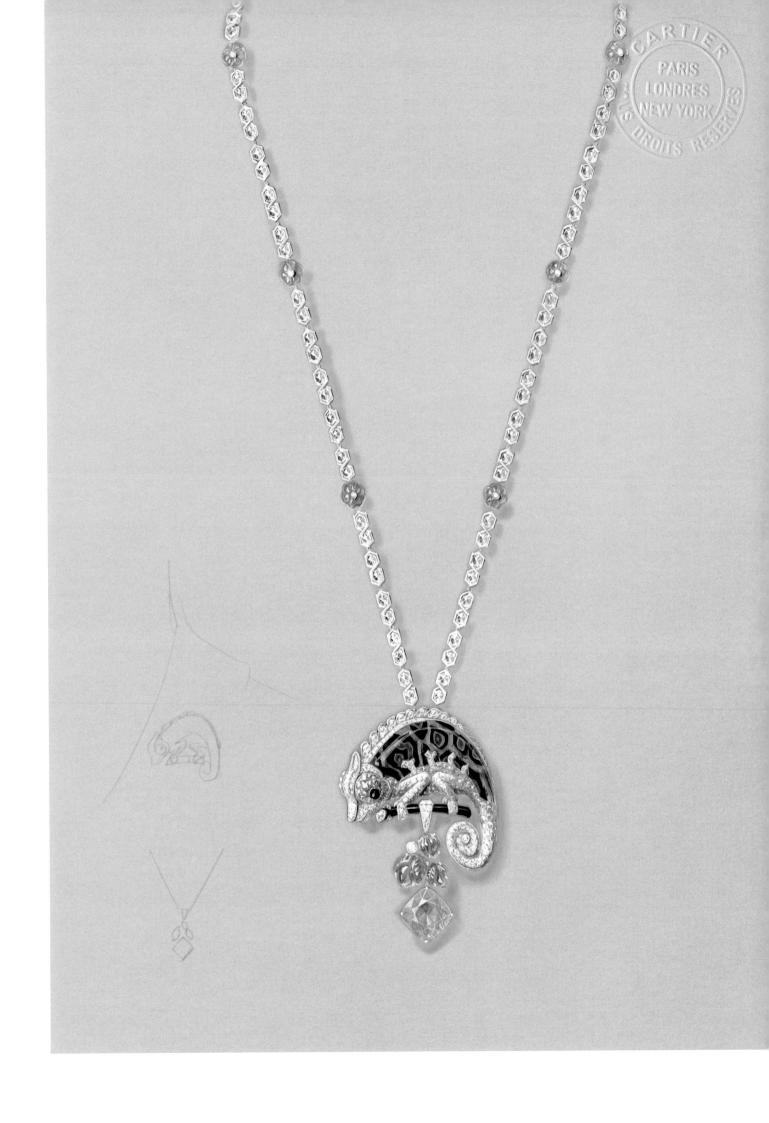

CARTIER
PARIS
LONDRES
NEW YORK
TOUS DROITS RÉSERVÉS

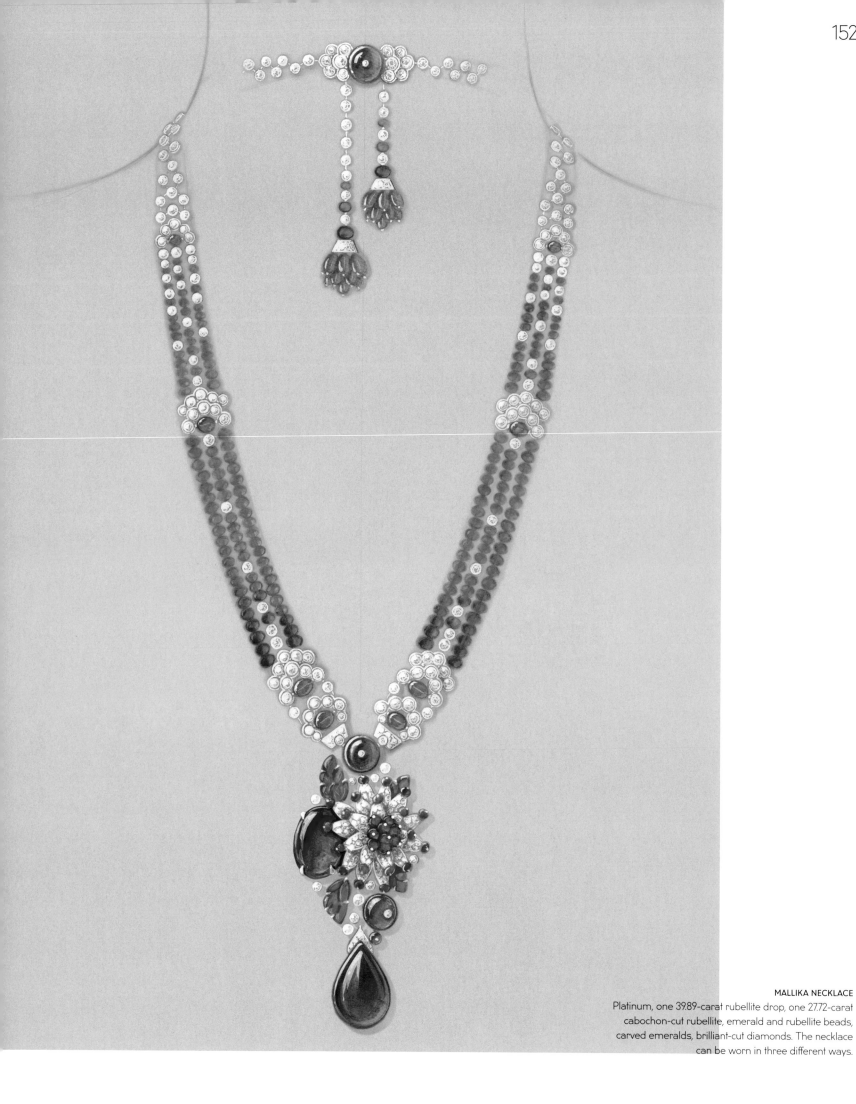

MALLIKA NECKLACE
Platinum, one 39.89-carat rubellite drop, one 27.72-carat cabochon-cut rubellite, emerald and rubellite beads, carved emeralds, brilliant-cut diamonds. The necklace can be worn in three different ways.

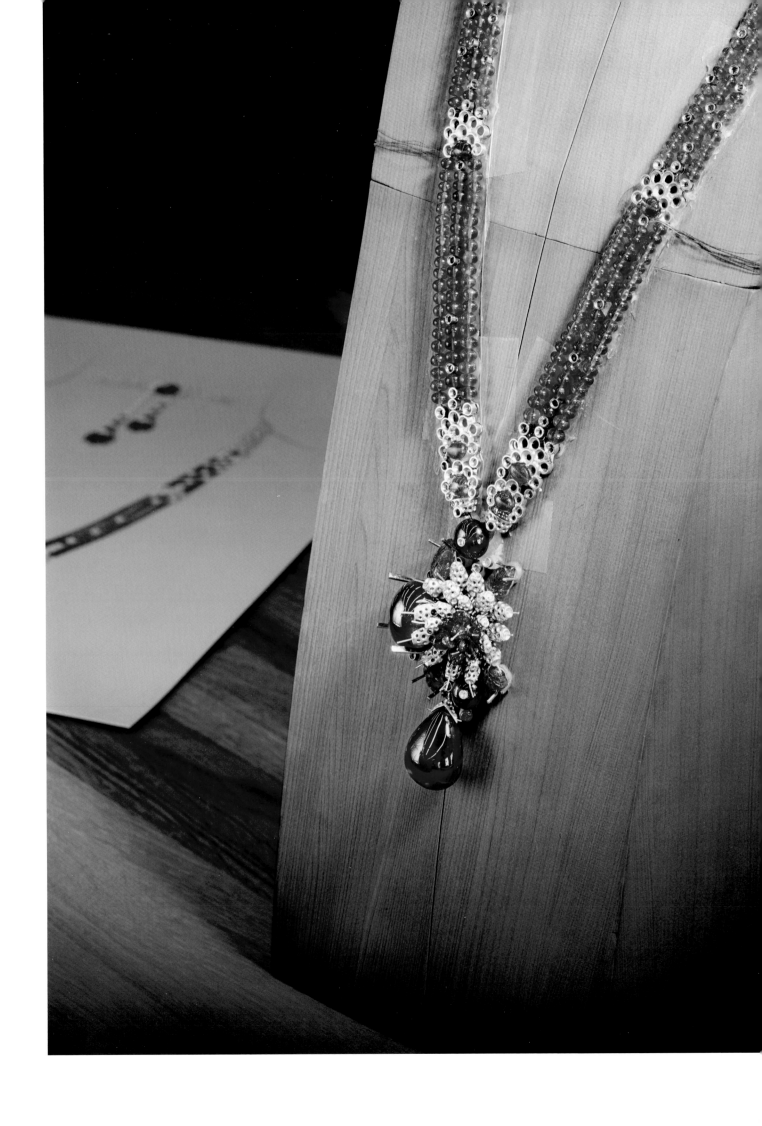

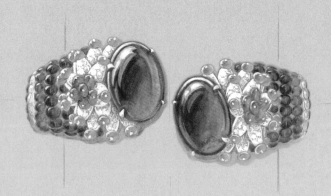

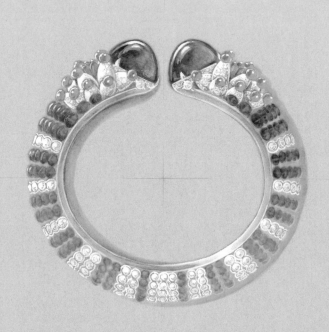

MALLIKA BRACELET
Platinum, two cabochon-cut rubellites
totaling 64.85 carats, emerald and rubellite
beads, brilliant-cut diamonds.

MALLIKA EARRINGS
Platinum, emerald and rubellite beads,
brilliant-cut diamonds.

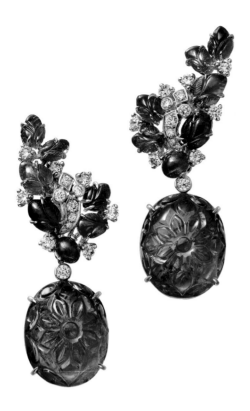

SAGAR EARRINGS
Platinum, two carved emeralds from Zambia totaling 39.56 carats, carved emeralds, rubies, and sapphires, sapphire beads, brilliant-cut diamonds. The carved emeralds are detachable.

SAGAR RING
Platinum, one 11.94-carat carved sapphire, carved sapphires, emeralds, and rubies, brilliant-cut diamonds.

SAGAR BRACELET
Platinum, one 51.51-carat carved emerald from Zambia, two carved emeralds from Zambia totaling 13.40 carats, carved sapphires, emeralds, and rubies, cabochon-cut emeralds, brilliant-cut diamonds.

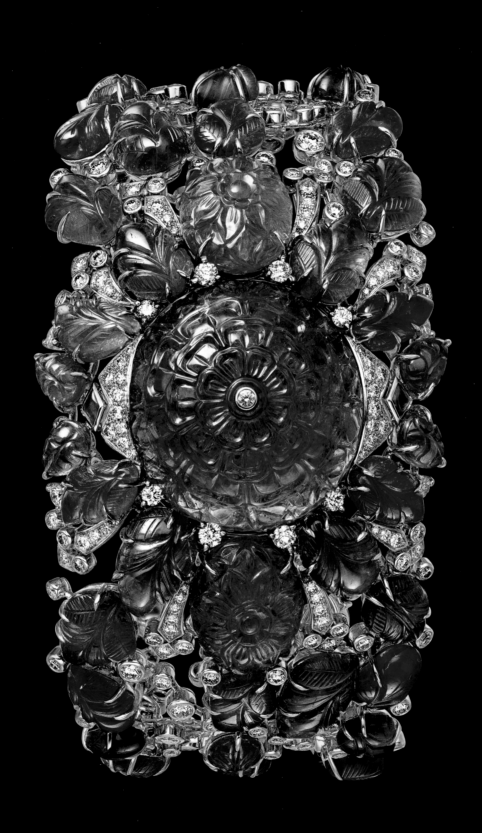

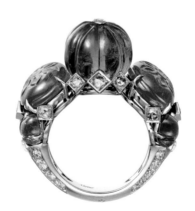

ADHIKA RING
Platinum, one 9.89-carat carved emerald
from Zambia, carved rubies and sapphires, rose-cut
diamonds, brilliant-cut diamonds.

ADHIKA NECKLACE/PENDANT
Platinum, one 24.32-carat carved emerald
from Zambia, one 14.60-carat carved sapphire drop
from Burma, one 8.62-carat cabochon-cut ruby
from Burma, carved rubies, sapphires and emeralds,
square-shaped, rose-cut, and brilliant-cut diamonds.
The necklace can be worn in three different ways.

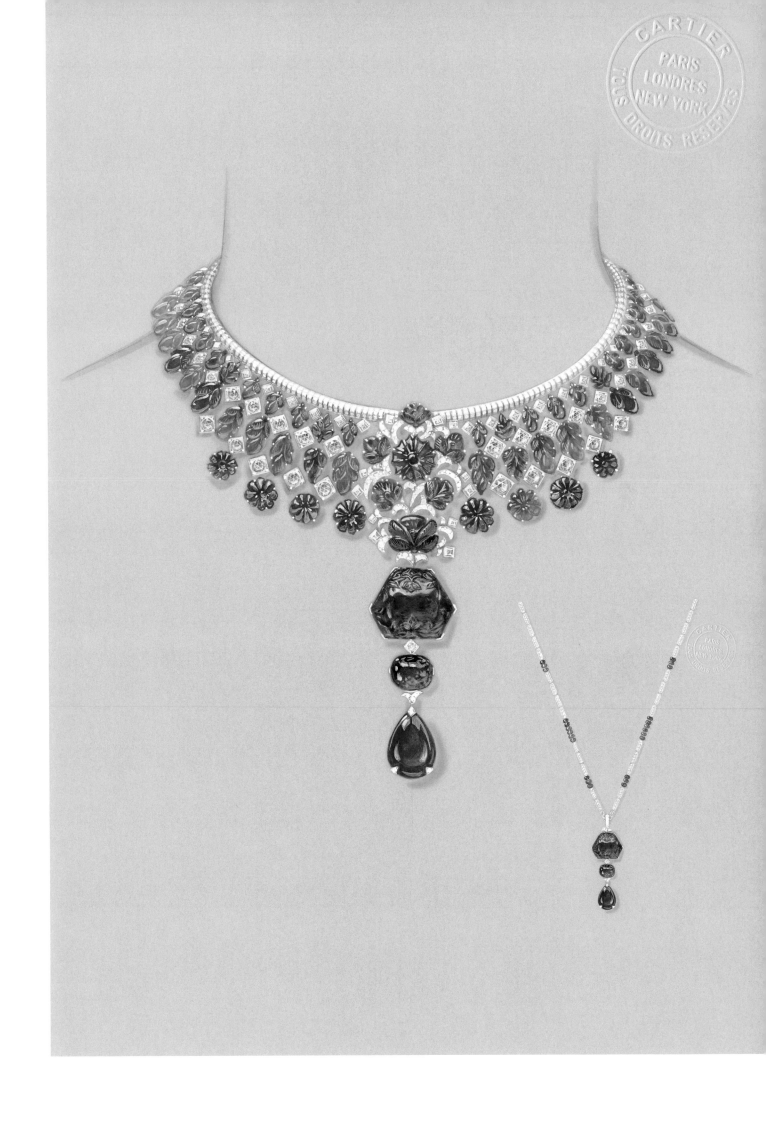

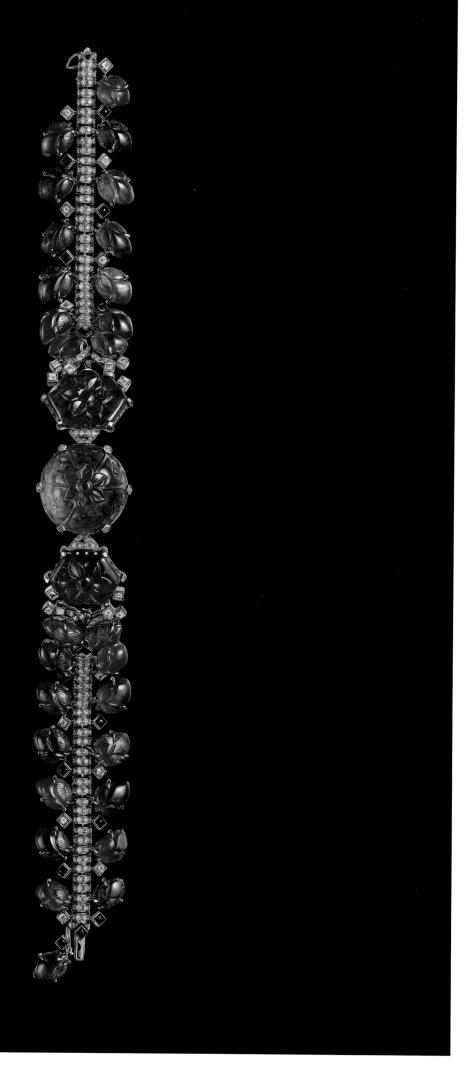

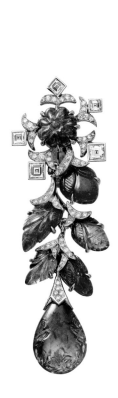
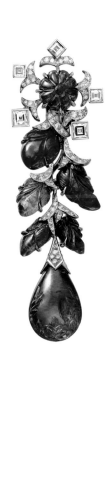

ADHIKA BRACELET
Platinum, one 21.44-carat carved emerald
from Afghanistan, two carved rubies from
Mozambique totaling 14.39 carats, carved rubies,
sapphires, emeralds, onyx, square-shaped
diamonds, brilliant-cut diamonds.

ADHIKA EARRINGS
Platinum, two carved sapphire drops totaling
17.21 carats, carved rubies, sapphires, and emeralds,
square-shaped diamonds, brilliant-cut diamonds.

The image of a delightful garden in the springtime, naturally embellished by the singing of birds and the perfumes of paradise: since the 1920s, all the senses are summoned to take part in a profusion of delights with Cartier's Tutti Frutti pieces.

For this necklace, the designers brought a central theme in Indian iconography—the tree of life—into bloom in a French-style garden. The organic learns geometry as the jeweler learns gardening, arranging foliage, flowers, and buds in symmetrical flowerbeds, radial arrangements, sculpted hedges. Airy and rhythmic, this arrangement of precious stones gives the Maota necklace a majestic equilibrium in perfect harmony with the golden ratio of the Taj Mahal. The rubies, emeralds, and sapphires have been carved with plant motifs in keeping with time-honored Mogul tradition. They are set off by onyx bars giving shade and relief to this vibrant garden.

This piece of jewelry can be divided into two necklaces and worn in eight different ways. The exceptional 45.80-carat sapphire displays the warm nuances of its Burmese origins. Cut into a very original drop, it is removable, as is the pendant linking it to the impressive 35.66-carat cabochon-cut ruby, which is only half carved to highlight the quality and intensity of its crystal.

We hear the notes—both joyous and wise, audacious and meditative—of this symphony of bright colors, a feminine voice at the height of her art.

MAOTA NECKLACE
Platinum, one 45.80-carat carved sapphire from Burma, one 35.66-carat carved ruby from Burma, one 12.01-carat carved sapphire from Burma, one 9.43-carat carved ruby from Mozambique, 59 melon-cut emerald beads totaling 279.17 carats, carved sapphires, emeralds, and rubies, emerald, sapphire and ruby beads, onyx, brilliant-cut diamonds. The piece can be worn in eight different ways.

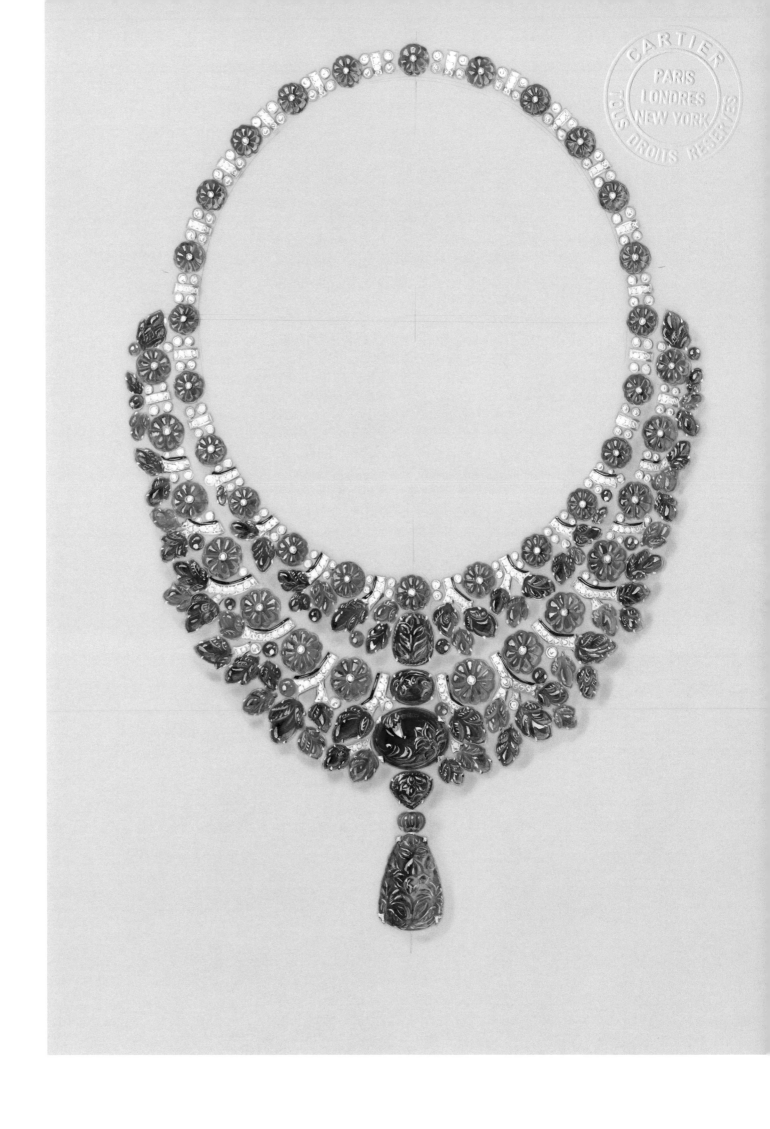

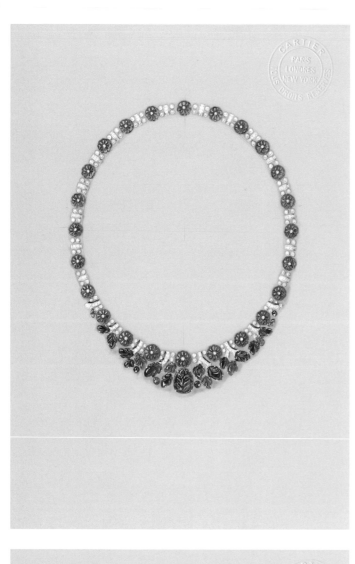

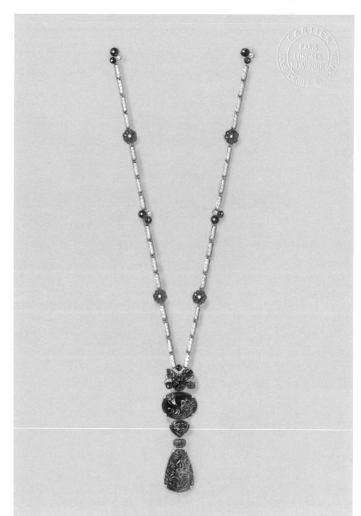

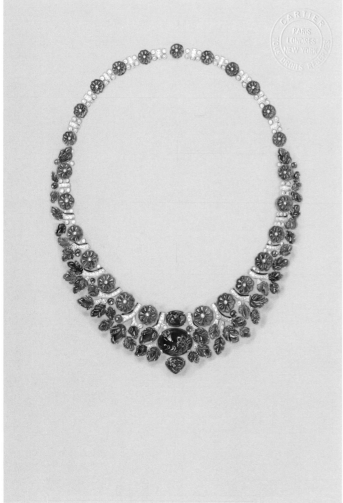

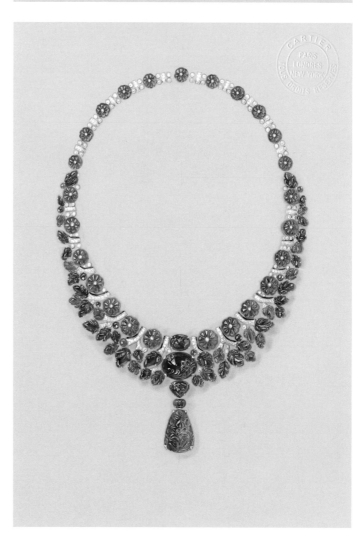

CARTIER
PARIS
LONDRES
NEW YORK
TOUS DROITS RESERVES

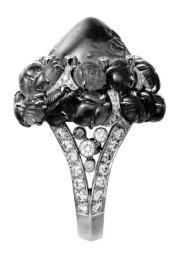

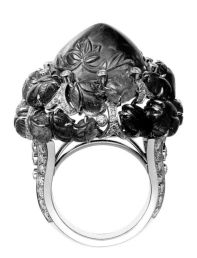

MAOTA EARRINGS

Platinum, melon-cut emerald and sapphire
beads, carved sapphires, emeralds, and rubies,
sapphire and ruby beads, brilliant-cut diamonds.
The earrings can be worn in two different ways.

MAOTA RING

Platinum, one 22.77-carat carved cabochon-cut
sapphire from Ceylon, carved sapphires, emeralds,
and rubies, brilliant-cut diamonds.

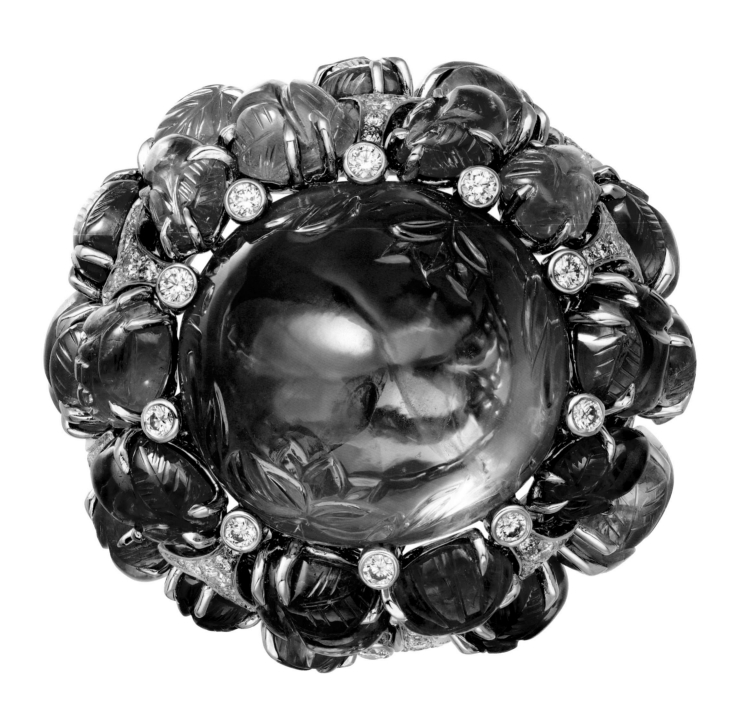

RED, BLUE, AND GREEN

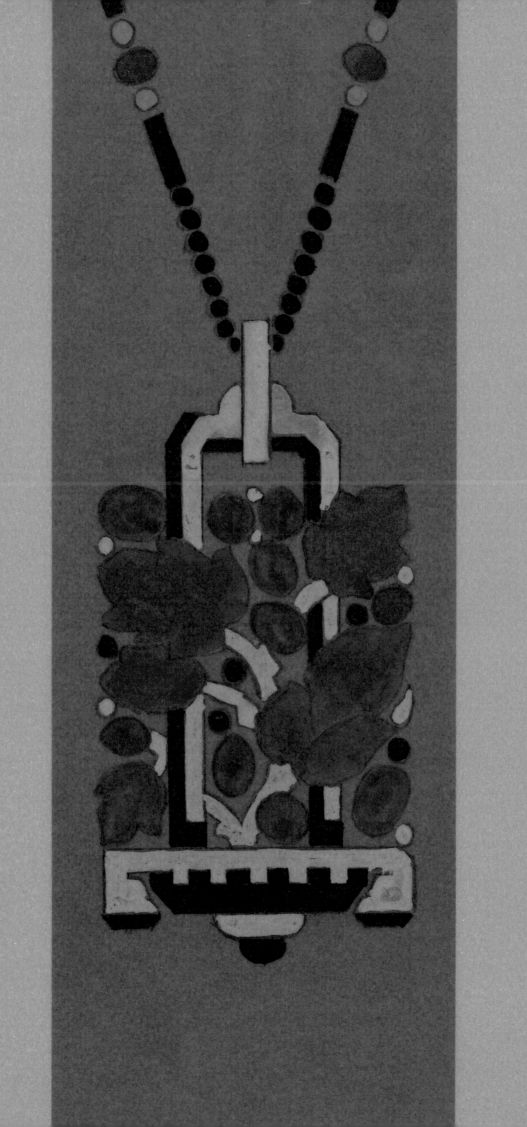

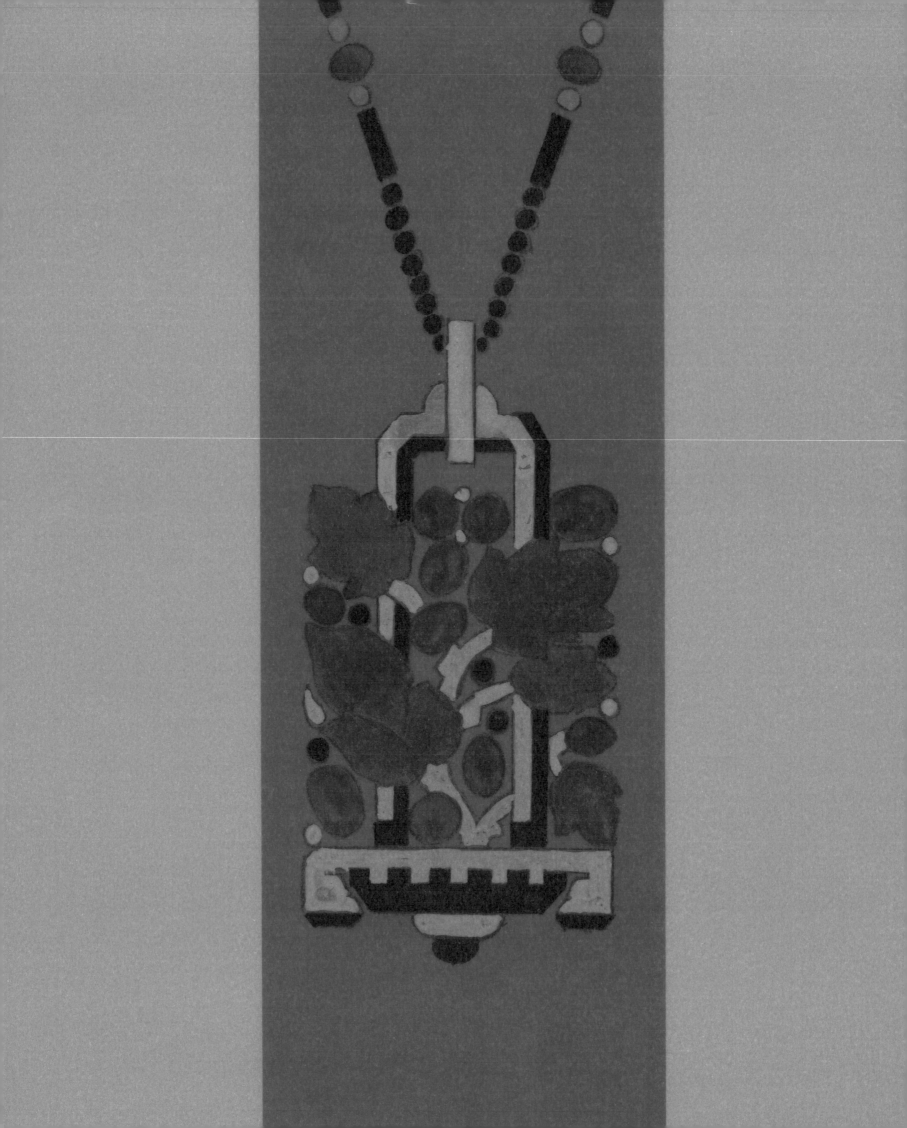

Simon Hantaï, *Untitled (C.F.3.4.34)*, 1974.
Albright-Knox Art Gallery, Buffalo, NY.

Drawing for a Tutti Frutti pendant.
Cartier Paris, 1923. Executed in platinum, emeralds,
rubies, sapphires, onyx, and diamonds.

Red of fire, love, passion. Blue of peace, serenity, comfort. Green of nature, springtime, hope. Together, these three colors relate the mystery of our lives and the essence of our sentiments as human beings on Earth. We find them together in a bouquet of flowers, in a garden in the springtime—that of Claude Monet in Giverny, for example, or the Majorelle Garden in Marrakech with irises and forget-me-nots, pansies and tulips, grasses, leaves and water lilies. Together they release a lovely garden scent accented by a deliciously tart taste.

Inspired by that sparkling natural palette, some painters resolutely integrated them into their works, Matisse foremost among them. Seeking the pure vibration of color in large fields, he often juxtaposed these three colors, as we see in *The Dessert: Harmony in Red* (1908) or *Music* (1910). In 1953, in his eighties, his health failing, he composed the monumental *La Gerbe*, bringing together the three colors into a very dynamic pattern of leaves, a final outburst of joy.

Rubies, sapphires, and emeralds, the three gemstones associated with these colors, representing vivid and generally happy emotions, are rarely found together in a single piece of jewelry. It was also rare to find them together in the multicolored parures of the maharajahs: in India the sapphire was often viewed with distrust for its nightlike shadow and its association with Saturn.

After having combined the three colors a few times in the 1910s, Cartier further explored their possibilities in the following decade. The discovery of Diaghilev's Ballets Russes by Louis Cartier and his chief jewelry designer at the time, Charles Jacqueau, certainly played a determining role in the renewed affirmation of this audacious color combination. Cartier then invented a style of jewelry where rubies, emeralds, and sapphires produced dazzling fireworks and an extremely feminine sense of freshness. To achieve this, the designers closely assembled the deeply and intensely colored stones, paying painstaking attention to overall harmony, placing each perfectly according to its tone, size, and shape and creating a beautiful contrast with its neighbors. Cartier acquired the gems in India, where they had been carved and sculpted according to Mogul tradition into smooth or ribbed beads studded with a diamond, or cut and carved with nature motifs of foliage and berries.

The very lively and audacious polychromy of these pieces—necklaces, bracelets, brooches, pendant earrings, and occasionally ornaments on accessories such as handbags—upended accepted practice in jewelry at the time. Some customers

were wildly in love with them, and this style became one of the showpieces of the Maison's Art Deco period and soon thereafter one of its principal emblems. Cartier originally referred to it in their record books as simple "foliage" in "colored stones." It would not be until the 1970s that it was dubbed Tutti Frutti.

Its first acolytes were Cartier's premier customers, high-society celebrities with unerring taste, who were very much admired for their collections of new jewelry. They included Linda Lee Thomas (Cole Porter's wife), Virginia Fair Vanderbilt, a member of one of the richest and most influential dynasties in the United States, and Daisy Fellowes, heiress to the Singer sewing machine fortune and former Paris correspondent for *Harper's Bazaar*.

World famous as one of the emblematic jewelry styles of the modern period, Tutti Frutti is now on permanent exhibit at the Victoria and Albert Museum in London, represented by a bandeau purchased from Cartier London on November 15, 1928 by Lady Edwina Mountbatten. Lord Louis Mountbatten was Queen Victoria's great-grandson, appointed last Viceroy of India in 1947, and his rather wayward wife was no stranger to the New Bond Street store. Before they were married in 1922, Edwina's future mother-in-law, Princess Victoria Mountbatten, gave her a magnificent ruby, which Cartier mounted in an engagement ring. As a wedding present, a former swain, the fifth duke of Sutherland, gave her a Cartier diamond bracelet.

The splendid Tutti Frutti bandeau worn by Lady Mountbatten on numerous occasions was transformable and could be split into two bracelets. A photograph shows Edwina tenderly cuddling her daughter and wearing both bracelets on one wrist. The bandeau was crafted in England and is now considered to be a national treasure. In 2004 the British government decreed that it may never be taken out of the territory of the Commonwealth.

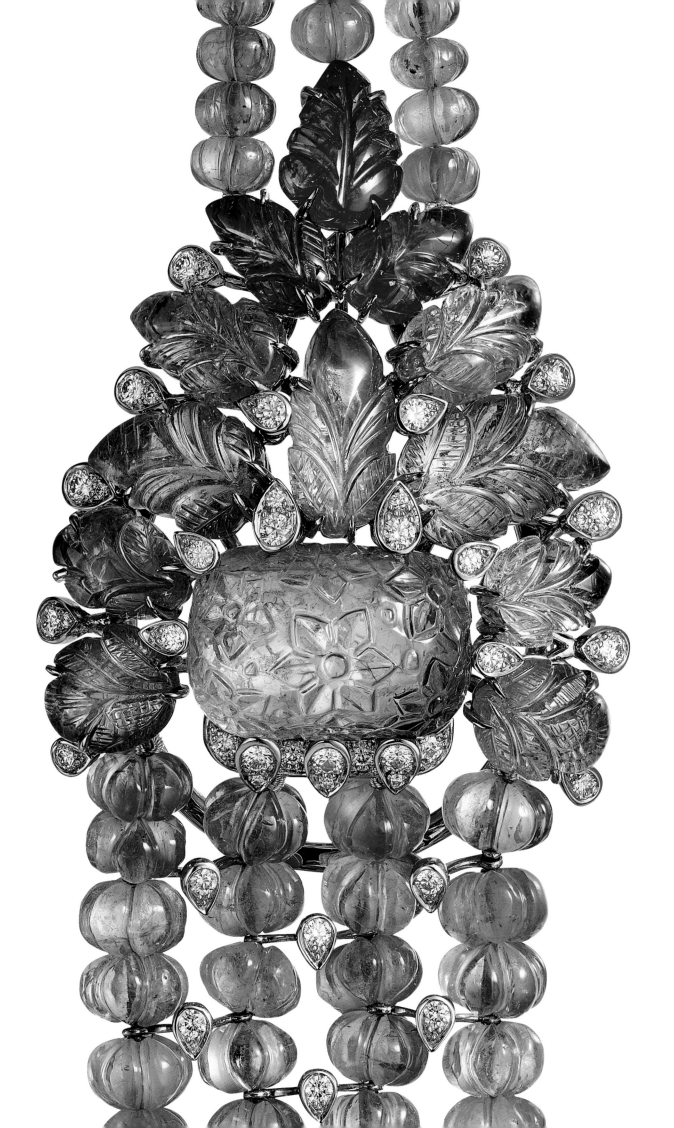

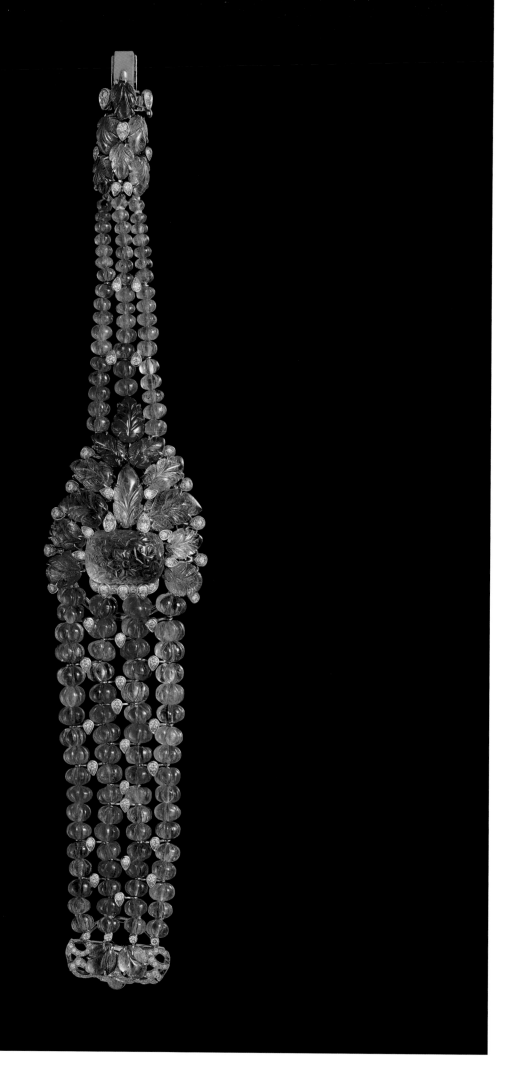

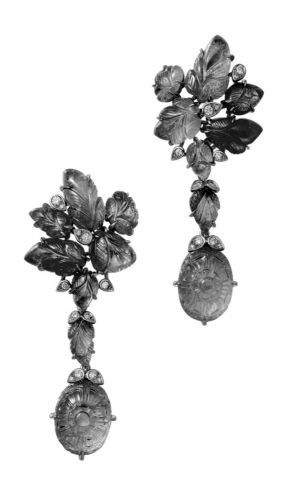

CHENNAI BRACELET
Platinum, one 12.38-carat carved emerald
from Afghanistan, melon-cut emerald beads,
carved emeralds, sapphires, and rubies,
brilliant-cut diamonds.

CHENNAI EARRINGS
Platinum, two carved emeralds totaling
16.52 carats from Zambia, carved sapphires, rubies,
and emeralds, brilliant-cut diamonds.
The earrings can be worn long or short.

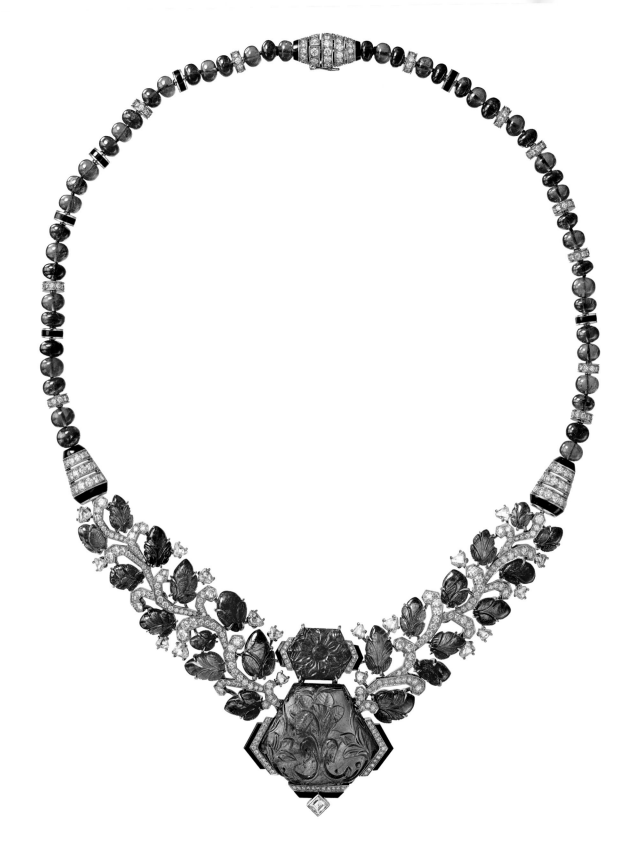

AMRAVATI NECKLACE
Platinum, one 50.44-carat carved emerald
from Zambia, two carved emerald drops from Zambia
totaling 71.22 carats, one 10.16-carat carved
ruby from Mozambique, carved rubies, sapphires,
and emeralds, sapphire and emerald beads,
onyx, triangular-shaped diamonds, square-shaped
diamonds, brilliant-cut diamonds. The necklace
can be worn in four different ways.

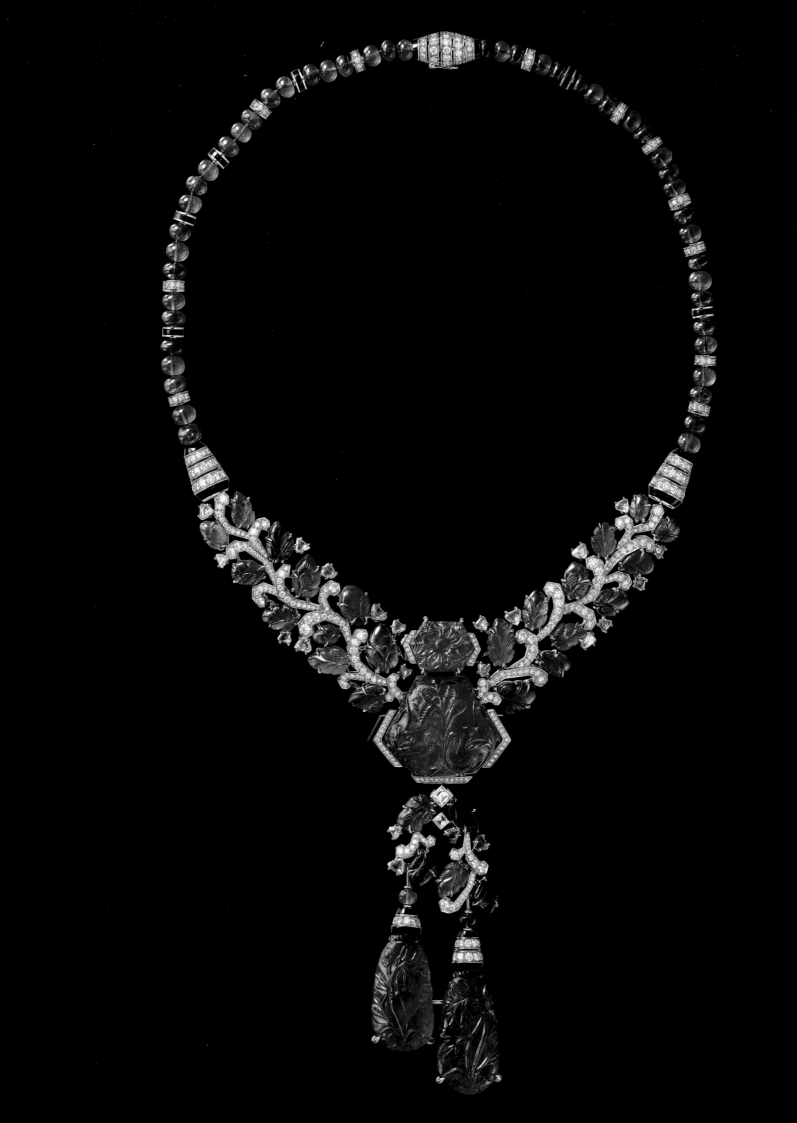

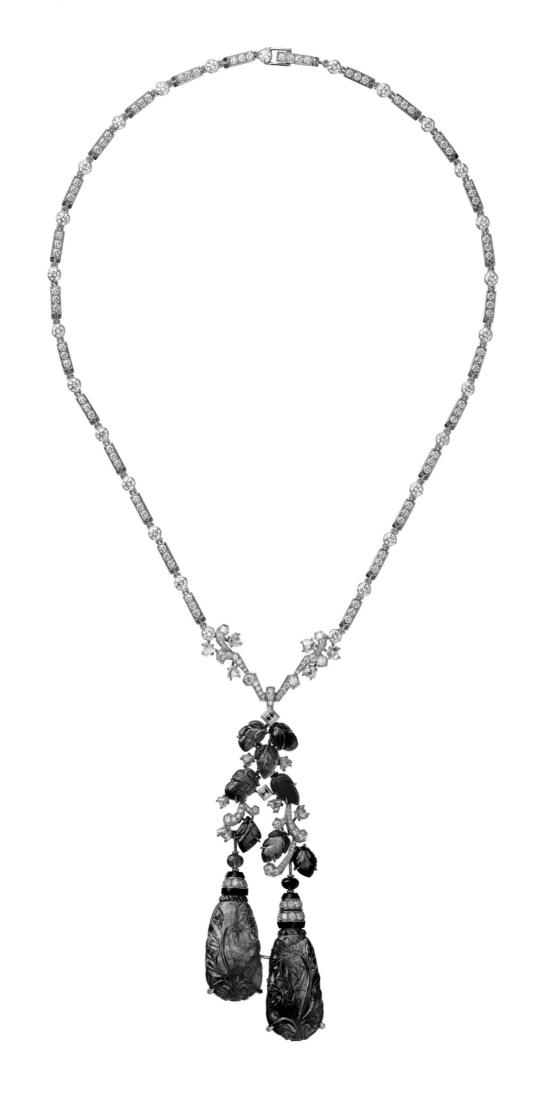

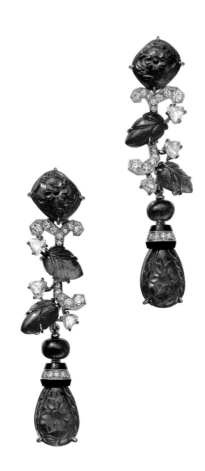

AMRAVATI EARRINGS
Platinum, two carved sapphires from Burma
totaling 14.48 carats, two carved emeralds
from Zambia totaling 13.07 carats, carved rubies
and emeralds, sapphire beads, onyx,
triangular-shaped diamonds, brilliant-cut diamonds.

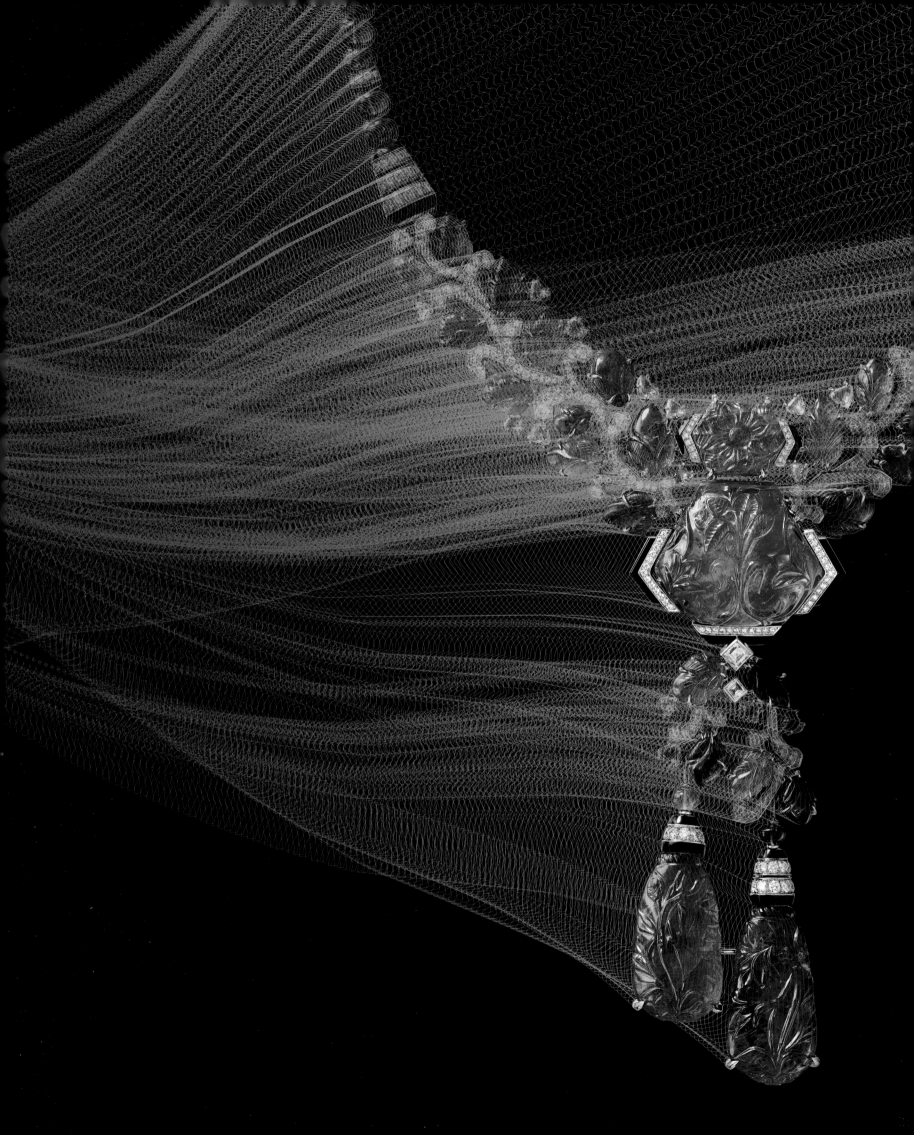

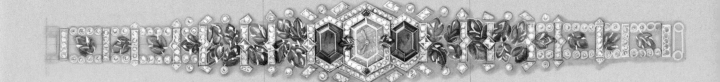

AMRAVATI RING
Platinum, one 17.64-carat carved emerald from
Zambia, carved rubies, emeralds, and sapphires, onyx,
square-shaped diamonds, brilliant-cut diamonds.

TUTTI FRUTTI GEOMETRIC WRISTWATCH
White gold, two hexagonal-shaped rubies from
Mozambique totaling 4.33 carats, carved sapphires,
emeralds, and rubies, baguette-cut diamonds,
brilliant-cut diamonds, quartz movement.

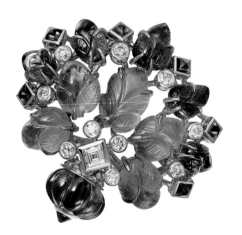

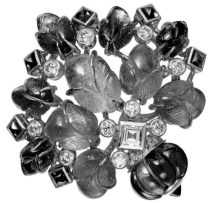

PENDJAB EARRINGS
Platinum, melon-cut ruby beads,
carved emeralds and sapphires, square-
shaped sapphires and diamonds,
cabochon-cut sapphires, brilliant-cut diamonds.

PENDJAB BRACELET
Platinum, one 93.34-carat carved emerald,
melon-cut emerald and ruby beads,
carved sapphires, square-shaped sapphires
and diamonds, brilliant-cut diamonds.

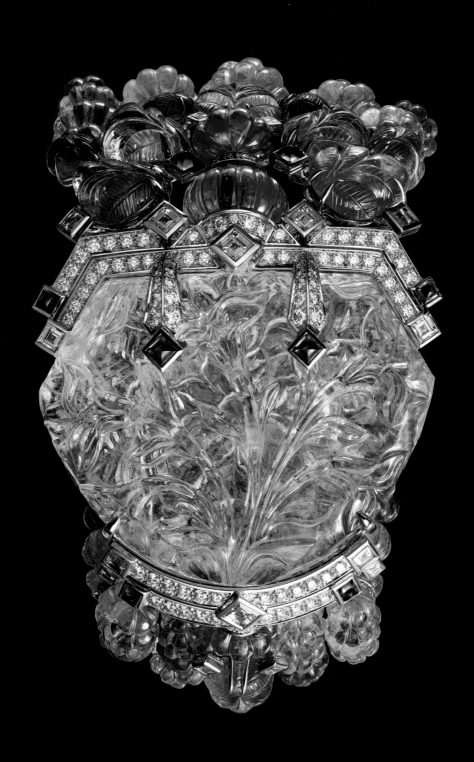

LATERNA EARRINGS
Yellow gold, carved rubellites, chrysoprases, morganites,
onyx, black lacquer, brilliant-cut diamonds.

LATERNA NECKLACE/PERFUME BOTTLE
Yellow gold, carved rubellites, chalcedonies,
chrysoprases and morganites, onyx,
mandarin garnets, one pear-shaped diamond,
brilliant-cut diamonds.

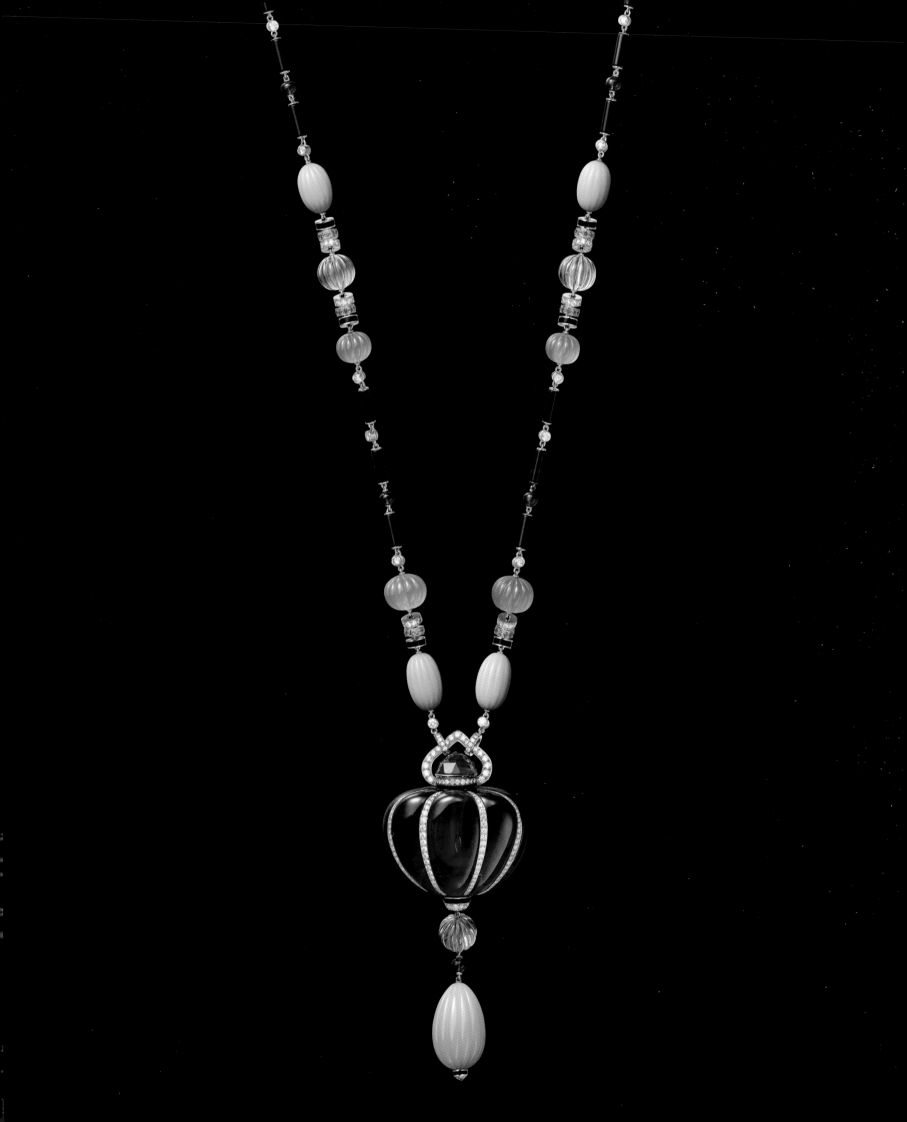

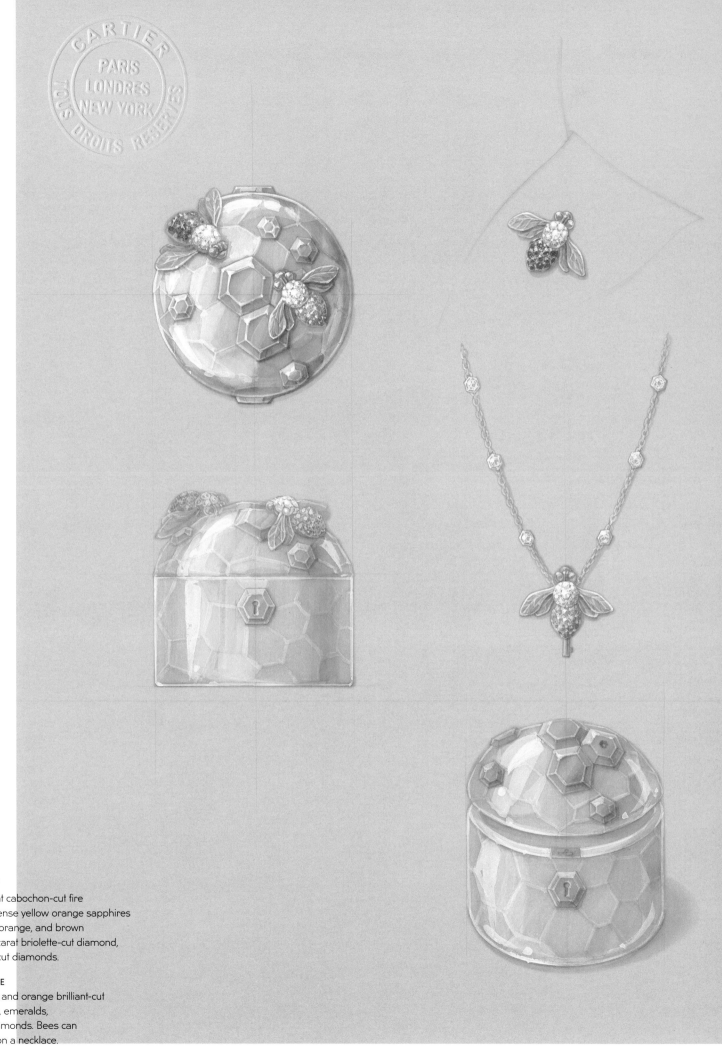

AKSHAYA BROOCH/PENDANT
Yellow gold, one 33.96-carat cabochon-cut fire
opal, six round-shaped intense yellow orange sapphires
totaling 6.01 carats, yellow, orange, and brown
sapphires, onyx, one 3.23-carat briolette-cut diamond,
yellow diamonds, brilliant-cut diamonds.

BEES BOX/BROOCH/NECKLACE
Yellow gold, brown, yellow, and orange brilliant-cut
diamonds, orange garnets, emeralds,
rock crystal, brilliant-cut diamonds. Bees can
be worn as a brooch and on a necklace.

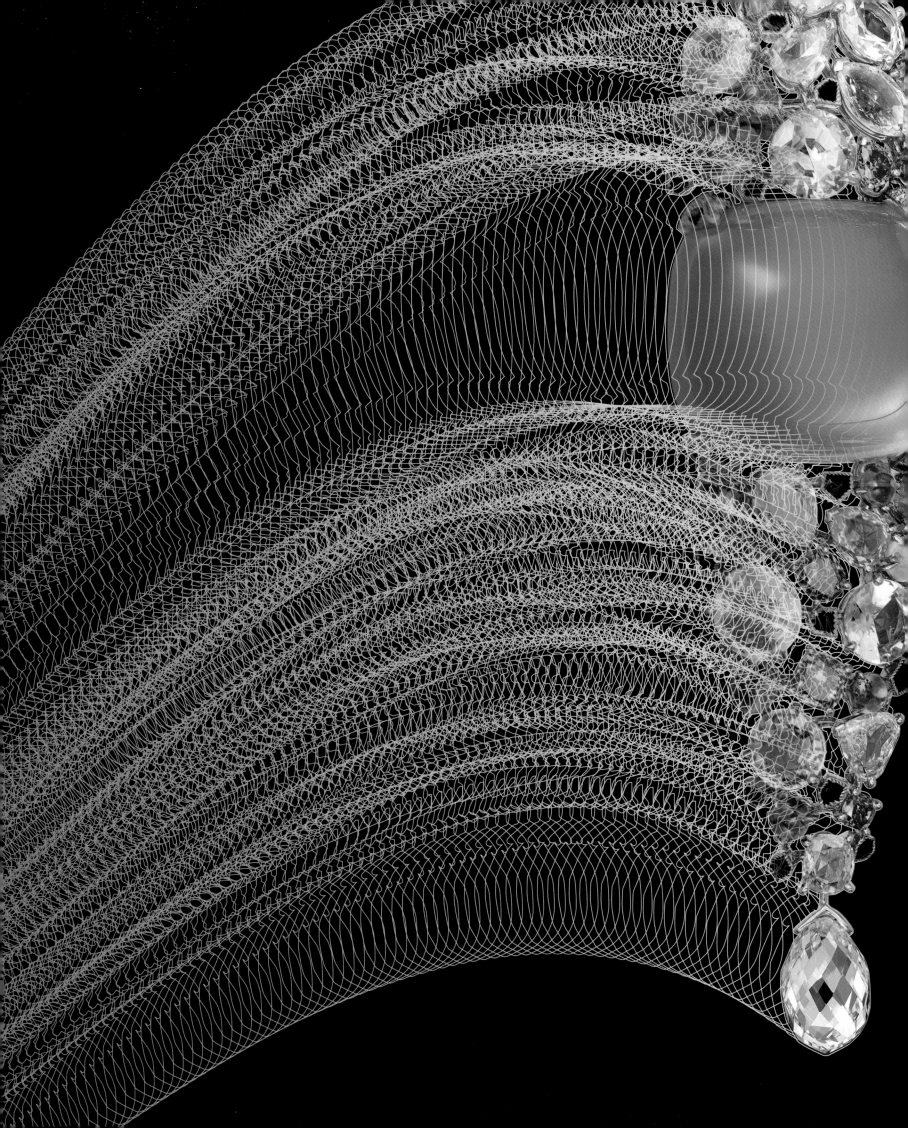

Along with the orchid, the alpine edelweiss is one of Cartier's talisman flowers. Its principal quality is that of being as rare as a precious stone. In the Alps, its rarity and whiteness (*edelweiss* means "noble white" in German) has made it a symbol of purity and love: in many legends, a young man risks his life in the mountains to find at least one blossom to offer to his beloved. Maison Cartier is also much smitten by the beauty of the edelweiss: its brilliant downy, star-like petals, forming a setting for small yellow inflorescences, they too rimmed with small white leaflets, make it a jewel of nature.

 Cartier has crystalized the whiteness of the edelweiss in a dazzling myriad of brilliants. An entire bouquet in all sizes has been artfully strewn on a multicolored bed of sapphires and moonstones. Bursting with gaiety and life, it is a very original illustration of a newly discovered, pastel-hued, lovely, and feminine side to the jeweler's art.

FLORALIES NECKLACE
White gold, twenty-seven colored sapphires
totaling 58.53 carats, three cabochon-cut
moonstones totaling 25.46 carats, rose-cut
diamonds, brilliant-cut diamonds.

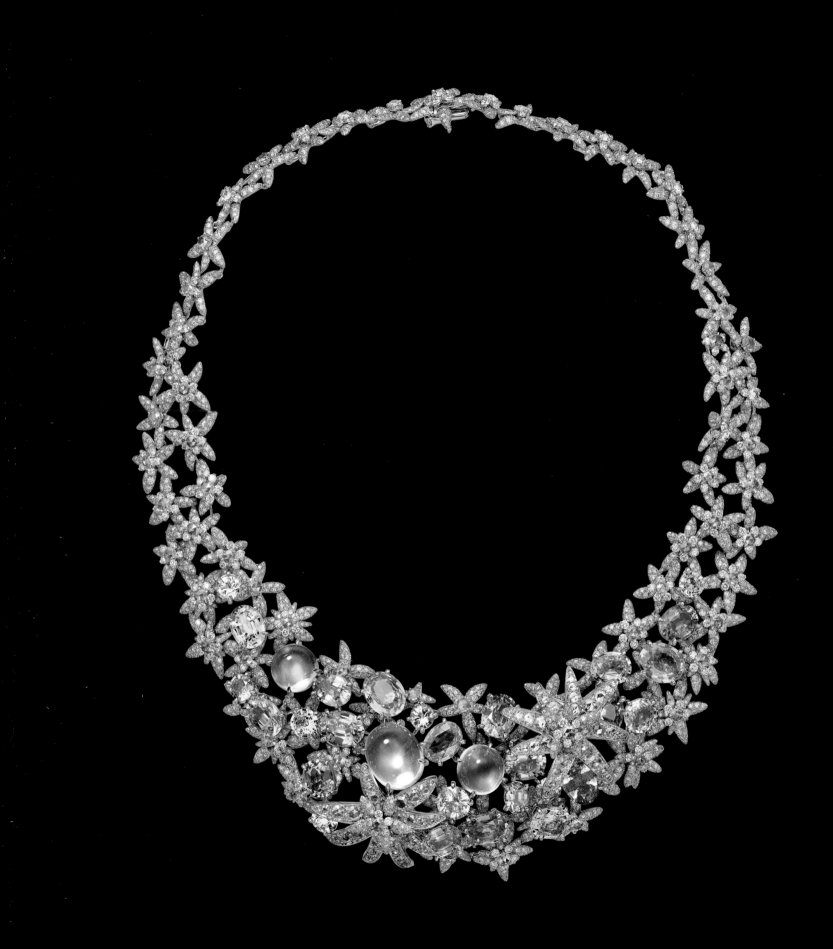

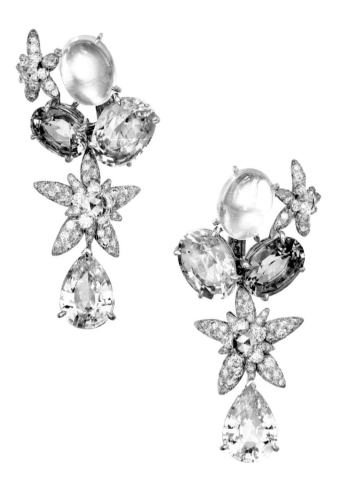

FLORALIES EARRINGS
White gold, two oval-shaped violet sapphires
from Ceylon totaling 5.52 carats, two pear-shaped
orangey yellow sapphires from Ceylon totaling
5.59 carats, cabochon-cut moonstones, colored
sapphires, rose-cut diamonds, brilliant-cut diamonds.

FLORALIES RING
White gold, one 5.03-carat cushion-shaped
orangey pink sapphire from Ceylon, one 4.46-carat
pear-shaped orangey yellow sapphire from
Ceylon, one 4.08-carat oval-shaped violet sapphire
from Ceylon, one 5.89-carat cabochon-cut moonstone,
rose-cut diamonds, brilliant-cut diamonds.

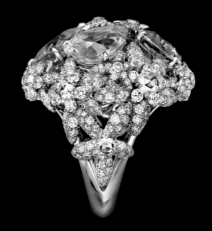

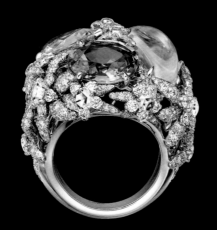

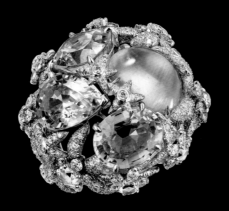

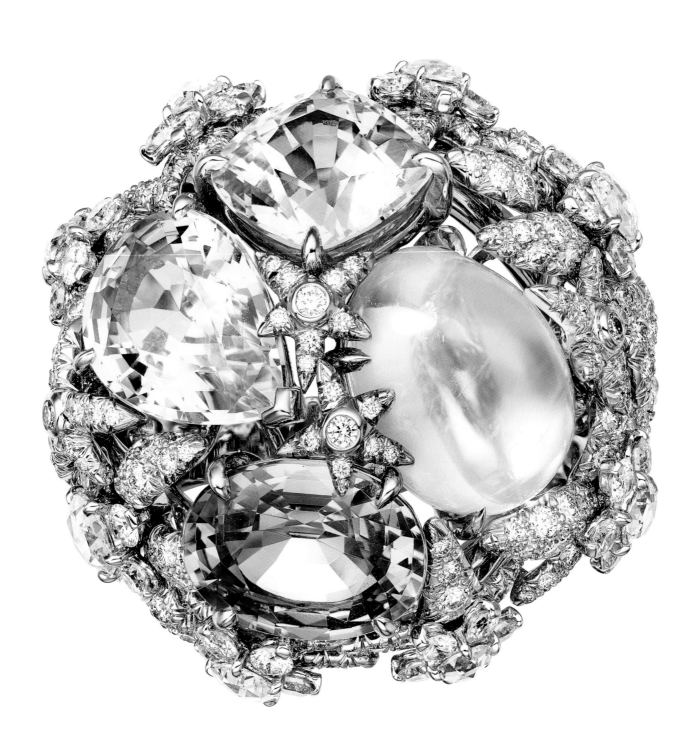

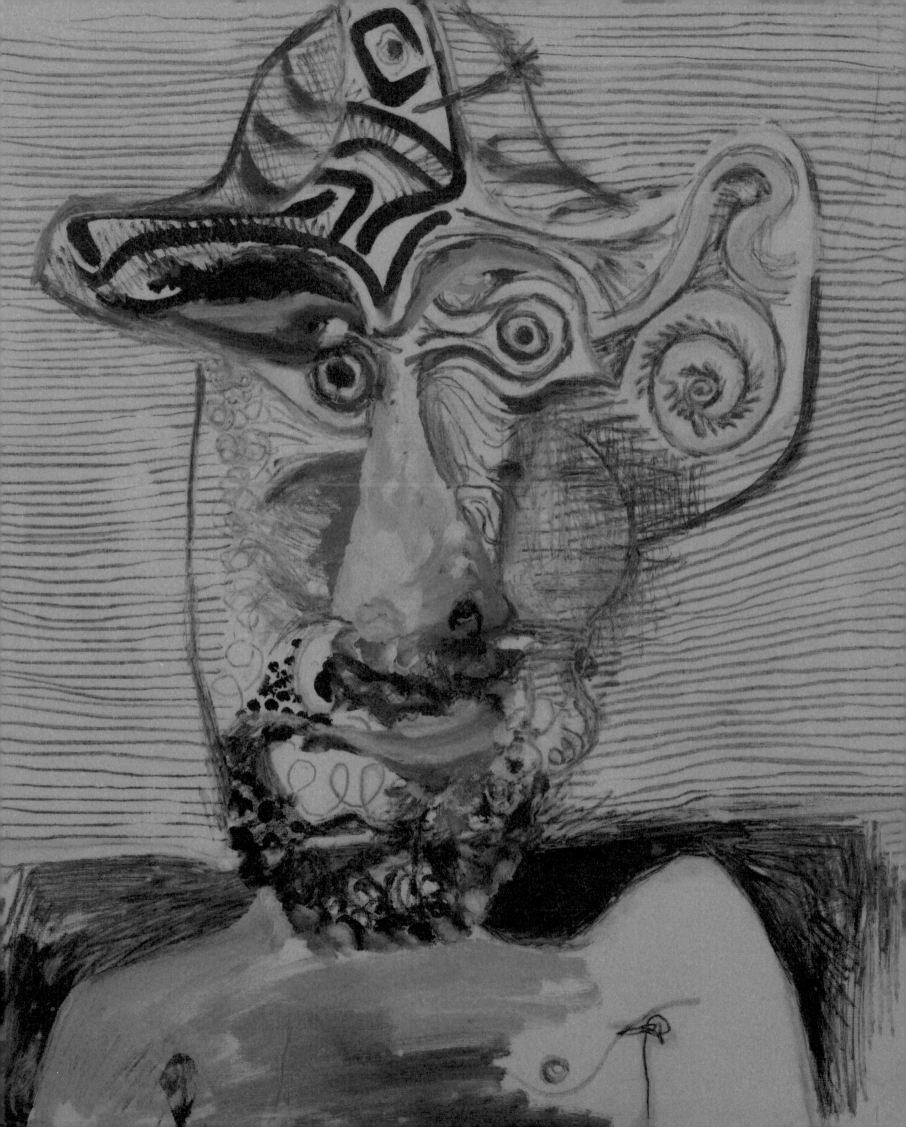

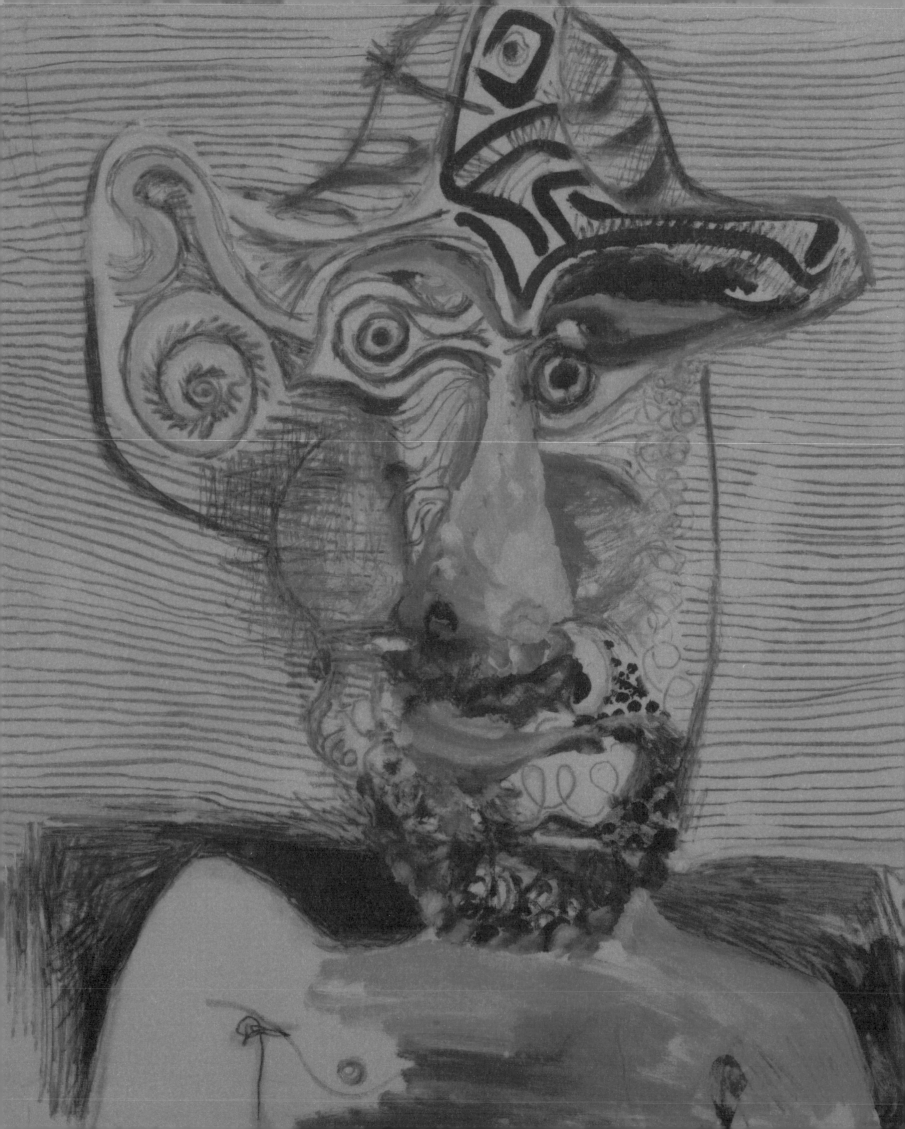

Josef Albers, *Homage to the Square: Guarded*, 1952. The Josef and Anni Albers Foundation, Bethany, CT.

Pablo Picasso, *Buste d'homme au chapeau*, 1972. Musée Picasso, Antibes.

Getting away from the strong contrasts generated by the association of distinctly different, even opposing, colors, the camaïeu technique—where an image is executed in shades or tints of the same color, or in closely related colors sharing a similar tone—evokes a more peaceful, gentle, and eye-soothing sensation.

The *grisaille*, *brunaille*, or *verdaille* techniques were used in the fifteenth and sixteenth centuries—employing different tones of gray, brown, or green, respectively—to imitate the principal materials of ancient art: stone, marble, or bronze. Thus the frescoes of Andrea del Sarto in the Scalzo cloister in Florence mimic ancient marble. In the following century, Calvinist austerity inspired certain northern European painters to eliminate bright colors from their works. Rembrandt was a genius in dark camaïeu (monochromes), masterfully bringing out the light with a few touches of brighter paint. We see this in the corpse in *The Anatomy Lesson of Dr. Nicolaes Tulp*, in the archangel's robe in *The Angel Raphael Leaving Tobit and His Family*, and in nearly all the faces emerging from a dark monochrome background in his portraits and self-portraits.

Other painters made wide use of the camaïeu technique for different reasons: Goya for his oneiric visions; Picasso to evoke the melancholy of his Blue Period or the happiness of his Rose Period; Marie Laurencin in her art of light inspired by Guillaume Apollinaire's Orphism; Braque during his cubist period, having this to say about the quality of his light: "One day I noticed that I could go on working my art motif no matter what the weather might be. I no longer needed the sun, for I took my light everywhere with me. But there was a danger: I almost slipped into monochrome."

Well before the camaïeu technique gained a hold in painting, jewelry aficionados were already familiar with cameos (a related word, although its exact origin is still a matter of discussion), semiprecious gemstones carved in relief, with the first exemplars dating to ancient Greece. In the fourth century BCE, Greek artists began sculpting agates with great finesse, exploiting the tonal differences between strata to create monochromatic cameos of great virtuosity. The Romans took this art to new levels, importing agates with multicolored layers from Egypt, Greece, Asia Minor, and India. The art of the cameo reached its height during the Renaissance, particularly in Italy and France, where it was sought after by art

patrons and collectors, such as Lorenzo de' Medici and Francis I of France. The stones used at the time were sard, onyx, and agates. In the eighteenth century, Madame de Pompadour, quite keen on cameos, engraved one herself under the watchful eye of Jacques Guay, official engraver in Louis XV's court.

Semiprecious stone cameos crafted by master engravers and the camaïeu technique used by painters, both exploiting subtle differences of color, melodious harmonies, and softly measured echoes, inspired a new stylistic adventure at Cartier in the 1990s with a return to an openly declared femininity. A number of exceptional pieces testify to this move toward graceful, soothing agreements. In 1998, for example, the Maison created a lariat necklace with a camaïeu of natural pearls. It is composed of a pink pearl choker and a tight cluster of gray, amber, pink, and golden pearls with similarly sized briolette-cut diamonds hanging from an oval-shaped brown diamond weighing close to 20 carats. The cluster looks like an enchanting improvisation of nature and culminates in an 11.28-carat briolette-cut brown diamond.

Notable pieces in the most recent High Jewelry collections include the Mandragore necklace of 2016, an ode to the hydrangea, where the various nuances of soft green are set off by beryls, tsavorite garnets, and a magnificent green-blue sapphire. A new pastel interpretation of the Cartier tradition of engraved stones was presented in 2017, where a profuse yet subtle summer garden culminates in sparkling diamonds, rubellites, tourmalines, peridots, garnets, rubies, and moonstones. Here Cartier has revisited one of its classics with the refinement that only comes with maturity.

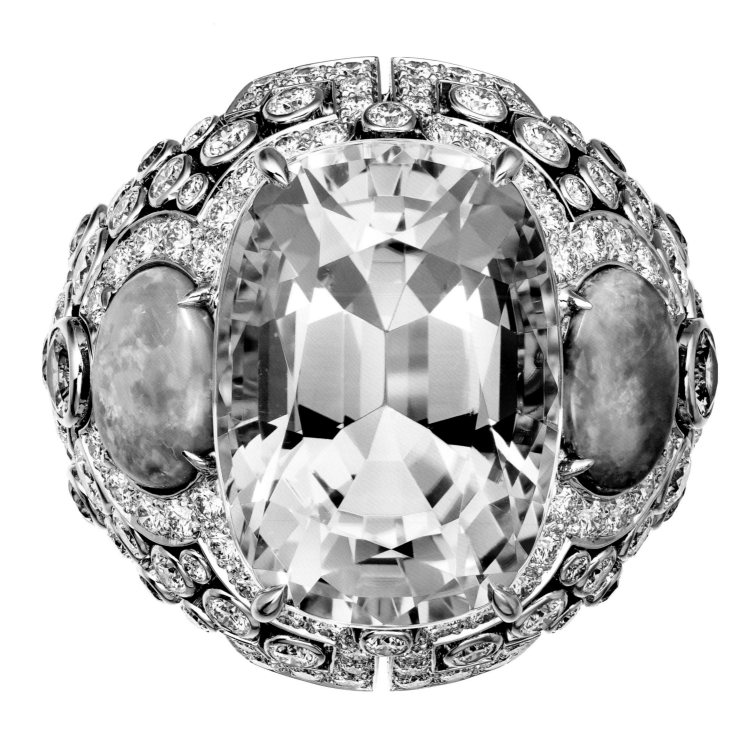

Hanami, one of the loveliest of Japanese traditions, reaching back to the seventh century, is a celebration of the first blossoms of spring—particularly fleeting, yet magnificent, white or pink cherry blossoms. The joyousness of this outdoor festivity shared by families and friends and the delicacy of the cherry blossom inspired a lithely botanical pastel-toned necklace. An array of superb morganites, tourmalines, and pink sapphires blends with the soft iridescence of opals to evoke the subtle color of the flowers.

The Empire of the Rising Sun has been an inexhaustible source of inspiration over the decades for highly refined and elegantly modern jewelry compositions, as illustrated by a bracelet from 1925 exploring the theme of cherry and plum blossoms. Precious flowers with emerald hearts and ruby corollas flourish on onyx branches, in a brilliant Art Deco interpretation of Japanism.

A jewel of eternal springtime, this necklace upholds another Cartier tradition: transformability. The pendant can be removed and the necklace can be worn in three different ways.

YOSHINO EARRINGS
White gold, two pear-shaped morganites totaling 23.50 carats, two cabochon-cut opals totaling 2.18 carats, pink sapphires, brilliant-cut diamonds.

YOSHINO NECKLACE
White gold, two emerald-cut morganites totaling 55.18 carats, three cabochon-cut opals totaling 8.13 carats, tourmaline beads, pink sapphires, brilliant-cut diamonds. The necklace has an additional chain and can be worn in three different ways.

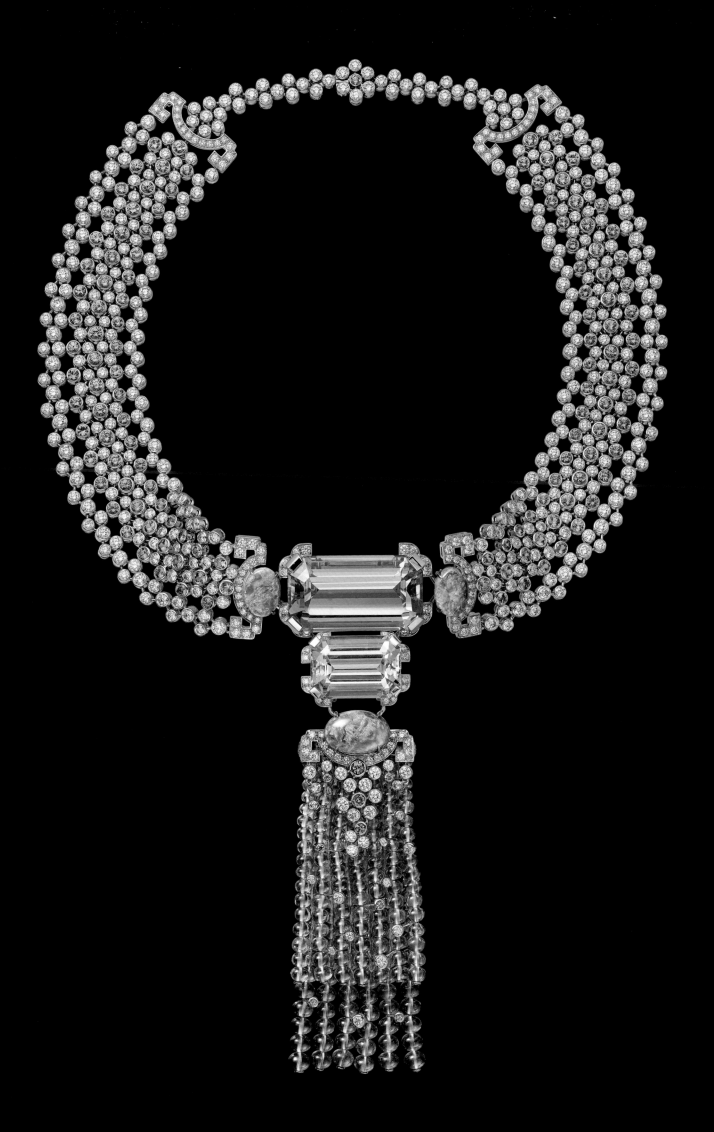

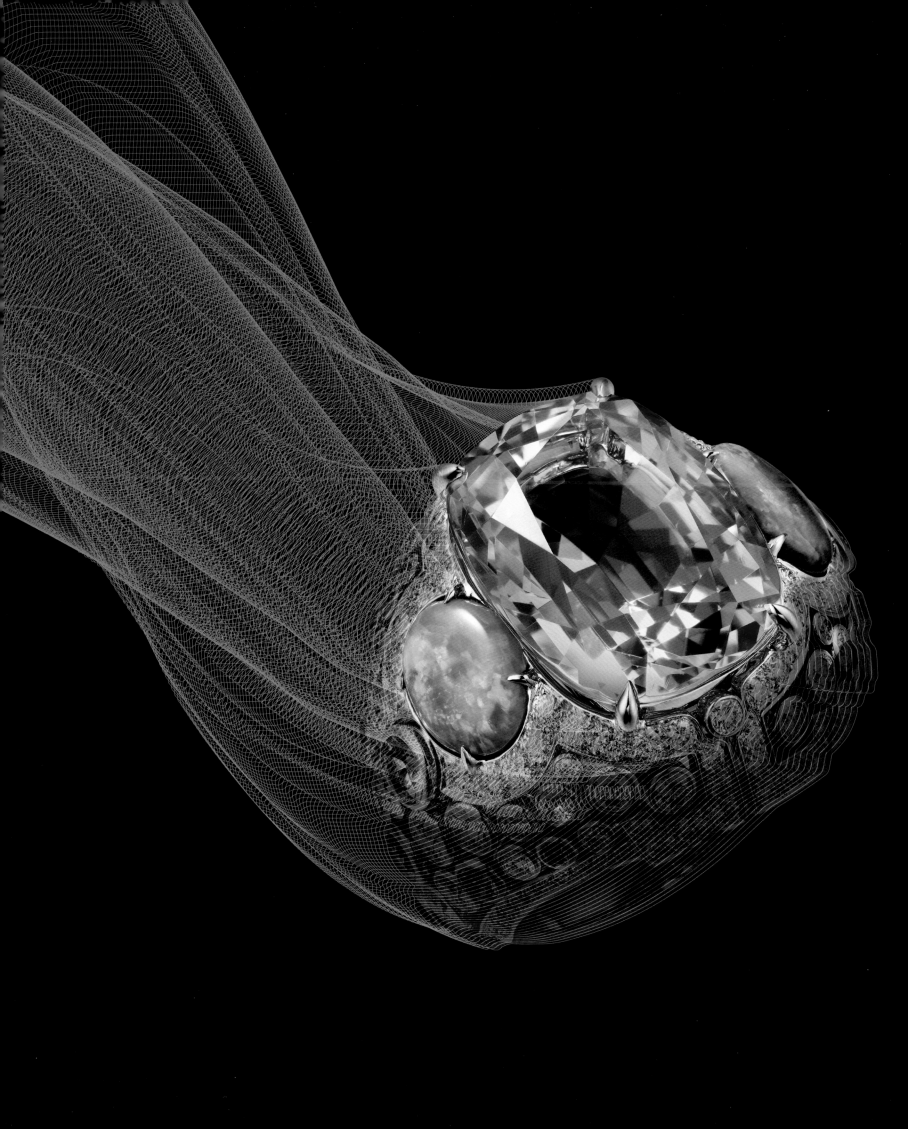

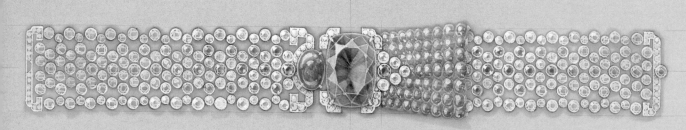

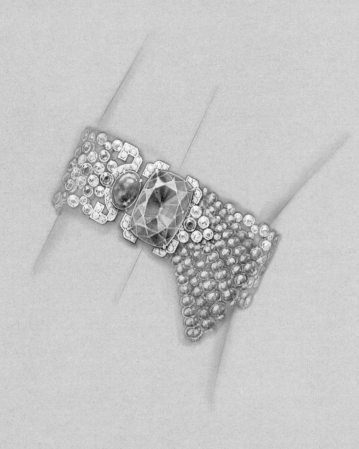

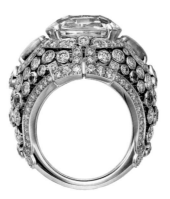

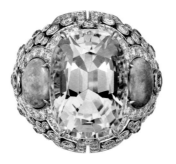

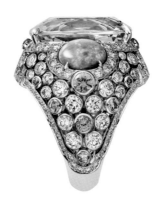

YOSHINO BRACELET
White gold, one 14.10-carat cushion-shaped
morganite, one 1.67-carat cabochon-cut opal, tourmaline
beads, pink sapphires, brilliant-cut diamonds.

YOSHINO RING
White gold, one 17.12-carat cushion-shaped
morganite, two cabochon-cut opals totaling 1.72 carats,
pink sapphires, brilliant-cut diamonds.

HANABI EARRINGS
White gold, square-shaped diamonds, coral,
onyx, brilliant-cut diamonds.

HANABI NECKLACE/BRACELETS
White gold, four square-shaped diamonds
totaling 10.99 carats, square-shaped diamonds,
onyx, coral, brilliant-cut diamonds.
The necklace can be worn at three lengths:
long, medium with one bracelet, or short
with two bracelets.

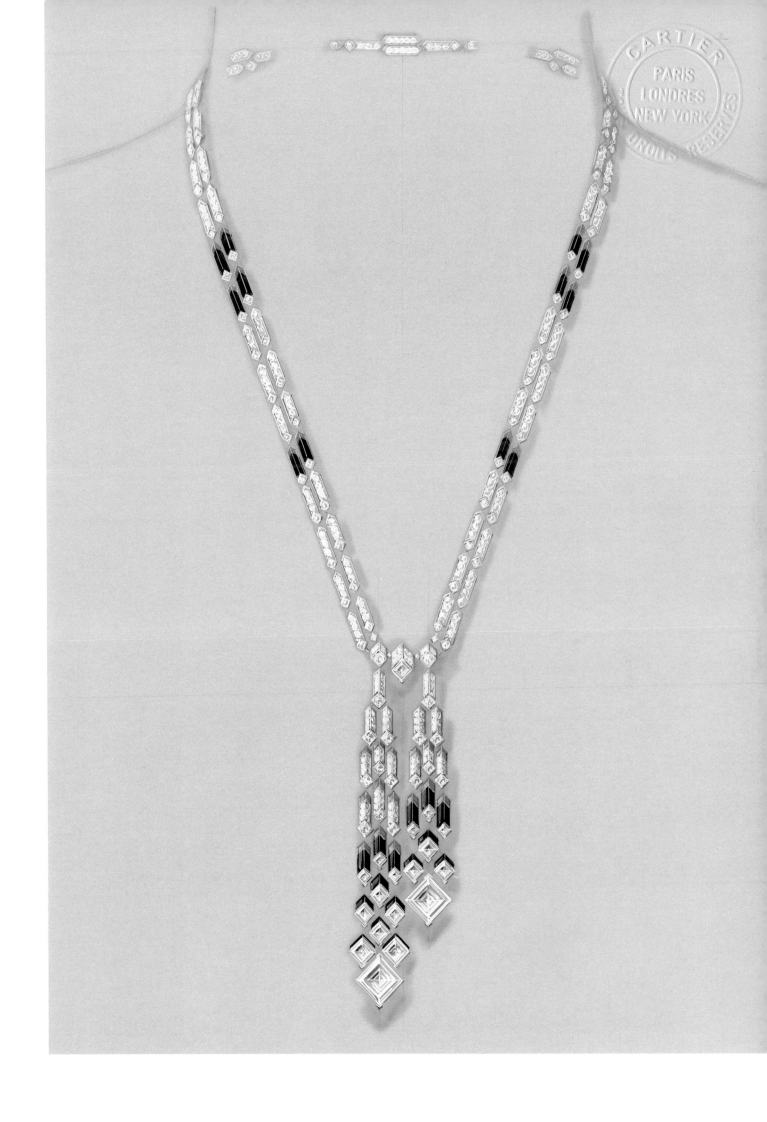

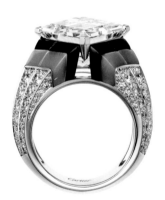

HANABI RING
White gold, one 7.45-carat F VS1 square-shaped
diamond, coral, onyx, brilliant-cut diamonds.

HANABI HEADBAND/NECKLACE/BRACELETS
White gold, one 5.47-carat F VVS1 square-shaped
diamond, square-shaped diamonds,
coral, onyx, brilliant-cut diamonds. The headband
can be worn in different ways.

219

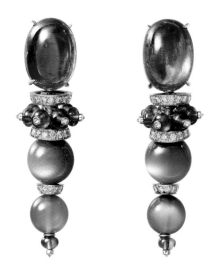

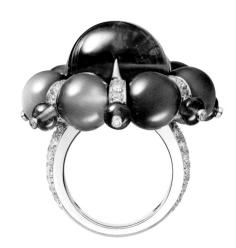

PAMINA EARRINGS
White gold, two cabochon-cut rubellites
totaling 26.13 carats, moonstone and rubellite
beads, brilliant-cut diamonds.

PAMINA RING
White gold, one 22.19-carat cabochon-cut rubellite,
moonstone and rubellite beads, brilliant-cut diamonds.

PAMINA NECKLACE
White gold, one 63.33-carat cabochon-cut rubellite,
moonstone and rubellite beads, brilliant-cut diamonds.

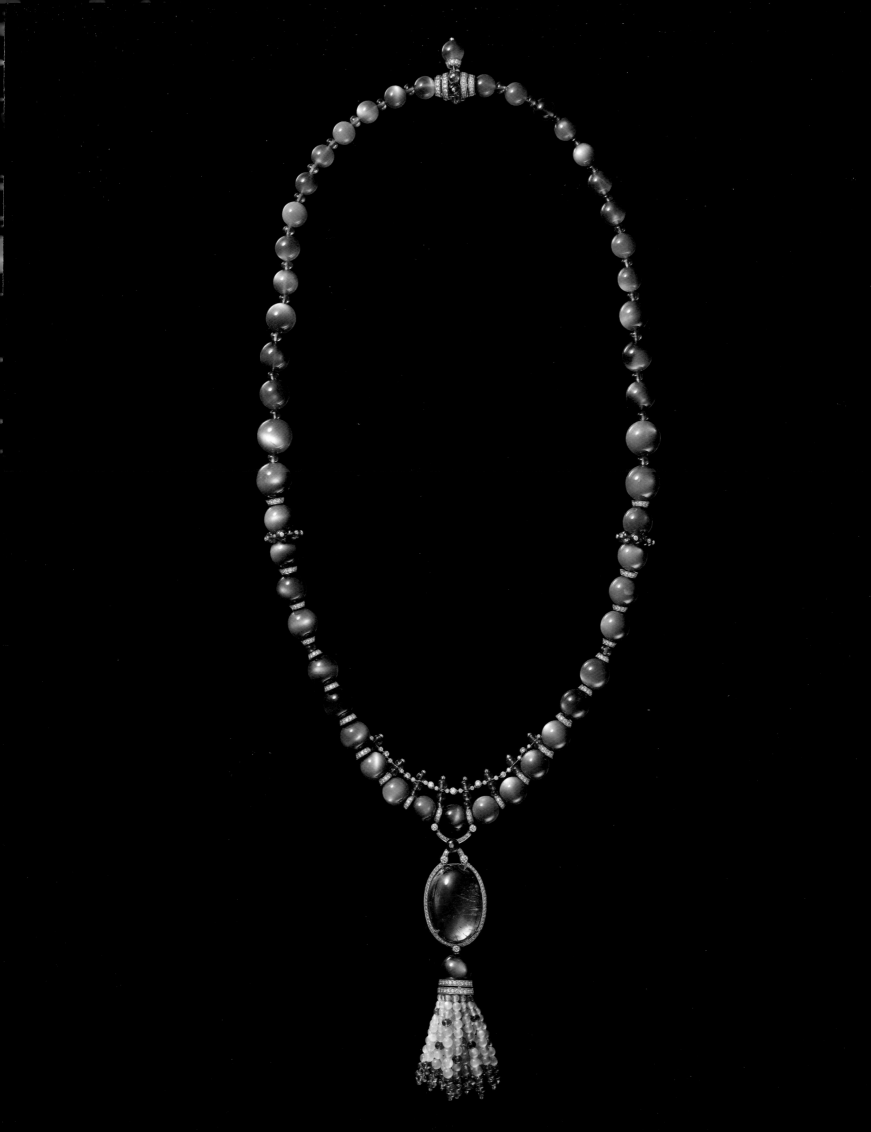

CARTIER
PARIS
LONDRES
NEW YORK
TOUS DROITS RÉSERVÉS

PANTHÈRE VELVET WRISTWATCH
White gold, eighty-eight melon-cut rubies totaling
94.75 carats, onyx, emerald eyes, brilliant-cut
diamonds, quartz movement.

PANTHÈRE DUO RING
White gold, one 40.18-carat cabochon-cut rubellite,
one 29.18-carat blue green sugarloaf tourmaline,
cabochon-cut rubellites, emerald eyes, onyx, brilliant-cut
diamonds. The two center stones are interchangeable.

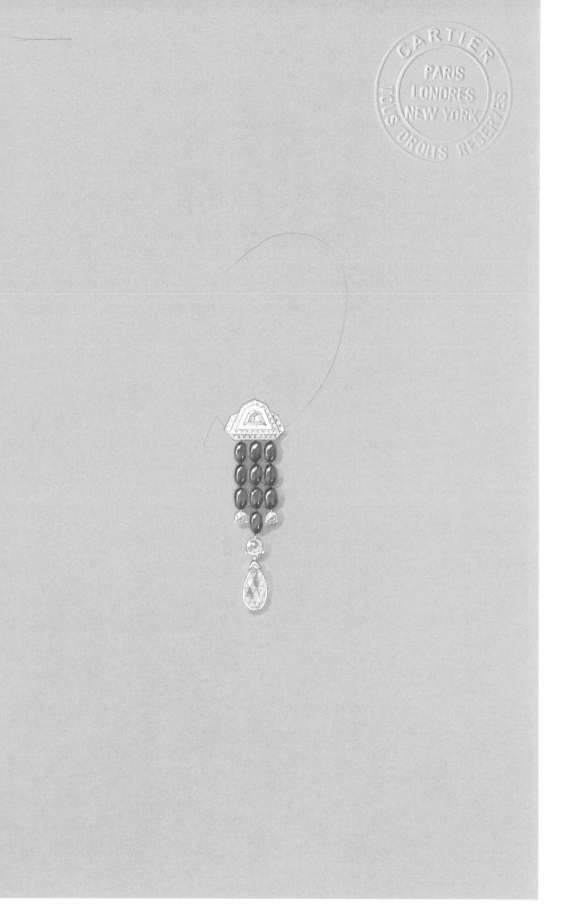

CARTIER
PARIS
LONDRES
NEW YORK
TOUS DROITS RÉSERVÉS

AMISTA EARRINGS
Platinum, rhodonite beads, one pear-shaped rose-cut diamond, one pear-shaped modified brilliant-cut diamond, kite-shaped diamonds, brilliant-cut diamonds.

AMISTA NECKLACE/BROOCH
Platinum, rhodonite beads, one cushion-shaped diamond, one pear-shaped rose-cut diamond, three modified shield-shaped step-cut diamonds, one modified pentagonal step-cut diamond, rose-cut diamonds, brilliant-cut diamonds.

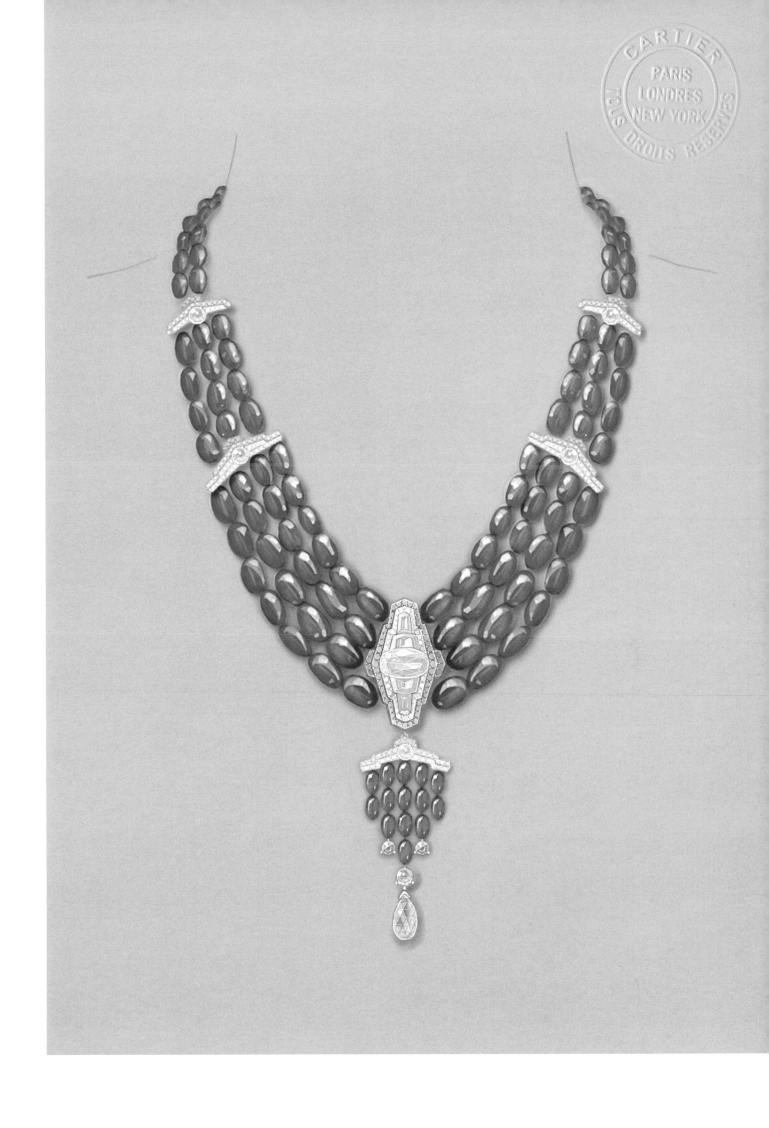

CARTIER
PARIS
LONDRES
NEW YORK
TOUS DROITS RÉSERVÉS

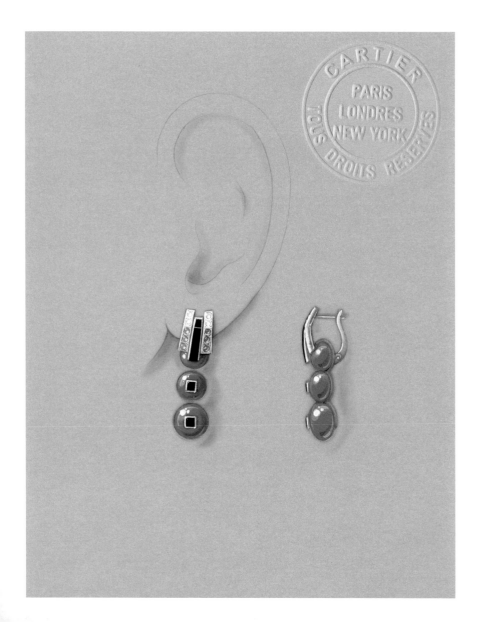

ORIENPHONIE RING
White gold, three orangey red coral beads totaling
12.84 carats, onyx, brilliant-cut diamonds.

ORIENPHONIE EARRINGS
White gold, six orangey red coral beads totaling
21.70 carats, onyx, black lacquer, brilliant-cut diamonds.

ORIENPHONIE WRISTWATCH
White gold, nineteen orangey red coral
beads totaling 130.46 carats, onyx, brilliant-cut
diamonds, quartz movement.

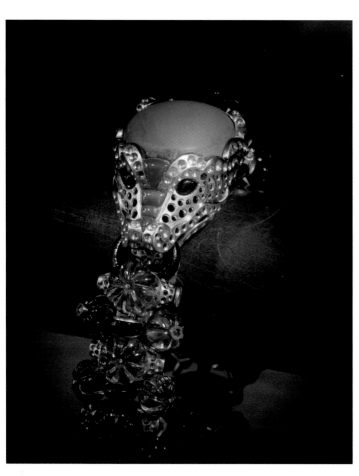

RYUJIN BRACELET
Platinum, one 20.83-carat cabochon-cut opal,
melon-cut peridots totaling 160.14 carats,
cabochon-cut sapphires, sapphire eyes, coral,
onyx, brilliant-cut diamonds.

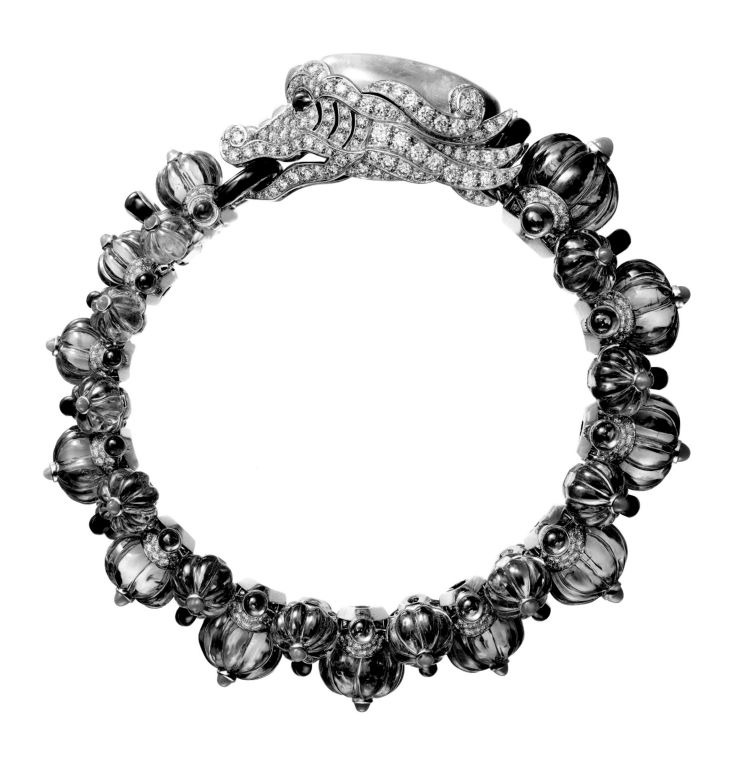

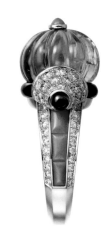

RYUJIN RING
Platinum, one 15.26-carat carved peridot, cabochon-cut
sapphires, coral, onyx, brilliant-cut diamonds.

RYUJIN EARRINGS
Platinum, melon-cut peridots, cabochon-cut sapphires,
coral, brilliant-cut diamonds.

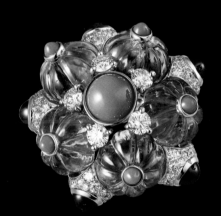
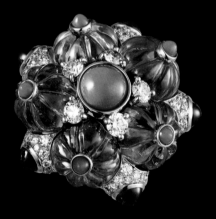

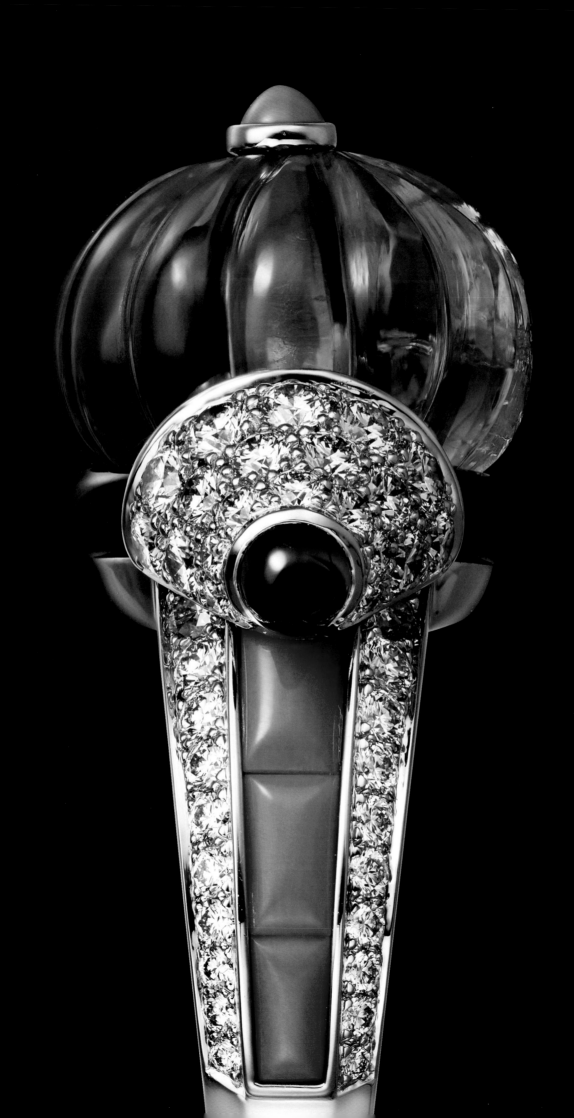

GREEN AND RED

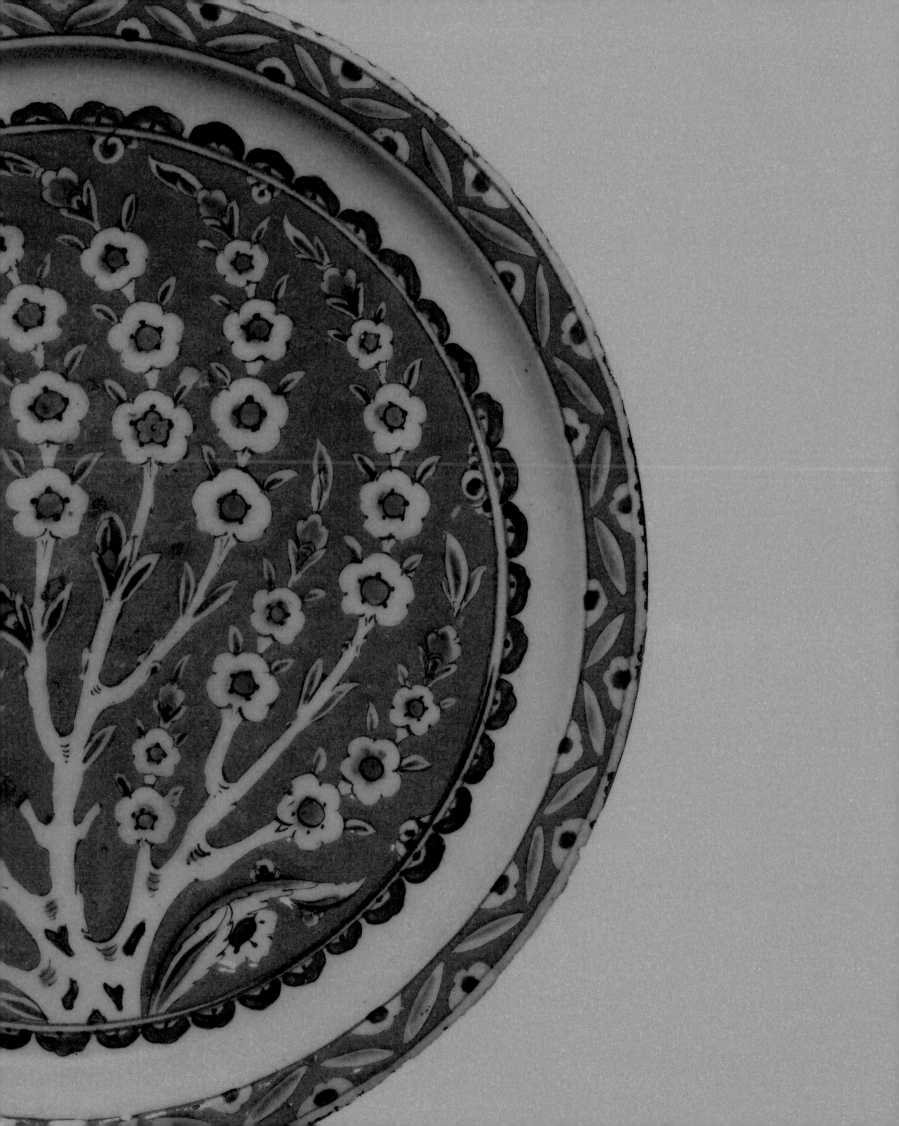

Mark Rothko, *Untitled*, 1949. Christopher Rothko collection, New York, NY.

Iznik ceramic plate with prunus decoration (detail), circa 1575–1600. British Museum, London.

Red enflames, green soothes. Red is the color of twentieth-century revolutions, while in Rome, well before green became the comforting color of nature and health, emerald powder was prescribed to soothe eye pain!

Separated into different psychological and symbolic camps, when juxtaposed, these two colors are subject to an optical law described in the nineteenth century by a great scholar of color perception, Michel-Eugène Chevreul. The director of the Gobelins tapestry works published a treatise in 1839 titled *De la loi du contraste simultané des couleurs et de l'assortiment des objets colorés* (the English translation was published in 1854 with the title *The Principles of Harmony and Contrast of Colors*), which had a lasting influence on later painters. One of his main observations regards the juxtaposition of two colors: if we place them side by side on a neutral background they appear more dissimilar, more in contrast, than if we keep them separated. When united, they may even appear to change hue, but of course they haven't. This law regards complementary colors in particular, such as red and green, which each gain in brilliance, appear more saturated, if we juxtapose them.

Thus the combination of red and green is rich in intensity, energy, and power—or, as van Gogh would put it, in a certain dramatic tension. Vincent wrote a letter to his brother Theo about the interior of *The Night Café* (1888): "I've tried to express the terrible human passions with the red and green." Do we not feel something similar looking at Monet's famous *Poppy Field*? Would not the country outing in Île-de-France by a mother and her son have been more serene without those red spots strewn amidst the grass? More recently, other artists have explored the intensity of this association, such as the painter Mark Rothko. Quite keen on red, even before his abstract period, he frequently associated it with green, fretting about the aftereffect described by Georges-Louis Leclerc, comte de Buffon in 1743 in his *Essay on Accidental Colors*. Leclerc writes that when one stares at a red figure on a white background, one sees a faint greenish halo form around it. If the observer then shifts their gaze to a white background, they will see the same figure appear but tinted green tending toward blue. So Rothko asked Bryan Robertson, director of the Whitechapel Art Gallery in London, where the artist was going to exhibit in 1961, to warm up the white walls of his gallery with a faint rose tint. He was afraid that if they were too white, they would have generated a green echo of his red paintings, and that echo would rival the originals. This is the same

afterimage generated by the overwhelming red in Henri Matisse's *L'Atelier Rouge*, which may well have been conjured in the painter's mind after a good long immersion in the intense green of his garden.

The French furniture and interior designer Pierre Paulin made the combination of red and green one of his emblems, envisioning a madder red and malachite green décor in the Nikko hotel in Paris in 1976, or frequently combining vermillion and fresh-grass-green in his furniture. A century and a half earlier, the same strong contrast was found in Empire-style decorations, where a similar green was frequently combined with Pompeian red, crimson, or purple.

In India, rubies, spinels, and emeralds, often carved, were already, with jade and diamonds, the queenly stones in the Mogul empire, particularly at its height in the seventeenth century. The traveler Jean-Baptiste Tavernier—who brought back from India and sold to Louis XIV many gemstones, including the famous Tavernier Blue diamond—described the imperial throne in Delhi, clad in enameled gold and studded with diamonds, rubies, and emeralds. At that time, in traditional Kundan jewelry, where one side bears the gemstones in their settings and the reverse is finely enameled, red and green were very frequently associated on either side. Maharajahs began to be very fond of associating rubies and emeralds starting in the late eighteenth century, often accompanied by the white of pearls and diamonds.

The Cartier brothers were familiar with this tradition, and reproduced it in their India-inspired jewelry starting in the 1920s as we see in drawings and surviving pieces, such as a magnificent necklace ordered in 1928 adorned with rubies and emeralds. But Cartier often broadened their red-green palette in a less traditional combination: coral and emerald. They are found in a good number of jewelry pieces of various inspirations from the Art Deco period: purely geometrical in bracelets from the early 1920s, antique in a fruit-bowl brooch from 1928, or with a Chinese touch in a dragon's head bracelet from the same year.

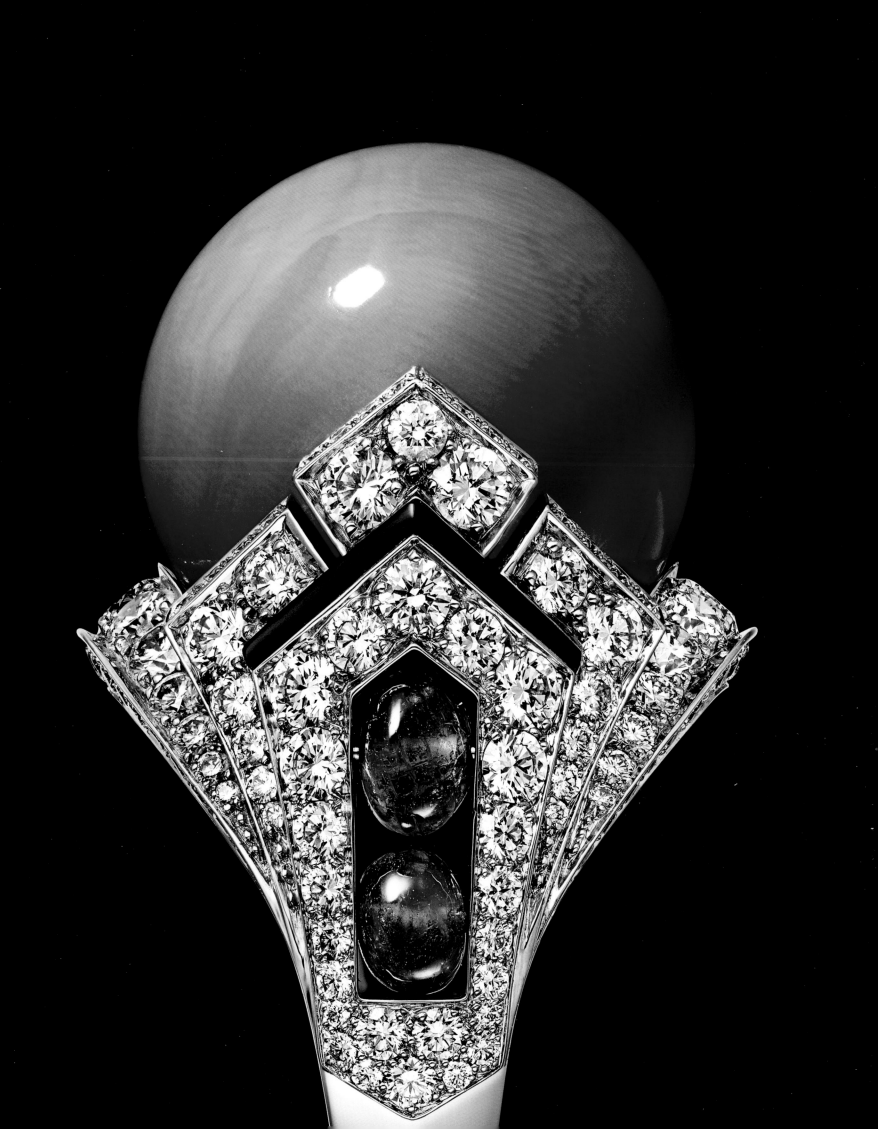

The botanical freshness of green, the radiant warmth of red: Cartier has always expressed its art in this alloy where two opposites, like yin and yang, harmoniously complement each other. The *collerette* composition of this necklace is gracefully oneiric while also achieving a certain sober elegance: the echoes of the colors of the emeralds and coral are answered by a symmetry of design; the sensual generosity of the gems is met by the clarity of the volumes and the rhythm created by the small touches of onyx.

Its virtuosity as an ensemble does not deny the possibility of transfiguration: this necklace presents many magical faces, it metamorphoses, it breaks up and is recomposed. At first sight, the asymmetry of the two pendants is intriguing. Then the central motif transforms into a tiara, a supplementary piece taking its place, so that the two jewels can be worn as a dazzling set.

MAVRA NECKLACE/TIARAS
Platinum, white gold, sixty-eight emerald beads
from Brazil totaling 310.84 carats, cabochon-cut coral,
onyx, brilliant-cut diamonds. The central elements
of the necklace and the tiara are interchangeable.

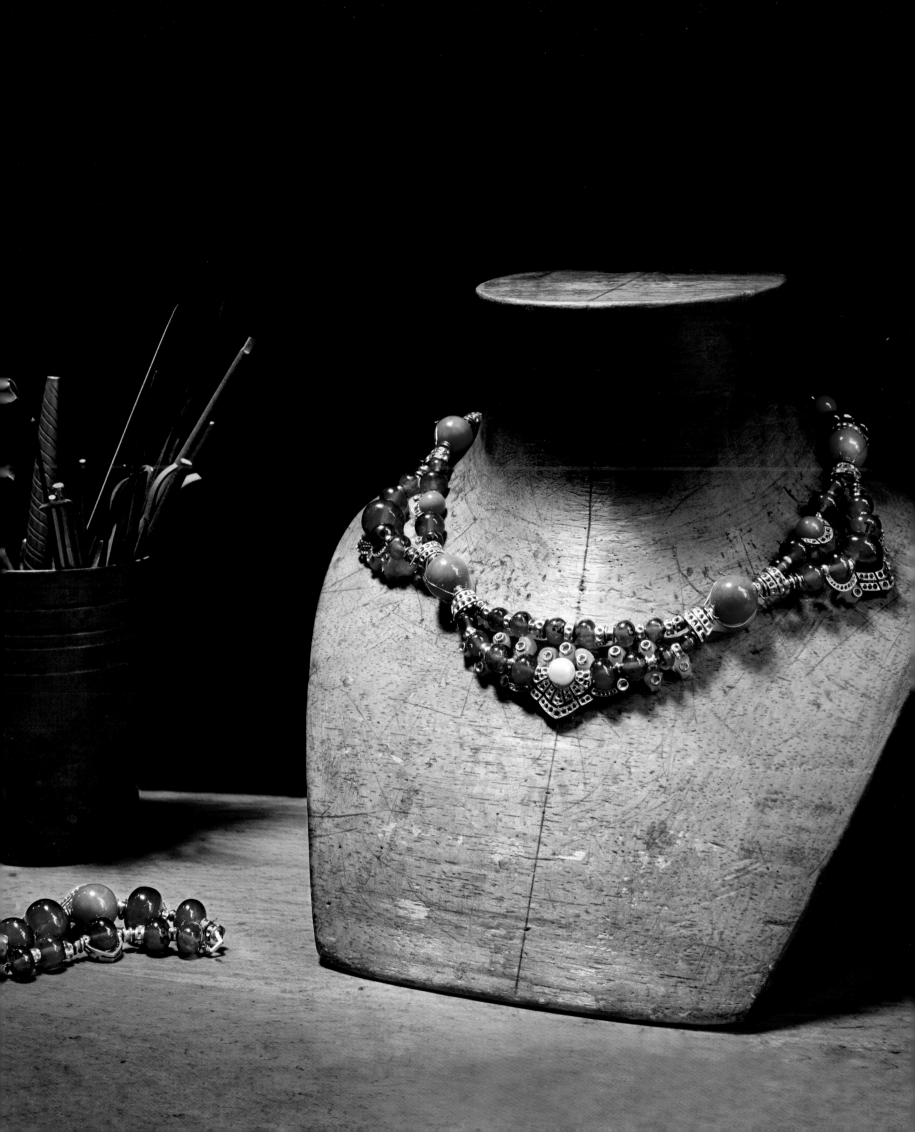

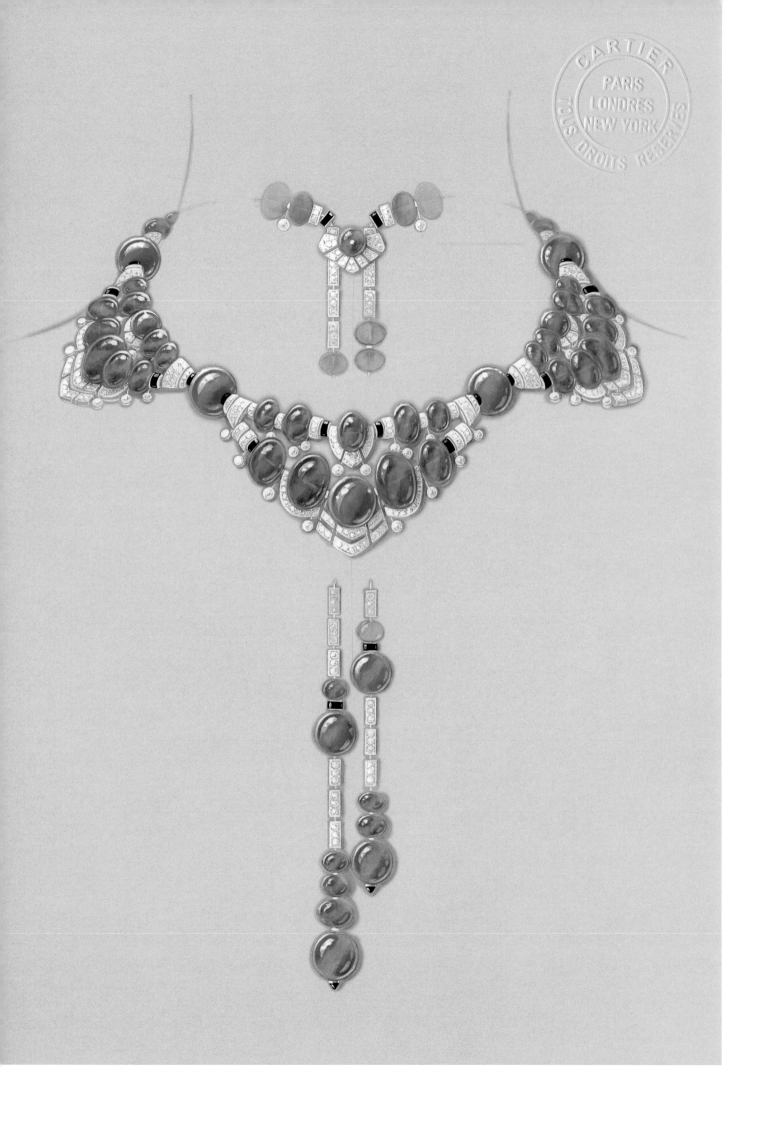

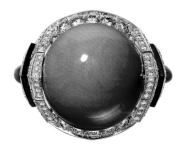

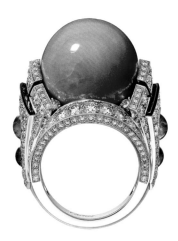

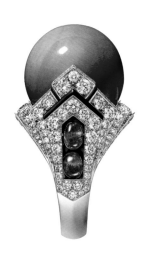

MAVRA RING
Platinum, one 35.00-carat orangey red coral bead,
cabochon-cut emeralds, onyx, brilliant-cut diamonds.

MAVRA EARRINGS
Platinum, two orangey red coral drops
totaling 41.35 carats, emerald and coral beads,
onyx, brilliant-cut diamonds.

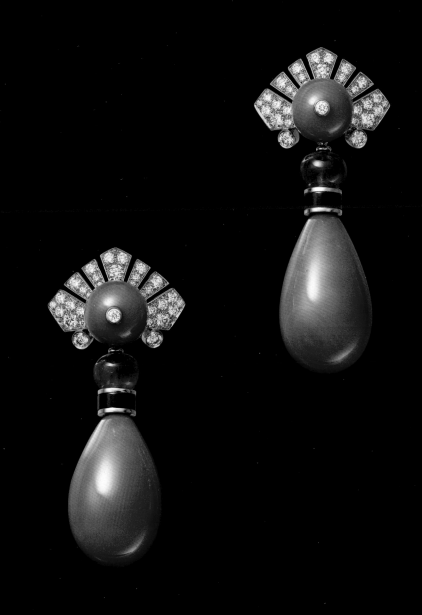

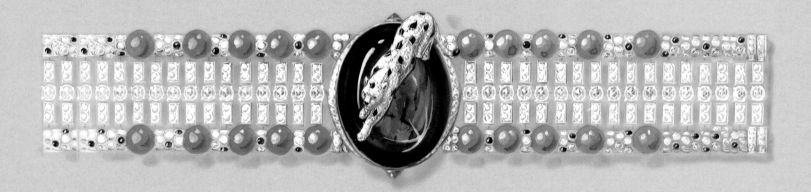

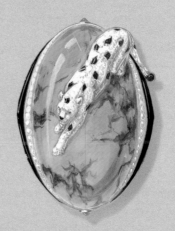

PANTHÈRE INTRÉPIDE BRACELET
Platinum, pink gold, one 101.18-carat cabochon-cut brown star sapphire, twenty orangey red coral beads totaling 83.45 carats, cabochon-cut coral, emerald eyes, onyx, brilliant-cut diamonds.

PANTHÈRE INTRÉPIDE BROOCH
Platinum, one 100.94-carat cabochon-cut turquoise, cabochon-cut coral, emerald eyes, onyx, brilliant cut-diamonds.

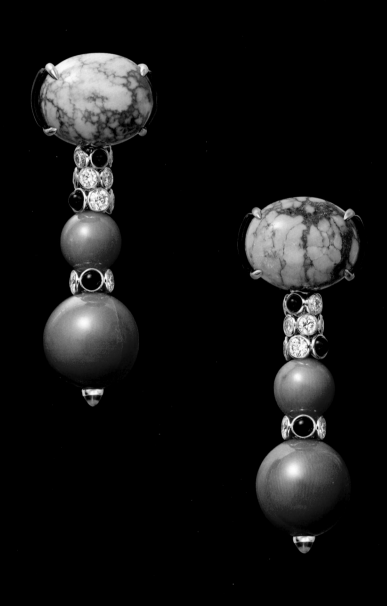

PANTHÈRE INTRÉPIDE EARRINGS
Platinum, two cabochon-cut turquoises totaling
23.56 carats, four orangey red coral beads
totaling 40.79 carats, cabochon-cut emeralds,
onyx, brilliant-cut diamonds.